Eco-Aesthetics

RADICAL AESTHETICS – RADICAL ART

Series editors: Jane Tormey and Gillian Whiteley (Loughborough University, UK)

Promoting debate, confronting conventions and formulating alternative ways of thinking, Jane Tormey and Gillian Whiteley explore what radical aesthetics might mean in the twenty-first century. This new books series, *Radical Aesthetics – Radical Art (RaRa)*, reconsiders the relationship between how art is practised and how art is theorized. Striving to liberate theories of aesthetics from visual traditions, this series of single-authored titles expands the parameters of art and aesthetics in a creative and meaningful way. Encompassing the multisensory, collaborative, participatory and transitory practices that have developed over the last twenty years, *Radical Aesthetics – Radical Art* is an innovative and revolutionary take on the intersection between theory and practice. Published and forthcoming in the series:

The Aesthetics of Duration: Time in Contemporary Art, Paul O'Neill and Mick Wilson

Indigenous Aesthetics: Art, Activism and Autonomy, Dylan Miner

Practical Aesthetics: Events, Affects and Art after 9/11, Jill Bennett

For further information or enquiries please contact *RaRa* series editors:

Jane Tormey: j.tormey@lboro.ac.uk

Gillian Whiteley: g.whiteley@lboro.ac.uk

RADICAL AESTHETICS – RADICAL ART

Eco-Aesthetics

Art, Literature and Architecture in a Period of Climate Change

MALCOLM MILES

BLOOMSBURY
LONDON · NEW DELHI · NEW YORK · SYDNEY

Bloomsbury Academic
An imprint of Bloomsbury Publishing Plc

50 Bedford Square
London
WC1B 3DP
UK

1385 Broadway
New York
NY 10018
USA

www.bloomsbury.com

Bloomsbury is a registered trade mark of Bloomsbury Publishing Plc

First published 2014

© Malcolm Miles, 2014

Malcolm Miles has asserted his right under the Copyright, Designs and Patents Act, 1988, to be identified as Author of this work.

All rights reserved. No part of this publication may be reproduced or transmitted in any form or by any means, electronic or mechanical, including photocopying, recording, or any information storage or retrieval system, without prior permission in writing from the publishers.

No responsibility for loss caused to any individual or organization acting on or refraining from action as a result of the material in this publication can be accepted by Bloomsbury Academic or the author.

British Library Cataloguing-in-Publication Data
A catalogue record for this book is available from the British Library.

ISBN: HB: 978-1-4725-2910-7
PB: 978-1-4725-2940-4
ePDF: 978-1-4725-3098-1
ePub: 978-1-4725-2460-7

Library of Congress Cataloging-in-Publication Data
A catalog record for this book is available from the Library of Congress.

Typeset by Integra Software Services Pvt. Ltd.
Printed and bound in India

CONTENTS

List of illustrations vi
Preface ix
Acknowledgements xii

 Introduction 1
1 Climate Change and Culture 9
2 Ecologies 31
3 Aesthetics 49
4 Ruins and Catastrophes 71
5 Regressions and Reclamations 91
6 Representations 117
7 Interruptions 141
8 Cultures and Climate Change 167

Notes 195
Selected bibliography 223
Index 231

LIST OF ILLUSTRATIONS

(author's original photographs except where otherwise credited)

Chapter 1

1.1 Alba d'Urbano, *Il Sarto Immortale*, poster displayed at the Ludwig Forum, Aachen, 1999 20
1.2 Agnes Denes, *Wheatfield*, re-created at Dalston Mill, London, *Radical Nature: Art and Architecture for a Changing Planet, 1969–2009*, 2009 (photo Eliot Wyman, courtesy of the Barbican Art Gallery, London) 25

Chapter 4

4.1 The feet of Ramesses II, The Ramesseum, Thebes, Egypt, possible source for Shelley's 'Ozymandias' 75
4.2 A young seagull with a supermarket bag, Lyme Regis, 2011 90

Chapter 5

5.1 Paul Bonomini, *WEEE Man*, mixed media (waste electrical products), 2005, The Eden Project, St Austell, Cornwall 92
5.2 The Eden Project, St Austell, Cornwall: Geodesic domes housing African and Mediterranean biomes 92
5.3 Herman Prigann, *Himmelstreppe* (Heaven-stairs), earthwork with concrete slabs, 1997, Gelsenkirchen 102
5.4 Herman Prigann, *Die Gelbe Rampe* (Yellow Ramp), earthwork with concrete slabs and broom 1993–1994, near Cottbus, Germany 105
5.5 Herman Prigann, *Die Gelbe Rampe* (Yellow Ramp), earthwork with concrete slabs and broom, 1993–1994, henge of concrete slabs 106

5.6 Emscher Park, near Duisburg, Germany, 2013 107
5.7 Arctic perspectives initiative: At Ikpik (Northwest coast of Baffin Island) preparing for orthophoto flights; Bramor UAS in foreground while Marko and Matthew install high-frequency radio antennae in the background (photo Nejc Trost, courtesy of API) 111
5.8 Arctic perspectives initiative: Lou Paula, Josh Kunuk, August Black and Zacharius Kunuk (left to right) prepare a qamutik for a trip to an outpost camp on Siurarjuk Peninsula to test the API Isagutaq (renewable power generation system) and perform live video stream discussion from the land for the Contemporary Nomadism event at Canada House, London (UK), in May 2010 (photo Matthew Biederman, courtesy of API) 111

Chapter 6

6.1 Peter Randall-Page, *New Milestones*, Purbeck limestone, near Lulworth, Dorset, 1986 (photograph 2012) 120
6.2 Peter Randall-Page, *Still Life*, Kilkenny limestone, 1988 (photographed on Dartmoor, courtesy of the artist) 121
6.3 Peter Randall-Page, *Seed*, Cornish granite, 2007, The Eden Project, St Austell, Cornwall 123
6.4 Matthew Dalzeil and Louise Scullion, *Drift*, installation, 2001 (courtesy of the artists) 126
6.5 Matthew Dalziel and Louise Scullion, *Habitat*, installation, 2001 (courtesy of the artists) 126
6.6 Map of the BTC oil pipeline (courtesy of Platform) 132

Chapter 7

7.1 Eve Andrée Laramée and Duane Griffin, *Parks on Trucks*, mixed media, Aachen, 1999 141
7.2 Alex Murdin, *Inclusive Path*, outdoor photographic installation, 2007 (courtesy of the artist) 144
7.3 Cornford & Cross, *Open Day*, steel girder on newly completed motorway, 1991 (courtesy of the artists) 148
7.4 Cornford & Cross, *Coming Up for Air*, proposal, 2001 (courtesy of the artists) 150
7.5 Cornford & Cross, *The Lion and the Unicorn*, installation, 2008 (courtesy of the artists) 151

7.6 HeHe, *Nuage Vert*, laser projection, Helsinki, 2008 (courtesy of the artists) 154
7.7 HeHe, *Is There a Horizon in the Deep Water?* model oil platform, performance, Cambridge, 2011 (courtesy of the artists) 157
7.8 Liberate Tate, *The Gift*, performance, Tate Modern, London, 2013 (courtesy of Liberate Tate, photo Martin LeSanto-Smith) 159
7.9 Liberate Tate, *Human Cost*, performance, Tate Britain, London, 2011 (courtesy of Liberate Tate, photo Amy Scaife) 162
7.10 Wall-painting, Stokes Croft, Bristol, 2011 165

Chapter 8

8.1 Deborah Duffin, *Red-flecked White Spiral*, galvanized and telephone wire, electrical sleeving and mixed plastic packaging, 2011 (courtesy of the artist) 168
8.2 Deborah Duffin, *Multicoloured Circle*, electrical wire, cut-up plastic bottle tops, lids and food containers, 2012 (courtesy of the artist) 169
8.3 Littoral, Scything Festival, Cylinders Estate, Elterwater, Langdale, Cumbria, 2010 (courtesy of Littoral) 175
8.4 Wishing Tree near Silbury Hill, Wiltshire, May 2013 178
8.5 The Merz Barn, Ambleside, Cumbria, 2012 183
8.6 Heather and Ivan Morrison, *I Am, so Sorry, Goodbye…*, wood, 2009, for *Radical Nature: Art and Architecture for a Changing Planet 1969–2009*, Barbican Art Gallery, London (photo Lyndon Douglas, courtesy of Barbican Art Gallery) 184
8.7 Self-build houses at Ashley Vale, Bristol (photograph 2013) 187
8.8 Vote Green sign, St Werburghs allotments, Bristol (photograph 2013) 189
8.9 Solar cooker on the dining room roof, Social Work Research Centre, Tilonia, Rajasthan, India 192
8.10 Recycled newspapers used for carrier bags, Social Work Research Centre, Tilonia, Rajasthan, India 193

PREFACE

Post-postmodernity, there has not only been a resurgence of interest in the complex relationship of art and culture to society and politics, but there has been a *radical* rethinking of the contested term *aesthetics*. Significant contributions to these debates include publications such as Jacques Rancière's *The Politics of Aesthetics* (2004) and *Aesthetics and Its Discontents* (2009); Alain Badiou's *Handbook of Inaesthetics* (2005); Francis Halsall, Julia Jansen and Tony O'Connor's (eds.) *Rediscovering Aesthetics: Transdisciplinary Voices from Art History, Philosophy, and Art* (2008); Gavin Grindon's (ed.) *Aesthetics and Radical Politics* (2008); and Beth Hindeliter, William Kaizen and Vered Maimon's (eds.) *Communities of Sense: Rethinking Aesthetics and Politics* (2009). Rather than being condemned as a redundant term, *aesthetics* has undergone rehabilitation and has re-emerged as a vital issue for critique, exposition and application through practice.

Invigorated by this revitalized debate, in 2009 we initiated the *Radical Aesthetics – Radical Art (RaRa)* project at Loughborough University to explore the meeting of contemporary art practice and interpretations of radicality through interdisciplinary dialogue. Of course, *radical* is a term that is open to interpretation but we use it to promote debate, confront convention and formulate alternative ways of thinking about art practice and reconceptualize radical notions of aesthetics. We set out to consider how art practice engages with the different discourses of radicality, its histories and subversions, and to develop the project in a number of directions beyond the confines of the institution.

In 2012, with an ongoing series of symposia, events, an ever-expanding network of individuals working at the intersection of art, culture, ideas and activism and various associated curatorial and dialogic initiatives in the planning stages, we launched the *RaRa*

book series with Jill Bennett's *Practical Aesthetics: Events, Affects and Art After 9/11*, published by I. B. Tauris. The *RaRa* book series explores what aesthetics might mean at this critical moment in the twenty-first century. Its fundamental premise is to reconsider the relationship between practising art and thinking about art, building on the liberation of aesthetics from visual traditions and expanding its parameters in a creative and meaningful way. Bridging theory and practice, it focuses on the multisensory, collaborative, participatory and transitory practices that have developed in the last twenty years. The series investigates current preoccupations with, for example, sensation, discourse, ethics, politics, activism and community. In short, we hope it will provide a forum for an in-depth examination of the intersections between philosophical ideas and practices and between art and aesthetics.

Now, with our new publisher Bloomsbury, we are especially pleased to introduce Malcolm Miles's *Eco-Aesthetics: Art, Literature and Architecture in a Period of Climate Change* as the second volume in the *RaRa* series. It hardly needs saying that how we tackle global climate change and how to develop more sustainable ways of living are vital questions that need urgent answers. As artists, community activists or citizens of the world, what we can do is limited. Ultimately, the fallout of global capitalism can only be addressed with global political solutions. As Miles explains in his introduction, *Eco-Aesthetics* is not a handbook offering solutions to environmental issues. Neither is it meant to be a survey of eco-art, literature or architecture. Instead, Miles sets out 'a critical, perhaps wayward, enquiry into the ideas and attitudes which might contribute to an ecologically aware relation between human observers and the worlds which they observe'. As it ranges across the rich histories of ecological thinking and the diverse theories of art, literature and architecture, and engages with philosophy and politics, Miles's 'wayward enquiry' presents a critical and eloquent reading of the dominant structures of late capitalist, neoliberal society. Since the publication of seminal works such as Rachel Carson's *Silent Spring* (1962) and Gregory Bateson's *Steps to an Ecology of Mind* (1972), an extensive historical literature has developed around ecological studies. Miles's book weaves through some of those histories, incorporating recent groundbreaking events

such as the *Radical Nature* exhibition at the Barbican (2009), while providing a critical examination of particular contemporary art practices, writings and the built environment.

Coming soon after publications such as Linda Weintraub's *To Life! Eco Art in Pursuit of a Sustainable Planet* (2012) and the special issue of *Third Text* (guest edited by T. J. Demos) *Contemporary Art and the Politics of Ecology*, January 2013, 27:1, *Eco-Aesthetics: Art, Literature and Architecture in a Period of Climate Change* is timely. Uniquely, this wide-ranging committed study takes a radical political perspective, speculating on the very nature of what 'eco-aesthetics' might be. As such, we believe it will provide a key contribution to the burgeoning field of eco studies and will play an important role in ongoing debates about the relationship of art, literature and architecture to ecology and sustainability.

Jane Tormey and Gillian Whiteley
Radical Aesthetics – Radical Art series editors
For more info see *RaRa* website http://www.lboro.ac.uk/departments/sota/research/groups/politicised/rara.html

ACKNOWLEDGEMENTS

I am grateful to the staff and postgraduate students of the School of Architecture, Design & Environment at the University of Plymouth for helpful conversations on areas of the book's coverage; to the School for financial support in making visits to France and Germany while researching the book and for a generous period of time in which to write; to Research Assistant Sophie Harbour for checking drafts of the text and helping me to source and gain permission for reproduction of images used in the book; to researcher Ioana Popovici for assistance in Internet searches; and to colleagues Alex Aurigi, Robert Brown, Daniel Maudlin, Krzysztof Nawratek and Katharine Willis for their continuing encouragement.

I thank the following artists, groups and organizations for supplying images, and in some cases for quotations: The Barbican Art Gallery, London; Matthew Biederman and Marko Peljhan of the Arctic Perspectives Initiative; Matthew Cornford and David Cross; Matthew Dalziel and Louise Scullion; Deborah Duffin; Helen Evans and Heike Hanson; Mel Evans of Liberate Tate; Celia Larner and Ian Hunter of Littoral; James Marriott of Platform; Alex Murdin of Rural Recreation; Peter Randall-Page; and Nicola Triscott of The Arts Catalyst.

Finally, I would like to thank Liza Thompson, formerly of I. B. Tauris, now of Bloomsbury, as commissioning editor, and Jane Tormey and Gillian Whiteley of Loughborough University as series editors, for their support during the longer-than-intended writing process.

Introduction

This has been a difficult book to write, as I find myself pulled between hope and despair: hope that a better world is possible; despair that it will be in my lifetime, or that art, literature and architecture can do a great deal to realize it.

The better world, as it is understood in a period of climate change, is a greener world, a world that values, cares for and conserves the land and its creatures and its ecologies, not one that dismisses it as mere environment. This is an underlying attitude, and a greener world is thus a political, economic, social and cultural as well as personal construct; all these aspects are integral, never separable, in the alternative to a prospect of species loss, social turmoil, wars over natural resources, runaway warming and so forth – the scenario is well rehearsed and has become a subcategory of the disaster movie genre. That is part of the problem: ten years ago, I would have said that the difficulty is that people do not know about climate change and its production through increased emissions of carbon dioxide into the Earth's atmosphere, but now it is clear – not least from frequent news reports – that people do know. They just do not act accordingly.

A further change is that, a few years ago, I could have cited signs of climate change in ways which were not too unacceptable. Global warming sounds quite nice in a cold climate. I could have written of a prospect of fields of sunflowers in England like those seen by holiday makers in the south of France or Spain; I could have observed that some bird species hitherto thought of as exotic visitors, such as the white Egret, were becoming established in English estuaries (they are now commonplace); and I could have said that people who have fig trees in their urban or suburban gardens might find that the fruit ripens and can be eaten. Now, it is more a matter of extreme weather, not just of warming, and

the increased frequency of floods and fires. Climate change has begun and the signs are material. Still, there is little prospect of the radical change in the economic and political systems which appears necessary to avert the worsening impacts of climate change, and global industries such as oil and aviation act as if there is no link between their operations and climate change, despite overwhelming evidence that the burning of fossil fuels is a prime cause. The script seems to be that, whatever it may mean, the planet will be processed into profit until nothing but dust and ash remain. And I am writing about art.

Well, yes, I am, because it is my field, and because in the absence of real political hope there is little else to which to turn, apart, of course, from the growing engagement of diverse publics in the global North and South with alternative social, political, economic and cultural formations. The world, like the climate, changes all the time, often imperceptibly but sometimes dramatically; looking back, the slave trade was abolished and universal suffrage was instituted although the campaigns for both took little more than a century in each case (not a long time historically, less than a blink geologically). Something may be done. But by whom? This is where new kinds of politics, such as Occupy and direct democracy, begin to offer new approaches to problems which are not simply ignored by the dominant structures of a late capitalist, neo-liberal society but are produced by those structures. It is, too, where new kinds of aesthetic engagement, some aligned to activism, may contribute to, or be conducive to new insights into the problems of, alternative social and economic formations.

The book's title *Eco-aesthetics* poses an intersection between ecology and aesthetics, but I do not propose this as a new specialism within philosophy; nor would I advocate new specialist practices such as eco-art, eco-writing or eco-architecture.[1] This is in part because the arts are not rigidly bounded fields today, but expanded fields (Chapter 1), and because subfields tend to reproduce the exclusionary tendencies of the fields from which they depart or to mask inadequacies in some of the practices which they contain. A new subfield can be a bandwagon for artists, curators and critics just as for anyone else. The cases of art, literature and architecture included in this book, then, are contextualized by wider terrains, and exhibit, for me at least, a resonance which I associate with the idea of aesthetic quality. That is a matter of interpretation, and opens

several cans of worms – who as much as what defines aesthetic quality; whether any such quality is more than, or outlasts, the conditions of its production; and the extent to which, worldwide, definitions which evolved within European rationality have any currency – which I leave alone. All I say now is that I take the position that, to communicate any message, art needs first to engage the viewer, and while this can be done through co-production – and there is an aesthetics of process as well as of image – it also requires evocation and integrity. It is a matter of how the world is sensed and understood, and from that of the relations between subjects and the objects of perception, and whether what are taken as objects might themselves be subjects. Perhaps the relation of the subject to other subjects/objects is key to an ecological approach, just as it is the central problem in rational aesthetics.

Aesthetics, then, is not a study of taste but has more profound implications. I attempt to introduce it in these terms in Chapter 3, and attempt a similar introduction to ecology – in terms of society and politics rather than biology – in Chapter 2. Both fields are historically and geographically specific, and have a role akin to that of ancestor figures for the rest of the book (always there, sometimes unseen but over the shoulder). Ecology, too, is an expanded field overlapping politics and social thought. And both are brought into discussion of climate change as today's presiding condition. This is referenced in the book's subtitle: *In a Period of Climate Change*. My initial idea was to call it something like 'art for a greener world' but I soon realized the naivety of this. The relation between art and political, social or economic change is neither direct nor causal. Art cannot save the planet or the whale; it can represent, critique and play imaginatively on the problem, and picture futures not prescribed by money. Art is itself produced in this context, too, and always reflects the conditions of its production just as it usually goes beyond them.

Walter Benjamin wrote of art in a period of technical reproducibility,[2] and I write (with a far less incisive insight) on art in a period of climate change as the material state and narrative which condition art's making today. But art interrupts and exposes contradictions; it intervenes to re-inflect the conditions by which it is conditioned; and this dialectical function validates art's response to climate change, as it also validates political movements, as part of a process of change which is never completed. My interest is,

then, in cultural work which critically responds to climate change or imagines alternatives to present situations. I read this as a revision of the project of rationality which began in the European Enlightenment, the aim of which is a free and happy society, and as a revision of dialectic materialism (or Marxism).

The book, then, is neither a survey of eco-art, literature or architecture nor a handbook offering solutions to environmental issues. It is a critical, perhaps wayward, enquiry into the ideas and attitudes which might contribute to an ecologically aware relation between human observers and the worlds which they observe. I have been very selective in the cases of art, literature and architecture included, looking for those which identify problems in how climate change is represented and critiqued while, as said, exhibiting aesthetic integrity. Because this book is one of a series titled 'Radical Aesthetics – Radical Art', I have written more on art than on literature and architecture. This also reflects my background in art and art history, although I now carry out research in an architecture school (architecture being eclectic in its theory).

Each chapter begins with an example of the material on which the chapter comments, like a cameo image. It may be a news report, an art project or a piece of writing. I do this to engage the reader's attention in a more immediate way than would result from a standard list of objectives (too much like a module description). This can be read as jumping in at the deep end; I invite readers to swim and hope the writing is clear enough to enable them to do so.

Part of my aim in Chapter 1 is to demonstrate a diversity of relevant practices and their sometimes oblique relation to green agendas, after some general remarks looking at three international art exhibitions staged between 1999 and 2009: *Natural Reality* in Aachen in 1999; *Groundworks* in Pittsburgh in 2005; and *Radical Nature: Art and Architecture for a Changing Planet 1969–2009*, in London in 2009. The exhibitions cover a diverse range of practices, some between art and architecture, and raise issues investigated in later chapters.

Chapter 2 outlines positions within ecology, beginning with an extract from Rachel Carson's *Silent Spring* (first published in 1962). I note Charles Darwin's theories of evolution, which were first published in 1859, and the work of Ernst Haeckel in the 1860s; I then move to the late-twentieth-century bodies of ideas called social ecology, deep ecology and political ecology. The latter brings in voices from the global South (as does *Groundworks* in Chapter 1).

In Chapter 3, I introduce aesthetics as an enquiry into subjectivity and the sensory knowledge of nature, citing the writing of Alexander Baumgarten in the 1750s and Immanuel Kant slightly later. I frame this by a reference to Johann Wolfgang von Goethe's colour theory and his interest in colour's emotional connotations; I then move to nineteenth-century aestheticism, which says nothing as such about ecology but is, for me, a passive resistance to a society based on the values of capital, harbouring the imagination of alternative scenarios to those imposed by a society's dominant narratives. Finally, I look briefly at today's relational aesthetics.

Chapter 4 concerns modern literature, reflecting critically on images of ruins and the attractiveness of catastrophe. I read this as partly explaining the gap between a knowledge of global warming and action to avert it, extending from the aesthetic concept of Sublimity as the other side of Beauty's coin. I cite works by J. G. Ballard, John Wyndham and Margaret Atwood. From this literature of doom, the question is whether it encourages action, produces a grim resignation, encourages fanciful regression or is subsumed in opiate-like genres such as the disaster movie.

Chapter 5 takes two critical positions in 1990s art criticism, juxtaposing a call for a return to a pre-industrial and prerational society with advocacy for a sense of place. The chapter then looks at art which intervenes practically to transform and reclaim industrially damaged landscapes in Germany; a project which aids the efforts of indigenous people in Canada to cope with the effects of climate change today; and a housing project in Chile in which dwellers co-produce the built environment.

Chapter 6 reconsiders representations of species loss and climate change in cases of art and literature since the 1980s, asking if the publics for such work might be reminded of the value of even the smallest natural life forms, or captivated by the imagery of melting ice sheets, or inclined to action when confronted by the realities of the oil industry's disregard for both human rights and natural environments, observed here firsthand by an author. The chapter ends by looking at representations of the lives of climate refugees.

Chapter 7 moves to polemical practices between art and environmentalism as critical, at times playful, readings of situations. I look at a small number of cases including the work of artists' groups HeHe, Cornford & Cross and Liberate Tate, drawing out evidence of art's criticality within its claimed autonomy. That is, in

the critical distance of aesthetic autonomy – like a safe house in an occupied land – it is possible to interrupt and show the banality of routines and the regimes that enforce them.

Chapter 8 addresses recycling as a way to make art and as an element of alternative living seen in DIY-culture and self-build housing. Alternating between art and culture, I ask what revolutions in everyday life indicate possibilities for a green society and what insights are gained from the use of tacit knowledges in dealing with environmental or social issues in the global South, but not only there. I end with an example of a residential campus in India where villagers gain practical skills, everything possible is recycled, but villagers also learn solidarity.

Solidarity is not ecology, but I suggest it is a form of human ecology: it implies an interconnectedness, a relation between people in which each aids and gains from the others according to one's ability and need. That is not far from anarchism, but in the present situation I would maintain that there is a need for the state. This is brought home by considering the potential impact of one's own efforts to a greener world in relation to the production of carbon emissions by industry in a world of trade de-regulation. It is as if the state, a creation of the Enlightenment, its function to protect the commonwealth and to advance the common benefit, has been abandoned. Activism is a response to this. Occupy arose suddenly (though not without background developments) in 2011.[3] And the Camp for Climate Action carried out research and resistance from 2006 to 2010, intervening at power stations, London's Heathrow airport (2007) and meetings of trans-national bodies such as the G8.[4] The actions of individuals in, say, refusing plastic carrier bags in the supermarket are another. I have no illusion that the latter is tiny, almost irrelevant but not quite so because it enacts green values in a way which, for most people in an affluent society, is possible.

This is a difficult issue. I live a simple lifestyle because I like doing so, without a car, a television, a freezer or a tumble dryer; I buy some of my clothes in charity shops, and no longer take long-haul flights. I took no flights in order to research this book, but I still take a few European flights for other research or to go to conferences. At some point I will stop flying and travel only by rail, or stay at home. But if my eco-footprint is modest for this society, it is massive compared to that of countries in the global South – it makes very little difference even if at times it makes me feel good, or loosely part of a movement. I am not an activist; my work is

in writing on art and culture. But, as sociologist John Holloway writes, a viable task is to stop reproducing capitalism (as the engine of environmental degradation) and to imagine a mode of doing which is not the toil on which capital relies for its accumulation of wealth at any price, and which does not affirm the inevitability which capitalism asserts against all reason and history:

> This is the pivot of our somersault, its centre of levity. The doing that we pitch against labour is the struggle to open each moment, to assert our own determination against all pre-determination, against all objective laws of development. We are presented with a pre-existing capitalism that dictates that we must act in certain ways, and to this we reply 'no, there is no pre-existing capitalism, there is only the capitalism that we make today, or do not make'. And we choose not to make it. Our struggle is to open every moment and fill it with an activity that does not contribute to the reproduction of capital. Stop making capitalism and do something else, something sensible, something beautiful and enjoyable. Stop creating the system that is destroying us. We live only once; why use our time to destroy our own existence? Surely we can do something better with our lives.[5]

Yes. The artists, writers and architects whose works are cited in this book appear to do that. It will never be enough. We need a revolution. We need to end capitalism, or at least to make major changes to its operations, thereby constraining it environmentally. There is not likely to be a revolution, although there is incremental change which spans institutions, cultures and ordinary lives, a long revolution as Raymond Williams called it.[6] Hence I do as I can, writing this book and, at times, finding moments of quietness when the noise stops, which is why I value monasteries and convents, even though I am an atheist and have not been to a monastery for many years (the one I did visit for a period in the 1980s was Buddhist).

As I complete the book, the news on climate change worsens. Markets have written off action on climate change (Chapter 1) and oil companies are setting about the Arctic, while there are plans for fracking to extract gas in Somerset, a tranquil part of southwest England. I am as much pulled between hope and despair as at the outset, but much of the book's material revolves around, or along, an axis of potential creativity between polarities. That is the insight of critical theory: keep the question open.

1

Climate Change and Culture

In April 2013, five years after the global financial services crisis, a British newspaper warned of another possible crisis resulting from an overvaluation of fossil fuel reserves.[1] If globally agreed carbon dioxide emission reductions are to be met, then it is necessary for two-thirds of the world's current oil reserves to remain unused. These reserves are included on oil company balance sheets but are worthless unless exploited, so that, if the oil remains unused, the impact will be a major downward valuation, or carbon bubble. For investors this would be disturbing except, it seems, for an assumption that carbon reduction targets will not be met: an assumption, that is, of global inaction on climate change so that the predicted bubble will not occur. The newspaper further quotes Lord Stern – the author of a report on the economic impacts of climate change[2] – that the $674 billion which the oil industry spent on exploration in 2012 could have met the cost of transition to a 'sustainable economy'.[3] Business-as-usual appears to be the norm in the oil industry despite overwhelming evidence that climate change is an outcome of human industry, especially of the burning of fossil fuels, which threatens the habitat on which human and non-human life on the Earth relies for sustenance and shelter.[4]

The price of oil is species extinction, water wars, famines and social disintegration as, according to a report published in 2009, the planet's habitable area will shrink by 2099 to a northern fringe

and the margins of the southern oceans.[5] Environmentalist George Monbiot warns of a terrifying scenario of runaway global warming:

> If...carbon dioxide concentrations in the atmosphere remain as high as they are today, the likely result is [a rise of] two degrees centigrade...the point beyond which certain major ecosystems begin collapsing.... Beyond this point, in other words, climate change is out of our hands; it will accelerate without our help. The only means...by which we can ensure that there is a high chance that the temperature does not rise to this point is for the rich nations to cut their greenhouse gas emissions by 90 per cent by 2030.[6]

Despite that, Monbiot shows that political factions on the Right, in collaboration with the oil industry, continue to orchestrate climate change denial.[7] The reality is indicated by headlines such as these:

> 'Worst ever CO_2 emissions leave climate on the brink' (30th May, 2011)
> 'Freak storms, flash floods, record rain – and there's more to come' (9th July, 2012)
> 'Four days in July...scientists stunned by Greenland's ice sheet melting away' (26th July, 2012)
> 'Official neglect blamed as wildfires sweep away lives and landscapes' (23rd August, 2012)
> 'Arctic ice melt likely to break record as 100,000 sq km disappears per day' (24th August, 2012)
> '"Catastrophic" warnings issued as Australian fires burn out of control' (9th January, 2013)[8]

And for societies in the global South, climate change is already a material reality. To give two examples: rising sea levels threaten villages and disrupt traditional livelihoods in the Maldives,[9] and Ethiopia (carbon emissions 0.06 tonnes per capita compared to 20 tonnes in the United States) has experienced droughts threatening the lives of eight million people.[10] Prospecting with a minimal regard for safety[11] and regularly abusing human rights,[12] the oil industry views the melting of sea-ice in the Arctic as an opportunity for further exploration and production. Faced with a global threat of this magnitude, depth and complexity, it would be fanciful to say

that art can contribute to the required shift of culture for climate change to be averted. At the same time, the arts reflect and inflect a society's shared values (its culture) so that an investigation of art, literature and architecture in a period of climate change could yet be worthwhile. This chapter introduces my attempt to do this and indicates some of the directions taken by contemporary visual culture in response to climate change and awareness of environmental issues. But I cannot separate art and culture from the political, economic and social systems and conditions which are more than a mere context for their production. That is, traces of these conditions are inevitably present in the art and culture of a specific period, and have their own agency (as do the concepts, such as freedom, or prosperity, which they generate), but the relation between ideas, values, systems and the art or culture in which those ideas, values and systems are articulated is always two-way: art inflects life just as life inflects art. Representations of ideas establish them, while shifts in a value structure within a society, or periods of moral or social uncertainty or upheaval, tend to engender departures from previous cultural norms. Aesthetics, then, as the investigation of the self (or subject) and sensory perception (as I attempt to explain in Chapter 3), is in one way at the heart of these fluidities since it is the understanding of the subject, and of what constitutes a subject and what constitutes an environment, which underpins attitudes to, say, the land.

From this follow power relations and decisions as to what, or who, is to be valued as equal or to be exploited as resource. In another way, however, when art becomes the preserve of an elite trading on supposedly superior taste as the evidence of a superior sensibility, it is so compromised as to be more or less useless in efforts towards a free society. Indeed, the incorporation of military camouflage into the high fashion of the affluent society (or global North), which is then cascaded at lower prices into street style, illustrates the abandonment of value as a concept under late capitalism. Anything goes. Whatever – except, what goes will be the habitability of most of the Earth's surface if predictions are accurate (and there is much evidence in their favour). Perhaps, then, the critical distance associated with modern art is not merely a restriction of access but offers the space of standing back in which dominant trends and systems can be seen afresh, and interrupted.

For Herbert Marcuse, a concern with aesthetics is justified by an absence of even the prospect (in the 1970s) of real political change. In *The Aesthetic Dimension*, his last book, he begins,

> In a situation where the miserable reality can be changed only through radical political praxis, the concern with aesthetics demands justification. It would be senseless to deny the element of despair inherent in this concern: the retreat into a world of fiction where existing conditions are changed and overcome only in the realm of the imagination. However, this purely ideological conception of art is being questioned with increasing intensity. It seems that art as art expresses a truth, an experience, a necessity which ... are nevertheless essential components of revolution.[13]

Marcuse's argument is that, first, art interrupts codes and structures (as of perception) which affirm the dominant ordering of society, and, second, that art, especially when read as the beautiful, is radically other to a world of oppression and repression, so that its presence fractures that realm's surfaces. Art, then, is for Marcuse the location of a radical force against the unfreedom of life under capitalism or totalitarianism. He writes,

> the work of art is beautiful to the degree to which it opposes its own order to that of reality – its non-repressive order ... in the brief moments of fulfilment ... which arrest the incessant dynamic and disorder, the constant need to do all that which has to be done in order to continue living.[14]

I have to leave that there for now – however, I have written elsewhere of Marcuse's concept of a literature of intimacy as the last resort of freedom in the darkest times.[15] All I will add here is that modern art's autonomy, far from being a disabling denial of the political (even though it is often used as that), is a critical dimension in which the aesthetic is a refusal of routine. That is one point of departure; political activism is another. There is no hierarchy. They overlap in some of the cases cited in this book. For that reason I do not separate art from critiques of political and economic structures; nor do I separate arguments around ecology and environmentalism from those around social justice. Abuse and damage result, throughout, from the same attitude. If an alternative

society emerges in a period of climate change, it will enact, rather than propose or represent, values of caring and well-being. To put this very simply, the means used do not so much lead to the ends produced, but are the ends.

Expanded fields

After Marcuse's death in 1979, discussion of contemporary art moved in several new directions, largely in response to, or to encourage, conceptualism. Marcuse was, in any case, more familiar with (and probably more interested in) literature than art and drew as much on mass media and news reports as on art in scripting his public interventions. From the 1970s, however, art moved into hybrid, mixed-media and textual modes, parodying and re-framing its material in oblique critiques of the society and cultural conditions in which it was made. It was not new to say that art should be political – and much art of the period either did this only indirectly or did not do it at all – but the mode shifted into what might be called the not-political. That is, the prefix *not-* became a way to indicate a relation of difference but not a disconnection. Art thus became not- many other fields, or an expanded field. In its expanded field, art was not-architecture, not-landscape and so forth (those being obviously adjacent fields), and, I would argue in the case of community-based arts projects, something like not-social-reformation.[16]

The model of an expanded field was introduced by art historian Rosalind Krauss in 1979. For Krauss, the demise of the public monument at the end of the nineteenth century put sculpture specifically in the position of a de-contextualized practice, which, by the late 1970s, became not-architecture and not-landscape.[17] The latter was especially echoed in the practice of earthworks,[18] and the immediate issue faced by Krauss was how to write about them when the categories, such as sculpture, into which they were conventionally put were stretched by them to breaking point. *Perimeters Pavilions, Decoys* by Mary Miss (1978) was the example discussed by Krauss in her 1979 essay: a square hole in the ground with wooden supports and a ladder, set outdoors. While minimalism had produced three-dimensional objects, the formal qualities of which were its only content, and *Perimeters Pavilions, Decoys*

both reproduces this refusal of connotation and re-introduces it by resembling but not being the entrance to a mine, then, it appeared helpful to situate modes of working by seeing them from outside as well as inside, as what they are not but imply, or by what they overlap and re-shape.

This fluidity of boundaries was further enhanced in the 1990s and 2000s by relational aesthetics, a term used by curator Nicolas Bourriaud[19] for gallery events in which spectators co-produce the work. Bourriaud cites Felix Guattari[20] and was informed by the writing of Jacques Rancière. But Rancière is more cautious than Bourriaud in what he claims, so that while he reads art's sensitivity to traces of common experience in 'the uncertain boundaries between the familiar and the strange, the real and the symbolic',[21] he also asks, art historian Toni Ross points out, whether the new practices described as relational aesthetics move away from the vital antagonism of radical politics.[22] I return to Rancière briefly in Chapter 3. The point here is that, since the 1970s, art is no longer a unique or contained practice, but a range of practices in a matrix which also includes fashion, design, architecture, social relations and many aspects of ordinary life. This does not mean that traditional practices, such as stone carving (see Chapter 5), do not or cannot address climate change and species depletion, but that many of the cases cited in this book operate in art's expanded field and cannot helpfully be separated from political critique or cultural discourse.

Literature and architecture are now as much expanded fields as art. Literature is not-politics in the work of Arundhati Roy, who writes of the disempowerment of people whose homes are in the way of construction projects such as dams.[23] As a writer and a professional, Roy contributes to the visibility of class and environmental struggles. Citing Noam Chomsky, she writes that democratic and authoritarian regimes use news media to manufacture public opinion 'like any other mass-market product' while the space of free speech is auctioned to the highest bidders. Roy adds, 'Neo-liberal capitalism isn't just about the accumulation of capital (for some). It's also about the accumulation of power (for some).'[24] In a different way, Margaret Atwood uses writing to draw out the absurdities and dangers of, say, genetic modification of species (discussed in Chapter 4). This is writing, or literature, and has the aesthetic resonance of good writing; it is also not-biological

critique and not-politics. Since the Romantic period, and through the evolution of the form of the novel (in which a narrator or a subject – I (first person) – invites readers into a journey of social and personal experience and change), Western literature has been integral to social, political and economic conditions, just as social, political and economic realities shape and re-shape its form for its publics. To say that the reader completes the text, as in deconstruction theory (the death of the author), is one part of this; another is that texts add to, or re-inflect, societies.

The idea of deconstruction is a challenge for architecture, since a standard form of architectural writing is the well-illustrated monograph dealing with – usually celebrating – the career and designs of a named architect. This disregards the complex production processes of any building, involving the determination of site, material and timescale through planning, raising money and subcontracting of electrical and civil engineers, surveyors and builders as well as an architectural firm. The clients for signature buildings – those iconic shapes on a city's skyline – are mainly corporate, which affirms its complicity in the dominant economic system (which, of course, I see as responsible for global warming). But architecture found its expanded field, if slightly later than art, in interfaces with everyday life and recognition of the nonprofessionals relegated to the category of unnamed users. Caricaturing the narrow field, architects Sarah Wigglesworth and Jeremy Till describe an imaginary island where architects examine form self-referentially as, from time to time, boats arrive to bring 'fresh supplies of theory, geometry and technique' to maintain a decayed professional body.[25] Inverting the model of utopia as an island, they site the island in the profession's bounded – and to them moribund – state, opposing it with an architecture of interaction and negotiation: processes which are never completed and self-renewing.

For Till, architecture is a matter of linked, diverse practices of contextual and social meaning, while design and building are co-produced with users.[26] I think something similar can be said of art and writing, but this does not lessen the need for the artist's, writer's or architect's knowledge of making art, literature and architecture. It is more a matter of equal status – local, tacit knowledges beside professional expertise – in a wider shift of culture (in the broadest sense, as the enactment of shared values in ordinary life) conducive to a greener world. That sounds a nice idea, almost too easy. In

practice it entails new experiences for all involved. The outcomes – of art, literature and architecture in a context of climate change as for new political movements from anti-roads protest to Occupy – will be messy and uneven in efficacy. Still, there is a need for hope as well as critique. Giving up is as unacceptable as climate change denial. I move now to three exhibitions of art in its expanded field, which, in various ways, address issues of ecology, environmentalism and the need for a culture which is conducive to a more sustainable form of social organization.

Three exhibitions: Prelude

These three exhibitions did not occur in a vacuum. In the context of art's expanded field, from the 1970s, art galleries began to show piles of turf and garden soil, and the walking-and-finding art of Richard Long, Hamish Fulton and Chris Drury, among others, in photographic records of encounters with the material substances of landscape,[27] or in more material reconstructions (as in Long's re-arrangements of stones on a gallery floor). This coincided with an expansion of sculpture-in-landscape in forest parks such as Grizedale and the Forest of Dean in England,[28] and a spread of earthworks, or land-art, in North America (such as Robert Smithson's *Spiral Jetty*). In Britain, Andy Goldsworthy's re-arrangements of twigs and leaves, sand, ice and other natural materials in their natural settings gained a wide public through lavish colour photographs. This was not presented as eco-art, and the eco-footprint of Goldsworthy's trip to the Arctic, for example, remains unstated. Still, an association between art and awareness of the natural world is implicit in Goldsworthy's tracing of, say, seasonal change in the colours of leaves, the natural forces of flowing water and the fragility of ecosystems interrupted by insertion of artificial substances such as pigment, as well as stated implicitly in the ephemerality of the work.[29] I read this art as reflecting rather than advancing a then-incipient environmentalism.

At an opposite polarity was the beginning of green activism, as in the organizations Greenpeace (founded in 1970) and the millenarian Earthfirst! (formed in 1980). Earthfirst!'s first act was to erect a sign honouring an indigenous warrior, Victorio, and his destruction of a

white mining camp in the Gila Wilderness, New Mexico. Other acts included prevention of forest felling and anti-roads campaigning. The enemy of environmental continuity was, for Earthfirst!, not the political system as such but 'corporate industrialism, whether it is in the United States, the Soviet Union, China, or Mexico'.[30] In Britain, the history of revolutionary groups such as the Diggers was excavated by radical groups, such as the New Age Travellers, who established Tipi Valley in Wales in 1982 (which is still there and has been more or less accepted by the local community, of which it is now part).[31]

Much has changed since then but the message remains that environmentalist agendas are incompatible with capitalism (now in the form of neoliberal extremism). But can human interactions create new, dialectical sites? The work of Mierle Laderman Ukeles addresses the issues performatively in terms of society's production and handling of waste (Chapter 5). As artist in residence in the New York City Department of Sanitation since the 1970s, in her first project, *Touch Sanitation*, she shook the hands of the city's garbage collectors – hands tainted by the filth they handle – to thank them for their work. Art historian Patricia Phillips writes that Ukeles refuses to view the repetitive tasks which are vital to the maintenance of cities as marginal.[32] Although the handshake is a gesture, used in society both meaningfully and as a routine reaction, the act appears to offer an unexpected break in routine as well as occurring within that routine. This suggests Henri Lefebvre's concept of a moment of liberation when, even during the dulling regime of capitalism, suddenly, unannounced and at any time, anyone may experience a moment of understanding or calm which, while ephemeral, lingers and is in its way transformative.[33]

To say this may overburden the work described before it; I am cautious throughout this book as to what art can do. Still, as David Reason wrote in 1987, in the catalogue to an exhibition titled *The Unpainted Landscape*,

> The work of art is, unlike nature, incomplete.... [It] is not self-sufficient, and...inevitably tempts word and thought. The work of art is *completed* in interpretation, commentary, and criticism, not in the sense of being finished (off), but as an electrical circuit may be completed...so that energy may flow.[34]

Reason adds that art is always taken up in discourse, just as it inevitably addresses or implies a public, and, coincidentally, reiterates the argument made by Marcuse (cited above) that, as Reason puts it, 'Artworks are not so much anticipatory...as ecstatic, securing the conviction that things might really be other than they are.'[35] Looking back, I think the interest in art-in-the-land(scape) of the 1980s and 1990s probably reflected a sometimes implicit and at other times explicit engagement with environmentalism. Ukeles established a more overt cultural politics, akin to the antagonistic politics of radical planning,[36] but, again, I am not interested in making hierarchies. To quote Reason once more before moving to the three exhibitions:

> Landscape – the art world's code word for nature – has become an awkward term for us; and this is a measure of the force of the ethical imperatives which are inescapable in considering landscape art today. In a fashion that strikingly parallels the controversial character of the nude in contemporary visual art, art which implicates and involves the aesthetic of landscape is committed to participating in the politics of nature and the environment. Western societies no longer sustain even the pretence of a consensus over the proper utilisation of the earth's resources, and so conceptions of nature and of landscape mark out the ground for political debate.[37]

That was in 1987. By 1999, the green agenda had gained far wider import and become more directly politicized.

Natural Reality

Introducing *Natural Reality*, curator Heike Strelow regards environmental damage as a result of nature's estrangement. Human subjects gaze on nature as either object or resource while the 'reality in which we live' is continuously shaped and re-shaped by representations which are complicit in that estrangement. Yet a notion of 'interdependence' links individuals, society and the environment to produce artworks which 'break the tight limits of the art context'.[38] That echoes the expanded field.

Natural Reality grouped works under three headings: human–nature relations, critical-analytical investigations in art and science,

and social perspectives on nature and landscape. The show included work by established artists such as Robert Smithson, Ana Mendietta and Joseph Beuys, in documentation or reconstructed for the show, but most of the artists were of emerging status. Some of the work emphasized natural materiality: Romano Bertuzzi made traditional cheese in the gallery each day, for example, and herman de vries's *Rosenraum* was a floor covered in rose petals, of which Strelow says,

> [It] grants nature a sacred, sheltering refuge, in order to counteract the appropriated and detached human handling of [nature]. In the museum...the rose petals refer to themselves in their concentration and sensitise the viewer to re-contemplate an unadulterated approach to nature; with pure instinct, availing oneself of all one's senses.[39]

In 1989, de vries exhibited *Natural Relations: In Memory of What Is Forgotten*, a work which included a plant cabinet containing 'mind-moving' plants collected on his travels, titled *The Locked Paradise*, and a book, *Natural Relations*, describing 2000 plants in terms from botany, philology and mythology, to commemorate knowledge which is 'thoughtlessly lost' while what remains is 'only fragments'.[40]

Other works in *Natural Reality* were more cerebral. *Il Sarto Immortale* by Alba d'Urbano uses a photographic image of the artist's body printed on fabric used for a series of garments which were displayed wrapped in tissue paper in couture boxes, modelled on a catwalk as well as reproduced on posters around the city (Figure 1.1). This work does not speak about landscape but deals with contested senses of identity and alienation, which, I suggest, also underpin attitudes to the environment. And it plays on notions of surface, skin, reality and illusion which permeate environmental discourses. By representing skin on the material normally used to conceal it, normality is short-circuited, but this is also a play on ideas and constructions of a subject, or the subject-as-object of a gaze. The gaze is a power relation, a power-over not a power-to, and is the same reductive mechanism as is used to devalue land and water when they are exploited: identity politics as not-environmentalism.

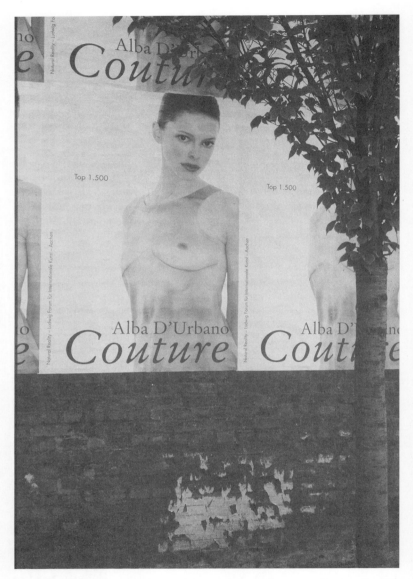

FIGURE 1.1 *Alba d'Urbano*, Il Sarto Immortale, *poster displayed at the Ludwig Forum, Aachen, 1999.*

Under the heading of critical investigation and science, Ursula Schultz-Dornburg's *Where Traditional Species Die Out, Humanity Loses Part of Its History and Culture* juxtaposed framed photographs of ears of wheat (from the Vavilov Institute, St Petersburg) with real grain set in aluminium boxes, pointing to the existence of 9000 types of wheat in contrast to the very few bred by biogenetics. Apart from archive holdings such as those at the Vavilov, many local varieties will be lost despite their suitability to local conditions. Playing on landscape representation in a more literal way, Mel Chin exhibited three pictures: one was a fourteenth-century Persian miniature, another a thirteenth-century Chinese scroll and the third a nineteenth-century North American landscape. All were painted by Chin and shown in a room the white false walls of which hid earth from a nearby toxic landfill site which slowly seeped onto the floor. In his earlier *Revival Field* (Minneapolis-St Paul, 1989–1993), Chin had demonstrated the practicality of using certain plants to de-contaminate toxic sites naturally by drawing the toxins out of the soil into their leaves or flowers (which could, in theory, then be harvested to regain toxic, expensive elements such as cadmium). Chin reads modernism as stemming from 'a deep belief in universal possibilities that were unrealized in the world and needed to be uncovered...We can't just think about art anymore. We have to be engaged in the political world'.[41]

Other artists in *Natural Reality* included Madeleine Dietz, who placed soft-focussed images of an embryo by a mandorla-shaped wall made of earth bricks; Mark Dion, who took microscopic images from one square metre of meadow; Alan Sonfist, who made a landscape referencing the layers of the city's past from pre-Roman times onwards; Georg Dietzler, who used oyster mushrooms in the de-contamination of postindustrial soil; Nils Udo, who intersected urban sites with landscape; and Herman Prigann, who showed documentation of his large-scale *Terra Nova* project for earthworks and the rehabilitation of de-industrialized sites in Germany (Chapter 5). In retrospect, I think the exhibition established that environmentalist art was a major category by the 1990s, with a history and a public, and that the practices were diverse and not always required to offer solutions to environmental problems

as much as to re-think what the questions are. Some artists – Chin, Dietzler, Prigann – engaged in problem-solving (though not only in that); others – d'Urbano and Udo – worked towards unanticipated perceptions which open up subjective modes of understanding. And some work – such as the mini-parks on trucks exhibited by Eve Andrée Laramée (discussed in Chapter 7) – was polemical, using aesthetic contradictions to echo those of social, environmental, political and economic life. Perhaps estrangement (voiced by Strelow, above) was the quality which came through most clearly. I read it as art's intrinsic condition – remote from what it depicts and paradoxically absorbed by it – and, as Strelow intended, the human incapacity to be quite at-one-with-nature while yet being undeniably of nature.

Groundworks

Groundworks, curated by Grant Kester in Pittsburgh in 2005, widened the field of art from the global South, combining documentation of past or site-specific work with proposals produced in response to localized, community locations in the city's de-industrialized urban-scape. This built on earlier but blander municipal projects for cycle paths and walking trails, and the rehabilitation of the area around a steel slag mound for green space (or Greenway) in a project coordinated by Robert Bingham.[42] As in *Natural Reality*, there were practical or pragmatic responses to environmental concerns, and polemical, discursive projects. Writing in the catalogue, Kester challenges the model of an avant-garde:

> In place of the stringent autonomy of avant-garde art, we find artists working in alliance with specific communities in political struggles involving environmental policy, urban planning, and cultural perceptions of the natural world.... collaborating with other artists, policy-makers, researchers, activists and community members, effectively blurring the boundaries of authorship through participatory interaction.... The audience's engagement is no longer defined primarily through distanced contemplation... but through haptic experiences actualised by immersion and participation in a project.[43]

Kester takes the expanded field as engagement, but *Groundworks* was still an art exhibition, funded by art-world as well as environmental organizations, in an art gallery within a large university campus. To an extent it was a survey of a certain kind of socially engaged art in the 2000s, but it was also an appeal to a wider constituency than that of contemporary art, notably to publics as well as art groups in the South, and to publics in the North willing to learn from the (often more radical) practices of the South.

Among Northern artists and groups included in *Groundworks* were WochenKlausur, who organize co-production design projects, based in Vienna; Helen Mayer Harrison and Newton Harrison, whose *Future Garden* in Bonn (1997) re-created a wildflower meadow on the gallery roof; Platform, an arts-education-human rights group in London (Chapter 6); Park Fiction, who worked with people from the St Pauli district of Hamburg against gentrification; and Laurie Palmer, who proposed *Oxygen Bars* in a wood threatened by industrial damage on the edge of Pittsburgh. But the exhibition's key achievement was, as said above, to introduce work from the South.

Ala Plastica, based in La Plata, Argentina, operate as an art-environment NGO and have worked since 1991 on bio-regional projects linking ecology, social networking and the use of local knowledges.[44] At *Groundworks* they presented the project *AA*, which aimed to create 'a space for the survival of those people affected by floods...caused by aggressive mega-engineering in the Rio de la Plata basin'.[45] Ala Plastica devises tools for collaboration, such as collaborative mapping, while challenging regional planning edicts which devalue local knowledges.

Huit Facettes-Interaction from Senegal made an installation depicting the process of development critically, contrasting local and human-scales with the global. Engaged in co-producing housing at the village of Hamdallaye Samba M'Baye, and encouraging local crafts and house decoration, they see social value as 'reopening spaces of inventiveness and creativity blocked by...the market, a totalitarianism that is economic, expansionist and ostensibly progressive'.[46] At *Groundworks* they staged a chess-like game to challenge the 'contradictory ideas, theories and concepts associated with the rise of globalism'.[47]

Indian artist Altaf, from Mumbai, showed a video installation of her project with Adivasi artists Rajkumar, Shantibal and Gessuram to provide water pumps in the village of Bastar in central India. Altaf writes that water 'plays a crucial role in agriculture and food production, health and hygiene, and folk tales, myths and religious rituals in Bastar' but lack of water restricts the education of girls as they 'have to walk miles each day to fetch water'.[48] She adds that state policies often produce uneven outcomes:

> The state government in Chhattisgarh recently sold a part of the River Kelo to a private industrial firm. As a result, the local community, which depends on this river for its survival, may be forced to migrate. It is essential that people become aware of their rights and responsibilities in this regard, so that they can protest the marketing of their water.[49]

This echoes Roy's critique of dam building (above) and environmentalist Vandana Shiva's refusal of global agribusiness and its destruction of local seed varieties as it seeks crop monopolies.[50]

Radical nature

Radical Nature: Art and Architecture for a Changing Planet 1969–2009 was shown at the Barbican Arts Centre, London, in 2009. The exhibition's subtitle states a retrospective intent and in this context the gallery commissioned a re-creation of Agnes Denes's *Wheatfield – A Confrontation* (1982) in Dalston, East London (Figure 1.2), sited with a functioning windmill and bread oven designed by architects EXYZT. The first *Wheatfield* was at Battery Park City in Manhattan (1982). While the buildings of the World Trade Center were still under construction, Denes showed capitalism the agrarian past from which its wealth was once derived, evoking 'world trade, economics... mismanagement, waste, world hunger and ecological concerns'.[51] Denes has recently designed a project for reclaimed gravel fields at Ylojarvi, Finland, arranging 11,000 native trees in the pattern of a sunflower seed head, centred on a conical hill. *Tree Mountain: A Living Time Capsule* was planted in 1996 and will last for 400 years (the natural life span of the trees).[52]

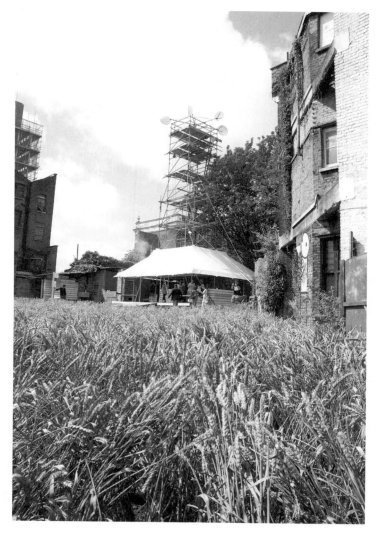

FIGURE 1.2 Agnes Denes, Wheatfield, *re-created at Dalston Mill, London,* Radical Nature: Art and Architecture for a Changing Planet, *1969–2009, 2009 (photo Eliot Wyman, courtesy of the Barbican Art Gallery, London).*

Other work in *Radical Nature* included Beuys's *The End of the Twentieth Century* (1983–1985), an assemblage of basalt slabs on the gallery floor, one for each tree planted in his *7,000 Oaks* project; a geodesic dome representing Richard Buckminster Fuller's alternative architecture; Hans Haacke's photographs of mini-ecosystems on his studio roof; and Heather and Ivan Morrison's *I Am So Sorry, Goodbye...*, a double geodesic dome made from wooden tiles and used as a café serving hibiscus tea (Chapter 8). The Barbican commissioned projects, too, from architects' group A12 (Andrea Balestrero, Gianandrea Barreca, Antonella Bruzzose, Maddalena de Ferran and Massimiliano Marchia), who design and insert temporary contemplation zones in urban sites; Anya Gallaccio, who showed a cherry tree rigidly wired in place; and Lara Almarcegui, who catalogued wastelands in the Lea Valley (site of the 2012 London Olympics).

Writing in the exhibition catalogue, critic T. J. Demos calls for art 'based on environmental justice in a global framework'.[53] He cites geographer Erik Swyngedouw that sustainability is too often presented as an apolitical idea[54] and seeks attention to conditions in sub-Saharan Africa and Asia. Oddly, Demos does not cite *Groundworks* but does cite *Greenwashing: Environment, Perils, Promises and Perplexities* at the Fondazione Sandretto Re Rebaudengo in Turin in 2008 as characterizing art's interaction with ecology.[55] Curated by the group Lattitudes with Ilaria Bonascossa, the exhibition asked,

> What is at stake in today's constant bombardment of ecological guilt, corporate agendas and political point-scoring with respect to so-called 'environmental issues'? How can we balance personal responsibility with collective consensus, local and global, or short-term remedies with visionary strategies?
>
> The terminology and agency around 'the environment' and sustainability has become increasingly asymmetrical and immaterial. Emissions' offsetting, food miles, environmental marketing, carbon debt, ecological footprints, and so on, are all recently coined terms tied to the anxious sense that the processes and practices of modernisation and globalisation, industrialisation and urbanisation have induced unprecedented deprivations and intrusions on the planet. Consequently there is the familiar refrain to limit growth, particularly in the developing world.[56]

Elsewhere, Swyngedouw writes that urban socio-environmental perspectives must 'consider the question of who gains and who pays', and the power relations by which 'unjust metabolic processes are produced and maintained'.[57] I agree. How is another matter. Perhaps new social movements are the most obvious response to widespread social and environmental injustices. Activist Susan George writes, 'The principal vector of change today is neither political parties nor governmental leadership but the global justice movement seeking a very different kind of globalisation from the neo-liberal variety we've got.'[58]

So why write about art? Rather than make judgements on the exhibitions profiled above, I need to reflect on this again. George adds, 'No one really knows why movements spring up when they do nor why they grow old and cold and wither away.'[59] Movements such as Occupy and the antiglobalization movement, which began in resistance to the World Trade Organization in Seattle in 1999, can be explained as reactions to provocations. In the case of Occupy this is to the perceived imbalance between 1 per cent of the world's people having most of its wealth at the expense of the other 99 per cent, though why precisely in New York in September 2011 is unclear. In contrast, art movements, whether committed to a manifesto or codified by critics after the event, appear in response to cultural discourses. Less understood, perhaps, is art's function in re-inflecting culture.

Art, culture and climate change?

The precedents for art's agency in social or political change are unfavourable: since the early twentieth century, political engagement has been seen as undermining the autonomy claimed for modern art. Nor were those art movements which took a political stance always progressive: the Italian Futurists, for instance, saw war as a necessary and desirable social cleansing, and most of the surviving members supported fascism in the 1920s. Against this can be set the Left-politics of German New Objectivity and the Bauhaus in the 1920s; Pablo Picasso's lifelong engagement with communism and his painting *Guernica* (1937, Madrid, Prado); and the work of writers such as Louis Aragon, Paul Éluard and André Breton (all of them members of the French Communist Party at some time). Yet

their motives are read by psychoanalyst Julia Kristeva as framed by a lack of stability in personal relations, the party assuming the role of law in the context of a fractured self-image.[60] Even when the avant-garde was politicized – in France after 1848, in Gustave Courbet's paintings[61] – its theoretical basis was flawed: for artists and writers to lead the people to a new society implies that artists and writers have a privileged knowledge of what form that society will take, while to interpret the world for others denies those others the agency of interpreting it for themselves, reproducing the power relation of leaders and led.

Today, contemporary art is subsumed in a global entertainment industry. New York-based artist Martha Rosler writes,

> The anti-institutional revolt was unsuccessful, and the art world has now completed something of a paradigm shift. The mass culture machine and its engines of celebrity have long redefined the other structures of cultural meaning, so that patterns of behaviour... in the art world are more and more similar to those in the entertainment industry... As the art world moves closer to an entertainment model of cultural production, it is moving toward a closer accord with mass culture in its identification of narratives of social significance.[62]

More recently, art historian Tim Clark has lamented the passing of modernism and socialism at the end of the 1980s: 'maybe it is true that there could and can be no modernism without the practical possibility of an end to capitalism... in whatever monstrous or pitiful form.'[63] I find myself in a similar position: reflecting on art and climate change, I see no possibility of a postcarbon society under capitalism. Indeed, in 1972, Herbert Marcuse cited a combination of military and ecological destruction in the Vietnam War, arguing that violence and pollution are outcomes of the same process, while dealing with it is 'a political process as well'.[64]

Marcuse saw an ecological outlook as incompatible with 'the law of increased accumulation of capital'[65] and argued for a critique of the structures which produced an ethical vacuum (now reproduced in the attitudes of oil companies to Arctic exploitation as well as human rights abuses). Coincidentally, Slavoj Žižek writes of a moral vacuum as a 'dimension of the apocalyptic times in which we live'.[66] He continues,

climate change will bring increased resource competition, coastal flooding, infrastructure damage from melting permafrost, stresses on animal species and indigenous cultures, all this accompanied by ethnic violence, civil disorder, and local gang rule. But we should also bear in mind that the hitherto hidden treasures of a new continent will be disclosed, its resources will become more accessible, its land more suitable for human habitation.[67]

He further comments,

> An extraordinary social and psychological change is taking place...the impossible is becoming possible. An event first experienced as real but impossible (the prospect of a forthcoming catastrophe which...is effectively dismissed as impossible) becomes real and no longer impossible (once the catastrophe occurs it is...perceived as part of the normal run of things...The gap which makes these paradoxes possible is that between knowledge and belief: we *know* the (ecological) catastrophe is possible, probable even, yet we do not *believe* it will really happen.[68]

Similarly, George Monbiot writes that while the statistics of climate change are easy to state, they are 'almost impossible to imagine'.[69] He adds,

> I can understand, intellectually, that 'life' in this country might not be the same in thirty years' time as it is today; that if climate change goes ahead unchecked it could in fact be profoundly and catastrophically different. But somehow I have been unable to turn this knowledge into a recognition that my own life will alter. Like everyone who has been insulated from death, I have projected the future as repeated instances of the present. The world might change, but I will not.[70]

Žižek and Monbiot identify a gulf between knowing and feeling, and between knowing and doing (anything, let alone ending capitalism). Perhaps I *am* lost in a dreamworld if I imagine a postcapitalist, environmentally just and sustainably joyful society, yet unless I can imagine it I have no way to begin to contribute to it. Walter Benjamin writes, 'the state of emergency in which we live is not the

exception but the rule.'[71] A concept of history is thus required in keeping; the task is to 'create a real state of emergency'.[72] Can art, literature or architecture do that? If they can, it is an imaginative as well as an interruptive project, requiring a re-visioning of the world's value structures. Meanwhile the grim situation worsens:

> Sea ice in the Arctic has shrunk to its smallest extent ever recorded... the rapid summer melt has reduced the area of frozen sea to... less than half the area typically occupied four decades ago.... leading to possibly major climate impacts. '... the loss of sea ice will be devastating, raising global temperatures that will impact on our ability to grow food and causing extreme weather around the world.'[73]

What happens next?

2

Ecologies

At the beginning of *Silent Spring*, first published in 1962, Rachel Carson gives a picture of a world in which everything in a landscape contributes to a cycle of well-being:

> Along the roads, laurel, viburnum and alder, great ferns and wildflowers delighted the traveller's eye through much of the year. Even in winter the roadsides were places of beauty, where countless birds came to feed on berries and on the seed heads of the dried weeds rising above the snow. The countryside was, in fact, famous for the abundance and variety of its bird life, and when the flood of migrants was pouring through in spring and autumn people travelled from great distances to observe them. Others came to fish the streams, which flowed clear and cold out of the hills and contained shady pools where trout lay. So it had been from the days many years ago when the first settlers raised their houses, sank their wells, and built their barns.[1]

Carson does not mention the first-nation peoples on whose land the settlers settled, nor that the settlers were not as benign as migrating birds, introducing alcohol, guns and diseases to which the indigenous population had no resistance. Nonetheless, the fable offers an idyllic picture of a society in harmony with nature – a lost Eden, a land in which plenty and beauty coexist – which is likely to resonate with the white North American myths of the log cabin and the open land taken to symbolize freedom.

The fable could also represent an ecosystem in which all animate and inanimate life coexists interdependently. *Silent Spring* chronicles its destruction by a military-agricultural corporate realm through activities such as crop-spraying. After its evocative opening, most of *Silent Spring* consists of accessible scientific writing, but the opening fable's selective image of humanity-in-nature, as if in an a-chronological world, lends the story a naturalness which, when undermined, is the more powerful. The argument rests not only on science, then, but also on questions of normality and deviation (which occur in the anthropological writing of the time, beside the prospect of an ecology of mind in the work of Gregory Bateson).[2] The tension between what is taken as natural and what is injected into a system, or manufactured, still informs aspects of ecological discussion, feeding a search for both a restored purity and a social structure in keeping with ecology as a holistic view of life.

Past idylls, however, cannot be restored because they tend not to have existed in the forms represented, if at all outside art, literature or folk-myth. Still, it is helpful to understand the conditions in which they occur, as well as that the natural world is a historically specific concept: nature is reproduced in the cultivation of land; Nature is produced in how cultivation and wildness are seen. The landscape which Carson presents is framed by a set of culturally derived preferences, just as any land-*scape* is framed by the various outlooks projected onto it.[3] Carson's image of a harmonious land where plants, birds and people coexist happily is a twentieth-century image of innocence. But,

> a strange blight crept over the area and everything began to change. Some evil spell had settled on the community: mysterious maladies swept the flocks of chickens; the cattle and sheep sickened and died. Everywhere was a shadow of death. The farmers spoke of much illness among their families.[4]

The malady is not the result of an evil spell but of attempts to eradicate insects which lessen the profitability of agriculture. Carson draws attention to collateral damage and argues that there is 'very limited awareness' of a threat which she ranks beside that of 'extinction ... by nuclear war' as a 'central problem' for life.[5] The reference to nuclear war is not extraneous: not only was *Silent Spring* published in the year of the Cuban missile crisis but insecticides

were, also, a by-product of the development of chemical warfare.[6] Carson notes the 'ironic significance' that in Germany in the 1930s, the nerve-gases used to eliminate humans were outcomes of research on insecticides.[7] Critical theorist Peter Sloterdijk observes, too, that Zyklon B (used in the gas chambers at Auschwitz-Birkenau) was a more efficient form of Zyklon A (used to fumigate cloth warehouses).[8] Making the link between insecticides and chemical warfare may have exacerbated the scientific establishment's antagonism towards Carson as it blackened her character as an unmarried woman and rubbished her science as the work of someone without a doctorate writing for a mass audience. Despite that, the book was a best-seller and remains in print today.

Ecosystems and webs of interdependence

Silent Spring gives an image of an ecosystem in which all agents are interdependent: to extract any one of them renders the system as a whole unstable. For Carson, life represents 'a history of interaction between living things and their surroundings',[9] which follows Charles Darwin's view of a natural world of complex (but unplanned) interactions. In *The Formation of Vegetable Mould*,[10] Darwin writes that worms produce more than an inch of soil every ten years, aerating it, keeping it well drained and aiding root penetration.[11] Worms belong to a 'web of interwoven lives', or a soil community,[12] which may be an anthropomorphic reading (mapping the human onto the non-human) but was influential in evolution theory.

The use of social terms to describe natural phenomena appears again in the work of Ernst Haeckel, for whom ecology was the study of the inter-relations of living organisms and their environments (a definition drawn from Darwin's *Origin of Species* of 1859). Haeckel published his theories in 1866 in *General Morphology of Organisms*, revised in 1868 as *The Natural History of Creation*.[13] He saw mind and body as a single substance, and emphasized the aesthetic qualities of natural forms while regarding mind and body, and indeed all life forms, holistically.

A century after Haeckel, another form of a whole earth was popularized by the Whole Earth Catalogue[14] and by media images of the Earth seen from space exploration voyages. This may superficially

suggest continuity from early ecology to New Age thought, yet the alluring image of the Earth from outer space is far from holistic: only humans have access to such distancing photographic images of this kind, while the distancing of visuality renders the Earth an object of use and management as much as one of contemplation. Another method of enquiry, or another path from ecology's nineteenth-century beginnings, is required to see the Earth as a *subject*, in the sense that humans are subjects (selves), although this might also be considered anthropomorphic, since the Earth is a sphere of rock. Even the indifference which is sometimes attributed to Nature, or the gods, is a specifically human projection. There is no exit from that dilemma but a pragmatic approach would ask what impact different ways of seeing have on the planet as a habitat for human and non-human life, or for inanimate nature.

For ecologist James Gibson, 'the words animal and environment make an inseparable pair as each term implies the other'.[15] This makes definitions of nature problematic, although, as architectural theorist Adrian Forty observes, 'the distinction between the world created by man [sic] – "culture" – and the world in which man exists – "nature" – [is] perhaps the single most important mental category ever conceived'.[16] It is a question of boundaries, as between the categories nature and culture, or creature and habitat, and whether the boundaries are any less arbitrary than those drawn on maps by the colonial powers in the nineteenth century as a means of administration. I explain below with reference to Darwin that species genealogies are made only retrospectively, and this applies to ecologies and ecosystems as well. Indeed, the term *ecosystem* already frames nature as a system, rather than as a wildness or as chaos prior to its management by humans, and in this context a field of eco-criticism has emerged in literary studies to argue that the concept of nature is nonviable.[17] Eco-science, meanwhile, has abandoned the model of a 'structured, ordered, and regulated steady-state ecosystem'.[18]

But to adopt an ecology of 'individualism, conflict, chaos, complexity'[19] extends a nature-red-in-tooth-and-claw approach more often aligned to Victorian imperialism. Carson evokes a steady-state nature to be reclaimed if pesticides are banned, but this must be read beside the fact that some of the highest levels of biodiversity are in suburban gardens today, and that an evolutionary clock cannot be turned back like the passenger's wristwatch on a flight which crosses time zones.

Ecology is, of course, a discipline in context of others. It shares the prefix *eco-* (from the Greek *oikos*, denoting household) with economics, and is as much an expanded field as art or architecture (Chapter 1). As a science, ecology is the study of living systems such as energy flows and the networks in which they occur. The New Ecology of the brothers Eugene and Howard Odum[20] views the behaviour of flows as systematic, hence open to study in the same way as factory production or business management. Geographer David Pepper notes that natural metaphors occur in economics – the green shoots of recovery, the perfect storms which cause crises – but that New Ecology sees 'integrated circuitry, geochemical cycling and energy transfer' as amoral, closed to ethical intervention.[21] He summarizes, 'mainstream scientific ecology' uses neither an Edenic image nor a picture of 'imperialist conflict' but presents a technocratic, managerial worldview, in which 'nature is something to be manipulated...to maximise its returns to humans over time'; so, 'the images and metaphors in nature, as represented by scientific ecology', are reflections of a 'larger cultural milieu...[including] economic culture'.[22] In the fable which opens *Silent Spring*, in contrast, nature is a timeless equilibrium closer to Haeckel's holistic view of the natural world as a 'unified and balanced organism'.[23] Yet New Ecology echoes Haeckel as well, differently, in an insistence on ecology's scientific status and as a model for human society (which New Ecology reads back into nature). Eden, however, is an imagined state, as if beyond awareness of mortality.

Haeckel's notion that people are rooted in their home locality, region and nation is a retreat from the flux of an industrialized world – which re-creates a sense of lack of control faced with the vicissitudes of nature and its seasons of plenty and famine – and also from mortality in its image of a continuity above the span of individual lives as communities maintain their patterns of life over long periods. This contributed, in Germany in the 1930s, to a doctrine of blood and soil, from an earlier *Volkische* (folk) culture of national rebirth: an 'idealised pagan and medieval golden age' projected onto an anticipated future, reunified Germany.[24] I do not dwell on this but the baggage of ecology is a connected sentimentality, which may explain why campaigns to save (mainly nice) species are more successful than resistance to the neoliberalism which produces global warming. Leaving that aside, I now move on to variants of

non-scientific ecology in social ecology, deep ecology and political ecology, as the most relevant among a range of ecological positions for this book.

Social ecology

Murray Bookchin's political development began when he joined the communist youth groups the Young Pioneers in 1930 and the Young Communist League in 1935. By the 1940s he had moved to Trotskyism, participating in the editorial collective of the small magazine *Contemporary Issues*. Ten years before publication of Carson's *Silent Spring*, he wrote an article on the use of chemical additives in food. Bookchin was part of a broad Left milieu which included art critic Clement Greenberg, who wrote for another Trotskyist magazine, *Partisan Review*. But Bookchin turned away from socialism by 1980, describing socialist ecology as a contradiction infesting 'the newly formed, living movements of the future' with 'maggots of cadavers from the past', which need to be opposed 'unrelentingly'.[25] Between this renunciation and his communist beginnings, Bookchin attempted to integrate socialist and ecological ideas, identifying the root of environmental problems as a defective ordering in (white) North American society.

Bookchin tends to oppose organic (or self-organizing) models of society to a centralizing, bureaucratizing drive which he aligns to modern industrialization. This is not unlike Carson's image of a small town in green fields, and Bookchin is increasingly anti-urban, but his vision is more grandiose than Carson's and takes evolutionary diversity as a counter-force to industrial and social standardization. Thus future human well-being unfolds through a consciousness which extends the natural process of evolution open-endedly:

> Diversity may be regarded as a source not only of greater ecocommunity stability; it may also be regarded...as an ever-expanding, albeit nascent, source of *freedom* within nature, a medium for objectively anchoring varying degrees of choice, self-directedness, and participation in life-forms in their own evolution.[26]

Human evolution becomes self-realization and realization of stability in diversity. Bookchin translates this as de-centralization, seeing a 'strong human proclivity' for home, which is not compatible with the centralization of a nation-state.[27] The state becomes not only a form of ordering but also an unnatural entity which exists only by enforcement. Elsewhere he writes that 'the universe bears witness to an ever-striving, *developing*... substance, whose most dynamic and creative attribute is its ceaseless capacity for self-organization into increasingly complex forms'.[28] This can be read as an anarchist version of Darwinism, so that mutual aid becomes cooperation in the furtherance of species-potential (a biological and not a moral imperative), but when he says, 'the link between evolution of external nature and social nature is profound,'[29] Bookchin appeals to a justification in nature as a realm which contains human society, which negates the need for political acts to bring about the desired state of freedom despite Bookchin's emphasis on the need to deal with power and centralization.

Bookchin argues that humans differ from animals in that humans create institutions, and institutions produce power-over others and nature. A society of de-centralized, communal units seems to echo Carson's image of a small town in the fields, but it updates it to the postwar period, and fits it to the municipal level, which is the level of local referenda and petitions. For Bookchin, this model is read as incompatible with socialism because socialism is at root a centralizing system. Again, Bookchin rejects Trotsky's idea of world revolution in favour of social evolution at the local level, which may be pragmatic but extends a view of nature as a basis for society, rather than investigating a view of nature produced within human society, so that human nature becomes ahistorical. To me, this is a concept which is as historically specific as culture.

Bookchin observes myth's 'arbitrary character' and lack of 'critical correction by reason'[30] but attacks Theodor Adorno and Max Horkheimer – members of the Frankfurt School who wrote critically on the problem of myth's reproduction in capitalist society – and mythicizes nature as a realm which, liberated from human domination, engenders freedom. The difference is that Adorno and Horkheimer see the world's disenchantment in modernity as freedom from rule by a mysterious, implacable Fate,[31] while Bookchin sees freedom as the great return, or Arcadian

renewal. Environmentalist Glenn Albrecht points out that Bookchin ignores the competition and struggle which are integral to biological evolution, in his image of cooperative, symbiotic relationships; the 'social correlate of this natural order' is thus a human community complementing 'the structure and processes of nature'.[32] But are societies natural? Bookchin follows Peter Kropotkin, nineteenth-century anarchist and author of *Mutual Aid*,[33] in claiming that humans survive through cooperation. Kropotkin demonstrates this using examples of pre-industrial village communities. Taxation, wars and land enclosures have erased this natural social state, so that it is 'hopeless to look for mutual-aid institutions and practices in modern society' while 'as soon as we try to ascertain how the millions of human beings live...we are struck with the immense part which the mutual-aid and mutual-support principles play even now-a-days in human life'.[34]

Kropotkin wrote in the first years of the twentieth century; Bookchin, in the 1980s, seems to react against his own Left past as much as against the industrial metropolis, rather than drawing on evidence from village or pre-industrial societies. To say that mutual aid represents a spontaneous principle of human social organization, a design innate to human beings, is a leap of faith rather than a political argument, but the point is that it relies on a conception of nature which, again, is cultural and as historically specific as any other view of nature. This position is not without influence, nonetheless, in a tendency towards craft production in eco-villages and in a strand in 1990s art criticism which looks to the re-creation of a pre-industrial age (Chapter 5). But Bookchin's work is significant in linking social and ecological approaches, as in this passage from a conversation published under the title *Defending the Earth*:

> We should never lose sight of the fact that the project of human liberation has now become an ecological project, just as, conversely, the project of defending the Earth has also become a social project. Social ecology as a form of eco-anarchism weaves these two projects together.[35]

And this is borne out by evidence from groups and societies in the global South who seek to preserve and protect the habitats

which support their livelihoods. I would argue, though, that the idea of a social ecology, or eco-society, is helpful in terms of the inter-relatedness of social and environmental justice rather than in prescribing a precise form of social organization. In brief, Bookchin adapts the critique of domination from critical theory (proposed by Herbert Marcuse[36] as well as Adorno and Horkheimer), but adopts a messianic attitude which often undermines it. He rejects Marx's trajectory – a new social order emerges as capitalism fails – as denying 'the power of speculative thought to envision a new society' within existing social relations,[37] but the target for which he reserves most vehemence is deep ecology:

> In America, the rapidly forming Green movement is beset by a macho cowboy tendency that has adopted Malthusianism with its racist implications... an anti-humanism that among some of the wilderness oriented 'campfire' boys has become a brutalized form of misanthropy, and a 'spiritualist' tendency that tends to extol irrationalism and view ecology more as a religion than a form of health naturalism.[38]

For Bookchin, deep ecologists are 'well-to-do people who have been raised on a spiritual diet of Eastern cults mixed with Hollywood and Disneyland fantasies'.[39]

Deep ecology

Deep ecology replaces anthropocentrism – putting humans at the centre – by eco-centrism, so that all species have equal status. Physicist Fritjof Capra similarly proposes 'a corresponding ecologically oriented ethics'[40] whereby the mechanistic view of the world found in scientific rationalism is replaced by a model of diverse natural systems arising from interactions and interdependencies, where 'the nature of the whole is always different from the mere sum of the parts'.[41] Norwegian philosopher Arne Naess takes this approach as a basis for national and international policy, proposing a plan which includes the valuing of all life in context of recognition of biodiversity, not as a means to human benefit but because it is ethically right. Naess argues for changes in economic policy and

the development of technology to ensure that the success of human life is compatible with the flourishing of non-human life, thereby refusing the imperative for growth.[42]

The end of economic growth was also proposed by systems theorists Dennis and Donella Meadows in 1972.[43] It is a persuasive argument, though one which is difficult for political parties to propose since the adjustments to work, leisure and standard of living it entails will never be easy to sell to electorates. Naess advocates education to promote nonquantitative attitudes and reduce consumption, and emphasizes personal self-realization. The cultural specificity of deep ecology surfaces here, as it is easier to propose this approach in Norway – the richest country in Europe, with a small population – than in either the most populous countries or those exhibiting the most excesses of consumption.

Looking globally, Naess adopts a Malthusian position on population. Thomas Malthus was a nineteenth-century Anglican cleric who argued that animal populations were limited by the extent of subsistence and that human populations followed the same pattern.[44] In Europe in the nineteenth century, in fact, birth rates fell and population growth was further mitigated by emigration, while rising agricultural productivity ensured rising subsistence. These were not natural but historical causes; nonetheless, in the 1960s, bio-environmentalist Paul Ehrlich repeated the Malthusian line, calling for action to prevent a 'population bomb'.[45] Malthusians generally omit to say how population limits are to be achieved (sterilization of the poor being a nasty possibility). Naess simply says it 'must have the highest priority'[46] and the authors of *The Limits to Growth* set the desired family size as two parents and two children, assuming that birth control is 100 per cent effective.[47] I wonder again how this is to be policed and note that critics from the majority world dispute that population is the problem, seeing the issue as one of distribution and the control of food by transnational monopolies.[48] An adequate level of production can be maintained through locally diverse agricultural means, but this adequacy is fractured by external intervention (in India, for instance). It is a political question which deep ecology is more prepared to consider than Ehrlich, if in a limited way.

Deep ecology is radical in refusing human superiority in what could be extended to a model of deep social justice and in rejecting

the fantasy of an ever-growing economy. Geographer I. G. Simmons describes it as combining eco-science and metaphysics:

> Like some western and many eastern philosophies, Naess constructs a world-view with no ontological divide in the field of existence; there can be...no dichotomy of reality (or value) between the human and non-human. Similarly people are knots in a total field and the realization of Self must not lead to self-centredness but rather to a connectivity with all things which goes beyond mere altruism.[49]

Simmons adds that deep ecology produces two norms: the primacy of self-realization, which means identification with the non-human so that to harm nature is self-harm, and a biocentric equality: 'The world is no longer our oyster, we share it with the oyster.'[50] This could be read as extending Kropotkin's idea of social interdependence; a difficulty arises if the argument is aligned, however, to anti-urbanism when a majority of humans live in cities and oysters owe their existence to cultivation as food in an unequal relationship with their urban consumers, while badgers, foxes and deer become semi-urbanized and reliant on the detritus of human consumption. It is not easy in these conditions to read nature as a pure system which looks after itself, rather than an evolving co-product of human intervention through farming, fishing, dwelling, industrialization, urbanization and political contestation (as well as in the longer term processes of geological movements and erosions). I want to avoid the mire of whether the human nature which enacts these processes is natural or deviation from a purer nature which can one day be regained; the former could be used to justify anything (like the red claws of neoliberalism) and the latter to exclude anything (like cities). I want to end this brief investigation of deep ecology instead by asking how Naess deals with politics, since my view is that an eco-society, whatever it is, will be arrived at by political processes.

In 'Politics and the Ecological Crisis', Naess steers an ambivalent course, citing Carson's *Silent Spring* to effect that everything, 'not just politics', needs to change.[51] He remarks on Carson's alignment of pesticides to government agencies and her argument that 'very powerful pressure groups would not only vote against necessary changes in the direction of responsible ecological policies, but that

they also had the power and influence to monopolise the mass media with counter-information'.[52] Naess concedes that 'ecological sustainability is...only one of the goals of a Green society' beside social justice and peace.[53] He puts the pursuit of an eco-agenda in terms of crisis, rejecting the pragmatism of increasing exports of natural gas as a means to reduce coal production in a generally uncompromising approach. But – unlike Bookchin – he sees a centralizing tendency in transnational initiatives which affect local communities as necessary, although, at the same time, 'many ideals of strong local communities formulated in the sixties and seventies can be retained'.[54] This may refer to the intentional communities of the counterculture and the eco-villages of the 1990s onwards, which could be seen as the research and development for a new society. But Naess seems to be caught between global, community and individual levels of responsibility, calling on individuals to be aware of their complicity in ecologically irresponsible policies in their ordinary lives. Deep ecologists should work in their situation to reject short-term evasions, and against anthropocentrism, remembering that they hold 'a philosophical total view' that includes 'beliefs concerning fundamental goals and values in life' which apply to politics as well as everyday living.[55]

Well, yes, but the difficulty is that the goals are read in a number of ways: policies for the equal benefit of all life forms, and more selectively when some non-human creatures are privileged over some groups within society. For example, social critic Henry Giroux relates the adoption of neoliberal austerity measures in the state of Arizona in the 2000s under which cuts in Medicaid mean that heart transplants are no longer covered, which, given the cost of transplants, means 'a death sentence to the ailing poor' while saving $1.4 million. In the same period, following environmentalist concerns, the state approved expenditure of $1.2 million to 'build bridges for endangered squirrels over a mountain road so they don't become road kill'.[56] Like pandas and whales, squirrels are prone to being saved because humans like them. Deep ecology is not, obviously, responsible for the policy of the state of Arizona, and might say that the solution to roadkill is to reduce the number and speed of cars. But the case raises a question as to how concern for species-equality affects the specific conditions in which it is put into practice. When such questions are introduced, a model of universal equality suggests a future in which humans will be prey

to a spread of new natural threats. Having said that, the basic messages of social and deep ecologies – mutual aid and the inter-respect of species – suggest a greener world. The question is how such values are appropriately to be enacted and what relations are effected between values, means and ends. One aspect of this is whether human agency is the necessary or the most likely means to a greener world, or whether the idea of agency, as power to achieve, is part of the problem.

Political and liberation ecologies

Austerity is a lifestyle choice in the affluent world. In the majority world, or for poor people within rich societies, it is an unavoidable imposition. Since the 1960s, development architecture in the majority world[57] and advocacy and radical planning in the North[58] have represented the experiences of nonprivileged groups (whose tacit knowledges have been shown to be better able than imported expertise to deal with environmental problems such as degraded land).[59] While the North blames Southern societies for causing environmental damage, often through overpopulation, geographer Lucy Jarosz argues that the cause is not population increase but – from her research on deforestation in Madagascar – increased logging by companies supplying a global market. Jarosz remarks that a Malthusian polemic 'returned with a vengeance' in the 1990s accompanying anxiety over global warming, so that 'population growth remains a popular explanation for world hunger' linked to a dismissal of local, uncoded means of maintaining adequate food production with traditional methods: 'the poor are stripped of their humanity and their history'.[60] This is used to justify so-called green revolutions, which enforce global seed and pesticide monopolies, the impacts of which are permanently devastating.[61] Jarosz continues,

> For the Malagasy peasants, shifting cultivation was a link to the ancestors, an affirmation of identity, symbol and means of resistance to state authority. For the colonial stare, shifting cultivation was a destructive practice transforming forests into degraded grassland and impeding state-led forest extraction, labour control, and tax collection. Recently, on the international

level...shifting cultivation has been defined as primitive, inefficient, and destructive in itself and then later redefined as destructive in terms of growing numbers of shifting cultivators.[62]

Such experiences have produced radical revisions in approaches to development, awareness of the relation of environmental injustices to injustices of race and gender[63] and an ecological ethic.[64] I realize that this is an argument for the maintenance of the pre-industrial modes of production and society, which I have said above cannot be regained, but I would argue that that critique is appropriate to the North while the global South offers experiences from which the North can learn without seeking to reproduce the conditions in which such experience was gained.

One such lesson is that ecology is political; a second lesson is that the development advocated by global capital for its own benefit is the problem, not the solution. A third lesson is that the technologies generally promoted as instantiating progress are not always appropriate.

To value local experiences refuses the neutrality of technocratic expertise on which claims by global capital for the benefits of development are based. For Peruvian diplomat Oswaldo de Rivero, 'transnational enterprises enjoy increasing world power' but assume no international responsibilities.[65] Indian writer Arundhati Roy campaigns against the building of dams in the Narmada Valley,[66] arguing that the strength of the poor is not in institutional or legal efforts but 'in the fields, the mountains, the river valleys, the city streets and university campuses' where 'negotiations must be held...the battle must be waged'.[67] This re-introduces the problem of the image of a whole earth. For anthropologist Arturo Escobar, the image affirms an instrumentalism of inscription, as environmental science seeks to expose the Earth's secrets 'to the positive gaze of scientists', so that the planet can be managed to ensure that degradation is, 'redistributed and dispersed, through the professional discourses of environmentalists, economists, geographers, and politicians'[68] Such critiques inform political ecology as it emerged in the 1990s.

Geographers Richard Peet and Michael Watts describe political ecology as a meeting of 'ecologically rooted social sciences and the principle of political economy' in research which takes the field as a political as well as social and geographical entity.[69] Their edited book *Liberation Ecologies* brings together contrasting cases of environmentalism in which politics, social formation and

geographical location fuse. Among the contributors, geographer Haripriya Rangan refutes Escobar's position that development is a 'totalizing and hegemonic discourse', arguing instead that it can be 'a dynamic process that involves states, markets, and civil societies' in 'reshaping social relations and institutions'.[70] But Rangan also observes that development is a bargaining chip for political interests. More recently, a less visible form of development has become widespread in the acquisition of tracts of land for future exploitation. In the affluent society, developers acquire parcels of land and submit planning applications as market conditions make development economically attractive. In the South, land is acquired by external national or commercial agencies to meet future needs for food or energy production, masking their land grabs as agricultural reforms and improvements. The expansion of palm oil production as biofuel, for example, disrupts locally generated patterns of cultivation and ownership. This 'green-grabbing' may also be claimed as aiding biodiversity, protecting ecosystems, promoting ecotourism or providing carbon offsets; in process, it raises questions as to the character of greening and involves 'the restructuring of rules and authority over the access, use and management of resources' as it imposes specific forms of labour relations and human–ecological relationships.[71] One aspect of this is that charitable interventions such as an invitation to adopt an acre of rainforest may contribute to the protection of species but in a way which is disempowering at the local level and which tends to embed wildlife conservation in a neoliberal market-based model, which, in a different view, is the cause of the environmental crisis in general and of land degradation in particular.[72] Just as the boundaries of nature and culture become contestable, so do those of capital, states and nongovernmental organizations (NGOs); 'a new range of intermediary actors is emerging as critical go-betweens to secure and enable resource appropriations' including a range of carbon and marginal land consultancies.[73]

Future perspectives

Tensions between global and local interests arise, too, in the management of scarcity. For sociologist Costas Panayotakis, pollution, deforestation, biodiversity loss, acidification of the seas and desertification 'have serious implications for the configurations

of scarcity people face worldwide'[74] and are a product of neoliberal economic deregulation.[75] He cites the World Commission on Environment and Development's definition of sustainability as meeting today's human needs without compromising those of future generations, to say that capitalism – 'a system that has always been characterized not only by ecologically destructive practices...but also by extreme inequalities' – is by definition unsustainable.[76] Panayotakis identifies two alternatives: first, market-socialism that enables workers' management of industry and a social regulation of capital achieved by tax;[77] second, a noncapitalist alternative based on workers' solidarity, but one which recognizes the environmental costs of production and consumption and avoids the inefficiencies of centralized state planning.[78] Both alternatives could apply as much in the South as in the North, although neither is likely to be realized any sooner than Bookchin's municipal ecology or Naess's model of a society of eco-equality. Still, if capitalism is a key factor in the problem (or *is* the problem), and is able to thrive on crisis anticipation and management,[79] it is not even likely that capitalist strategies will do other than deepen and prolong the environmental crisis.

At the same time, whatever initiatives are volunteered in the North will tend to be within the net of capital (just as charities become competitive businesses). Marcuse writes:

> Nature may be a negation of aggressive and violent society but its pacification is the work of man (and woman), the fruit of his/her productivity. But the structure of capitalist productivity is inherently expansionist: more and more, it reduces the last remaining natural space outside the world of labour and organized and manipulated leisure.[80]

Rudolf Bahro, however, sees the environmental crisis as having one positive effect in that it empowers marginal groups:

> The capitalist industrial system can only be driven back and destroyed by an ungraspable and manifold movement of humanity...the marginalised and the excluded, those with their backs against the wall, now have an unbeatable ally in this very wall...formed by the limits of the earth itself against which we really shall be crushed...if we do not manage to...bring to a halt the Great Machine....[81]

As a result of his criticism of the system, Bahro was imprisoned in the German Democratic Republic. On release he moved to the West, joining, but later leaving, the Green Party while remaining a communist. His caricature of the Great Machine echoes Fritz Lang's 1926 film *Metropolis*, depicting, for geographer James Donald, forces which 'have an unimaginable capacity for destruction'.[82] One is the proletarian crowd; another is technological progress. The dilemma appears to lack an exit.

Finally in this chapter, I want to look ahead by returning to Darwin. I have attempted to show some of the varieties and complexities of ecologically inspired thinking about the Earth as a habitat for human and non-human life. These attitudes, from localism to eco-centrism and the call for global environmental justice, are green, but the term *green* equally suggests wildlife conservation, wilderness protection and, in Buddhist terms, kindness to all sentient beings. I do not attempt to summarize these attitudes, nor to generalize them in a single outlook, but I want to emphasize the tensions running through environmentalism, between a romantic view of nature (which is entirely cultural) and a disinterested, scientific view of the natural world (including the human) as a set of systems. Haeckel saw beauty in natural forms and likened them to art; he also saw a fundamental unity in nature, of which the unity of the human mind and body is an aspect. But how do we view a situation in which human enterprise produces widespread destruction when the human is part of the natural order even as it destroys it? It seems irrational, or as unnatural as the destruction of Carson's rural idyll. Yet an appeal to a natural order equivalent to Reason, or to a timeless state of Nature, puts the problem back in the realm of the same human mentality which has produced the difficulty by projecting one of a variety of senses of order onto nature.

This is where Darwin matters. For Darwin, the natural world exhibits variation, proliferation and adaptation. Humanities scholar Elizabeth Grosz writes:

> Darwin provides little discussion and no real explanation of the *origin* of species [in *The Origin of Species*]. He analyzes only the *descent*, the genealogy, the historical movement ... of species ... a movement that presupposes an origin that it cannot explain, which perhaps is not an origin except in retrospect.[83]

Grosz notes that the principles of variation, proliferation and adaptation reflect the evolution of verbal language, and that Darwin took language as his model, with elements of economic theory, to demonstrate that systems can be contained *and* open-ended, being 'temporally and geographically sensitive...subjected to tendencies and probabilities rather than laws'.[84] Then, 'Under certain conditions, each can tumble into chaotic processes under which systems break down or new forms emerge.'[85]

Natural selection, as the process by which life becomes what it is and what it will be, has no end-goal or design. The only rule is that movement is always forward; hence previous states of nature cannot ever be recovered. This renders projections of past Edens onto an imagined future unrealistic. Although this does not lessen the need to imagine futures other than those prescribed, natural selection is an open-ended process and cannot be predicted. Humans are actors in evolution, although the processes themselves are not human while they 'form and produce their subjects'.[86] This does not mean that anything can happen: the future is seeded by the past; some paths are viable and others are not. Inasmuch as nature is an ordered realm, order is read into it, as in the classification of species which is retrospective, the projection of a pattern onto that which evolved without it. There is no guarantee that specific species will thrive when evolutionary success is simply an ability to mutate, proliferate and adapt.

One argument might be that adaptation means finding a sustainable way to live on the Earth: a model of inter-relatedness. Another is reducing the planet to profit for shareholders when the residue is dust. The choice depends on what values are espoused, which to me is a political question: so, I am conditioned by my environment but I can intervene to change it.

3

Aesthetics

In 1810, Johann Wolfgang von Goethe published a theory of colour as the interaction of light and darkness. For Isaac Newton darkness was the absence of light, with no presence in the visible spectrum. Newton and Goethe both refracted light through prisms, but while Newton sought to discover the laws which governed material reality, Goethe was interested in the experience of sensory perception and in colour as a vehicle for the expression of feelings. For Goethe, that is, specific colours evoke specific responses in the spectator's psyche as well as being the product of physical reactions in the eye. Although his enquiries are tangential to the sciences of physics and optics – and some of his deductions are simply wrong – they are of interest in aesthetics because they emphasize the subjective character of perceptions, and hence of concepts relating to perception such as Beauty. And, if Beauty is in the mind of the beholder, a feeling of happiness evoked by a view of a landscape is there, too. The spectator is a sensing subject and may constitute the land either as an object or as a subject mirroring her or his own state. As the philosophical examination of these possibilities, then, aesthetics is relevant to environmentalism in more complex ways than, for example, appealing for the conservation of a landscape on the grounds of its use for leisure. That would be an argument based on utility; in contrast, aesthetics, a branch of modern rational philosophy, investigates the relations of subjects (spectators) to the objects of sensory perception. Seeing the world as mere object implies its exploitation; seeing it, or feeling it, as a mirror of the self, which is more or less an ecological position, may imply a sense of

caring and of living in relation to rather than exerting power over worlds – of which there are as many as beholders, each as real to the person seeing or imagining it – structured by concepts such as Beauty. At the same time, it is important to remember that Beauty *is* a construct, not a natural property (or quality in a scientific sense) of matter.

Goethe's idea of colour as the mixture of light and darkness is not supported by the evidence, but in aligning colours to specific human feelings, dwelling on their interpretation in the spectator's consciousness, he moves towards insights on subjectivity. Goethe wanted his writing on colour to appeal to scientists, artists, chemists, dyers and physicians as well as to philosophers.[1] Consequently, he juxtaposes the results of his optical experiments to studies of the composition of plant and mineral pigments likely to attract the attention of chemists or dyers. Looking at the leaves of trees, he asserts that their green is a mixture of yellow and blue (which green is in paint), deducing from their turning in the autumn that the blue fades (as many pigments did then). This is inaccurate but Goethe's interest in pigments remains interesting, again, as a basis for his thoughts on emotive perception.

In the later sections of his 1810 Colour Theory, Goethe investigates colour's moral attributes as evident from their perception. Yellow is serene in its brightness; blue is a bright but negative colour containing more darkness and produces a contradictory response between excitement and repose. Green is the most welcoming colour, and hence the colour in which rooms should be painted (as several were in Goethe's house in Weimar). Such singular colour attributions are easy to contest, but no less so than the correlations of colour and mood in verbal language. Both tend to be specific to a given culture, yet to gain currency, a term in language requires a degree of credibility (as in all symbolism: snakes can symbolize renewal because they *do* shed their skin). To take green as an example: Goethe aligns green with both welcome and a feeling of sensuousness, but not everything green is regarded as sensuous in all cultures; it is the colour of green fields and leaves, which may suggest openness more than sensuousness, but it is also the colour of mould, the glow of radiation and ectoplasm in the séances of 1890s spiritualism. It can be material or immaterial in association and – perhaps from its association with landscape – has been adopted by environmentalist political parties. The abstract painter Piet Mondrian, however,

is said to have sat facing the façades of pavement cafés in Paris so as to avoid seeing the green leaves of street trees, using only pure (primary) colours (red, yellow and blue) in his work. Leaving that aside, the significance of Goethe's attributions is that, taken together, colours form a complete system in which significations are to be read, not as absolutes, but in relation to others in a mapping of human feeling via the senses. Again, this seems to constitute an ecology of aesthetics and perception.

Goethe examined the subjective effects of vision and sought a degree of objectivity by conducting repeated experiments, but the modern idea of a subject (a conscious, thinking and acting self) begins much earlier, with René Descartes's efforts to dispel doubt. Finding the knowledge gained in experience and book learning suspect, he took the act of questioning his own existence as the sole reliable proof of that existence. This established a possibility for objective knowledge but limited it to hermetic systems such as geometry and mathematics. Descartes's discourse on the method of thinking correctly of 1637[2] is not an obvious point of departure for aesthetics but political theorist Peter Wagner reads Descartes's reasoning as the beginning of modern rationalism in 'a radical positioning of subjectivity', which is extended by Immanuel Kant.[3] Wagner links this positioning of subjectivity to Thomas Dewey's spectator theory of knowledge, in which when the world is exposed to the human gaze, it is the distance between 'the knowing subject and the object to be known that allows for certain knowledge'.[4] Dewey wrote in the early twentieth century and regarded certainty as a lost cause: 'knowing goes forward by means of doing'.[5] While Descartes seeks certainty, then, Dewey sees a gap between subject and object, enabling a scepticism which limits the number of assumptions to be made on which contingent, pragmatic judgements may then rest. Dewey's *The Quest for Certainty* was published in 1929, the year of the Wall Street crash, and might bear re-reading after the financial services crisis of 2008. I leave Dewey there, and my reference to Goethe's colour theory draws on a romantic rather than pragmatic approach, but juxtaposing Goethe's alignment of emotional states with specific colours with Dewey's pragmatic distancing of the spectator suggests a spectrum, or an axis of potentially creative tension, between perception (and hence aesthetics) as embedded in the realm of matter and as extracted from it. Subject and object are thus defined by their alterity yet knowing an object is a process in

the subject's mind, so that objects are made real (realized) by being brought into the subject's mind while, at the same time, lending validity by being outside it. The paradox has no exit, only various permutations.

German cultural scholar Andrew Bowie notes that Kant grounds objective philosophy in the subject's rationality, establishing a more substantial alignment of 'the external world of nature' to 'self-consciousness' through a concern for 'what makes us appreciate and create beauty'.[6] Aesthetics is part of an attempt to find certainty in the world where subjects are conscious (embedded or distanced) by locating the ordering of that world in the subject's own mind. Beauty and order are both, then, in the mind of the beholder and are often linked. The mind is necessarily the location of reason, a human trait, but a question emerges as to whether the natural world (as it is perceived) is also structured by reason or discovered by perception. A form of this problem is the deduction of laws demonstrated through repeated experiments (such as the observation of plant growth). But the world might be wild and chaotic, and such order as is encountered in it may be a projection by the observer, or not, inasmuch as I can know it. A sense of beauty in a landscape is an example of an ordering via culturally specific principles; it is an apprehension of order which, going beyond the subject, may fall into what Descartes saw as the realms of doubt. Aesthetics asks what happens in such apprehensions, affirming an emphasis on the subject. In the eighteenth and nineteenth centuries it resides in the relationship of humanity and nature, a relationship which is endlessly problematic.

For Kant, nature and beauty are apprehended in a disinterested attitude whereby the spectator has no vested (such as financial) interest in what she or he is looking at, and can see nature and art as if from outside, objectively, by carrying no baggage of private concerns. The context for this is the eighteenth-century dichotomy of the state (representing public interest) and private wealth (to be protected from the state). For aesthetic theorist Antony Fredriksson,

> This division between nature and culture is a central component of modern aesthetics. The concept of disinterest that announces itself during the 18th century...signifies exactly this kind of categorical division between culture and civilisation, governed by our desires and interests, and the natural realm that is conceived

as a counterpoint, as something outside our human concerns. There is something deeply problematic about this categorical division.[7]

Why? Fredriksson writes, 'our understanding of nature ... makes us forget the whole story of our natural life-form.'[8] This forgetting enables an overview whereby other humans as well as natural forms are treated as external, or as environment, enabling their categorization as, for example, resource. Could natural scenes be a prompt for alternative perspectives or ditching the model of perspective itself which separates the viewer's eye from the scene observed? Or would that eliminate the distancing, which, in modern aesthetics, is the location of criticality?

Nature as propensity

Goethe's colour theory was admired by, among others, Friedrich Schelling, whose *System of Transcendental Idealism* asserts that philosophies are centred on key ideas around which the elements of life are organized systematically. This extends Kant's orderly thinking and leads to a differentiation of aesthetics from the natural sciences. This is relevant because, as Theodor Adorno puts it, art is its model; characteristically, as well as linking this to power − art masters the natural world to show it as beauty − Adorno states a paradox:

> Only through their polar opposition, not through the pseudomorphosis of art into nature, are nature and art mediated in each other. The more strictly artworks abstain from rank natural growth and the replication of nature, the more the successful ones approach nature. Aesthetic objectivity ... realises the subjective teleological element of unity: exclusively thereby do artworks become comparable to nature. In contrast, all particular similarity of art to nature is accidental, inert, and for the most part foreign to art.[9]

Art and nature, then, are poles apart or are taken as the polarities of an axis along which the *work* of art is done. In Enlightenment thought, nature is suspended between polarities, not of art and

nature but of natural phenomena as vehicles for laws of behaviour and the humanity which exemplifies them. But nature is purposeful, growing according to laws such as gravity while it conveys a movement towards an eventual resolution in a perfect form. This mirrors and is projected by a human subject observing nature correctly. Humans are equally subjected to the laws of nature but have a purposive will to freedom.

Idealism asks if human purposiveness is aligned to natural law. In *Naturphilosophie*, Schelling asserts that just as humans are self-aware and purposeful, so is nature productive in ways which can only be intuited. Bowie summarizes, 'This idea can be made less implausible if one considers the fact that the material in which a living thing is instantiated is in one sense less significant than its "idea," which constitutes what it is by combining matter into the particular kind of organism it is.'[10] So, the cells of an organism are replaced continuously; its reality is never the same yet it remains what it is. For Schelling, the process of maintaining this continuity requires intelligibility, and if nature has an implicit intelligibility, then this can be aligned with human intelligence, as consciousness is shaped by an unconscious (invisible but real) state of mind. Form and consciousness are outcomes of an ever-incomplete process of becoming. An extension of this in Schelling's later work is that the subject is produced by an aspect of itself which is not its will but is its nature. Idealism regards nature as purposive and a reflection of a purposive history or a trajectory of human life from survival to freedom (or ape to bourgeois), but that is another matter. Here, suffice to say that a difficulty arises as to the relation of concepts to what they indicate (the idea of a tree to millions of different tress). Bowie writes on Schelling, 'if one asks in a Cartesian manner how concepts located in an isolated consciousness can correspond to objects, one has already created an insoluble problem.'[11] A plant grows as it does, in a way which cognitive science could not explain in Schelling's time – before DNA – while human will operates within a self which is similarly maintained. In the absence of theology, art offers a means to understand this. Bowie explains:

> Natural science ... is an infinite task because each determination of what something is gives rise to new determinations, without there being any way of knowing that the task of determination could finally be completed. Art, in contrast, *already* shows

how...the conscious intention of the artist...coincides with the unconscious compulsion of the artist's genius. Art therefore need have no further purpose, because the finite human product embodies a purpose which cannot be cognitively grasped, only intuited.[12]

Contained in the last sentence is the basis for modern art's claim to autonomy in a refusal of utility validated by its mirroring of human purposiveness.

First aesthetics

I need now, having shown some of the complexities of aesthetics, to look back to its beginnings. Alexander Baumgarten's *Aesthetica* was published in two parts (in 1750 and 1758) and can be taken as the beginning of aesthetics as a branch of modern European philosophy.[13] Baumgarten recognizes philosophy's inadequacy in face of human emotions, like the pleasure derived from looking at a natural scene, and sees beauty as a state of perfection which can be found in natural phenomena and is represented in art by the suitably educated artist mediating natural appearances to reflect a wider awareness of Beauty. For Baumgarten, aesthetics is not art appreciation but a philosophy of the subject, nonetheless, because it is the subject as artist or spectator whose state of awareness is investigated. Literary scholar Kai Hammermeister writes,

> Baumgarten's aesthetics refers to a theory of sensibility as a...faculty that produces a certain type of knowledge. Aesthetics is taken very literally as a defence of the relevance of sensual perception. Philosophical aesthetics originated as advocacy of sensibility, not as a theory of art. Yet without a positive valuation of the senses and their objects, art could not have achieved philosophical dignity but would have remained with the lesser ontological status that traditional metaphysics had assigned to it, compared to rationality.[14]

There is a glimpse here of the hierarchy of thought and work, as the arts have a capacity for invention (*ingenium*) while the crafts (*ars*) merely make things as before, as well as possible. The foundation

of academies in the eighteenth century rested on this distinction – otherwise artists would be like mechanics – while promoting the intellectual rather than sensual aspects of art. To like the colours was not enough; a painting had to tell a story or evoke a mood, and Baumgarten validates art as a proof of the intelligence of the sensual, a matter concerning the subject more than pictures.

The view of nature found in the kind of art which could be seen in Baumgarten's and Kant's time was selective, a taming of nature; only later does the Sublime introduce a wilder nature in vast scales, wild seas and a threat of disintegration (as the other side of Beauty's coin, or the dark side of the moon). The modern idea of wilderness extends the Sublime while the ornamental garden or city park extend from Beauty (the management of nature in accord with human reason). Raymond Williams notes that aesthetics refers to the cultivation of the senses as a way to access the projection of reason onto reality, which is then lent the status of a universal truth. Baumgarten uses the term *aesthetics* for 'subjective sense activity' and 'the specialized human creativity of art'[15] but Williams cites a counter term, *anaesthesia* (absence of feeling), to affirm that aesthetics is about human feeling itself as much as its objects.

As aesthetics develops, especially with Kant's writing, a problem emerges that while human feeling is subjective, aesthetics concerns judgements of taste for which objectivity is claimed. Beauty is constant yet natural appearances reflect it partially. The educated spectator knows that Beauty is not a property of beautiful flowers as such but of human perceptions of them (and mental reflections on perception), and is thereby separated from the contingencies of ordinary existence. But Williams goes on to say that aesthetics splits the cultivation of the beautiful from its social context, affirming an isolated subjectivity:

> an element in the divided modern consciousness of *art* and *society*: a reference beyond social use and social valuation which…is intended to express a human dimension which the dominant version of *society* appears to exclude.…the isolation can be damaging, for there is something irresistibly displaced and marginal about the now common and limiting phrase aesthetic considerations, especially when contrasted with *practical*…considerations.[16]

This was a persistent tension during the Romantic period, from the late eighteenth to the mid-nineteenth centuries, when artists and writers seemed to be suspended between revolutionary desire and the requirements of making a living; between a desire to be free from social norms and the need for a public for their work; and between socially specific self-images and their quest for timeless values (the quest also being socially produced in reaction to a world of flux in urban expansion).

Two further tensions arise here: between sense impressions and intellectual ideas and between subjective feeling and objective judgement. Impressions may evoke feelings but are mediated by ideas, yet ideas are the basis for judgement and are taken as absolutes. This leads, in classical Greek thought, to a privileging of knowledge of the beautiful over utility; in neo-classical aesthetics it validates high culture as an intellectual realm over sensual pleasure. In Kantian aesthetics, especially, rationality is a human trait; hence Beauty is recognized by the observer because its appearance corresponds to a concept which exists in her or his mind. As philosopher Matthew Kieran expresses it,

> What it is to be a rational creature...is to be capable of perceptions, thoughts, beliefs and imagining different possibilities. In order to do this we must be able to perceive and think of things by forming our experiences in terms of concepts....All human beings...have the capacity to perceive and think of experience in terms of concepts.[17]

I think there is a further tension, however, between a desire for certainty and awareness that this is unrealizable except in the isolated conditions of Descartes's thought. Certainty exists in self-contained systems (like numbers) but not in human affections. The construction, then, of certainty is attractive because it masks life's material uncertainties and, paradoxically, the one experiential certainty, that life ends. A theorem in geometry, once proven, is always the case but ideas of harmony are contingent on the conditions in which they are produced, varying in history and between societies. This is part of the problem addressed by Kant.

Baumgarten was Kant's mentor but Kant goes further in reading Beauty as evidence of rationality. Beauty is accessible to the rational

mind, and the rational person is expected to appreciate it. By seeing nature, the spectator sees her or his own rationality and the limits to that projection. Kant's dilemma is that Beauty is beyond actuality and can be accessed only in perception. His solution is that aesthetic judgement fuses subjective taste and the objective element of a principle which has universal assent. Hence spectators can judge the objects they perceive as beautiful by relying on a pre-existing concept of Beauty which has general assent. Kant argues that judgements of taste are not based on concepts, however, because that opens them to dispute; they are felt, as immediate apprehension. Beauty is found only partially, in fragments, in nature despite that its essence is universal, outside circumstance. It differs from natural forms, which age and decay, and can be seen in its pure state in the heightened forms of art. The universality of an aesthetic judgement is contingent on the universality of human reason and accessed in contemplation.

Kant's aesthetics can be read as part of a project to establish Reason as a purposive basis for society. W. S. Körner likens Kant's distinction between purposiveness and purpose to observation:

> We often find particulars, whether man-made or not, whose parts are so intimately interrelated and so harmoniously fitted together and to the whole of which they are parts, that we speak of the whole as having a *design* without relating it either to a designer or to a purpose for which it is designed.[18]

Looking at a stretch of landscape, I might project onto it the balanced asymmetry I would see in a landscape painting painted according to academic rules. This does not reflect any interest I have in the land – I do not own it – but reflects a rationality which reflects my human nature.

Kant confirms his analysis by differentiating aesthetic from teleological judgements: an object is beautiful regardless of its purpose; it is not a means to something else but is itself in its own right. Perhaps the idea of purposiveness without purpose, if opaque, is helpful. For Kant, 'What is collected by the imagination has unity.'[19] This is viable if the concept Beauty is already present mentally, as if objectively, and confirms that I am a rational human subject. That opens several cans of worms, which I will leave alone, such as the status of spontaneous feelings of wonder or the

experience of feelings which might be called aesthetic in cultures which have no such philosophy. But what lingers, for me, is that an idea of purposiveness can exist without the will, or purpose, which leads to instrumentalism.

Sublime depths: What beauty is not

So far, ideas of feeling and distancing, purpose and judgement, have emerged within aesthetics as a study of the human subject-in-nature. Descartes uses an architectural metaphor to figure the mind as the location of certainty: 'there is often less perfection in what has been put together bit by bit... than in the work of a single hand.'[20] He compares older settlements which began as villages and became towns, and are ill-proportioned, to new cities which have been planned by an engineer in one phase, as the engineer draws regular shapes, inventing forms in the blank ground of the imagination. Literary scholar Claudia Brodsky Lacour writes that Descartes's claim to certainty is a quest for purity: the act of architectural drawing 'is the image of a non-conversational and nonrepresentational design'.[21] Descartes knew of planned cities such as Charleville and Nancy, but uses the plan as a metaphor. Lacour elaborates that 'design' has two meanings in seventeenth-century French: as plan and as intention. Descartes hovers between a planning of space, which is a rational counterpart to the notion of an ordered creation, and an intention to make new designs. Descartes's picture of an engineer is a proto-appearance of the modern subject who gains pre-eminence in liberal humanism. The engineer is the centre of the action; the line, once inscribed, cannot be erased. Like a figure on a stage, the subject acts according to an inclination, so that making a design is not so far from having designs on an object of perception. Literary scholar Catherine Belsey sees the emergence of the autonomous, liberal humanist self in seventeenth-century drama – the revenge tragedies of the Jacobean period – and the English Revolution, and concludes that if the subject acts as if determining a course of action, he or she also remains unfree: 'To be a member of society is to give tacit consent to its rules.'[22] She uses dramatic suicide as a counterimage: the liberal subject terminates life as a way to affirm autonomy in an act that simultaneously annihilates the freedom to which the actor

aspires. Death on stage can be captivating, even sublime, but not least because it is on stage and apprehended via a suspension of disbelief enhanced by the proscenium arch of the modern theatre (introduced in the seventeenth century). Remove that suspension and chaos looms.

The sublimely stormy sea is frightening yet pleasurable, assuming a certain distance. Again feeling and distancing come into play as the sublime challenges representation.[23] But, as Körner explains, Kant differentiates a mathematical from a dynamic sublime, the former from 'an interplay of imagination and cognition' and the latter from 'interplay of the imagination and desire'.[24] Both are the result of disinterested judgement, but wild nature is dynamically sublime.

In the eighteenth and nineteenth centuries, Sublimity was projected onto the scenery of the English Lake District, while the limestone cliffs of Gordale Scar in Yorkshire were painted by James Ward in 1815 and visited by J. M. W. Turner in 1808 and 1816. William Wordsworth wrote a sonnet on the scar as a setting for a local deity 'with oozy hair / And mineral crown, beside his jagged urn', who teaches the waters how to force a passage to the sea.[25] Cultural historian James Kirwan stresses that such scenes are to be viewed but not to be entered: 'our estimate of the object takes the form of simply *thinking* of ... our wishing to offer some resistance to the force' and recognizing the futility of such attempts.[26] The trick is not to cross the divide between the audience and the stage, or really dangerous conditions and the image which they present. A wild sea is a fit subject matter in art, but that is not a reason to drown in one. Glaciers (as seen by eighteenth-century travellers crossing alpine passes) can be understood as vastly powerful, so that the power of humans is comparatively slight; they can also be seen metaphorically to denote the tides of history, which are thereby lent the force of geology. Quite the contrary – images of melting ice sheets might now evoke conflicting responses of the limit of human power over nature or its opposite. I return to this in Chapter 4.

Georg Buchner's poetic story *Lenz* illustrates the sublime in another way, with swathes of colour which dissolve a landscape's form into air:

> They drew further and further away from the mountains that now rose into the red evening like a deep-blue crystal wave upon whose floods of warmth the russet glow of evening played; across

the plain... lay a gossamer of shimmering blue. It grew dark... a full moon high in the sky, distant objects all dark and vague, only the hill close up in sharp relief; the earth was like a goblet of gold over which the golden waves of moonlight foamed and rumbled. Lenz stared out, impassive, without a flicker of recognition or response, except for a turbid fear that grew as more and more things disappeared in the darkness.[27]

Sublime landscapes project deep space onto topographies. Kirwan cites Kant that the sublime is found 'in a formless object insofar as *limitlessness* is represented in it' while, contrasting to the calmness of beauty, it involves a '*movement* of the mind...'.[28] And Sublimity is political, if obliquely, in the poems of Percy Bysshe Shelley and George Byron. For Byron, the heroic-sublime of the Greek War of Independence proved fatal; for Shelley, who was prosecuted for sedition, the arrival of antiquities from Egypt informed his poem 'Ozymandias' on the fate of kings (Chapter 4). Stephen Spender, however, plays down Shelley's radicalism,[29] which may suggest that Sublimity refuses the agency of the subject while seeing nature as a leveller of human power. But when Sublimity is material, the outcome may appeal to the reactionary as much as to the progressive tendency, as in Albert Speer's designs for a new Chancellery in the Berlin of the thousand-year Reich on which architectural historian Kim Dovey comments:

> The scale of both the vast and useless voids and the formal designs that enclosed them were designed to belittle the human subject. The building signified the force necessary to produce it as the frozen armed guards signified the discipline and order to which the force was subject.[30]

The sublime is conflated with the real. The power by which the subject is awed has become a really terrifying power-over. Fascism played, too, on myths such as the return of Emperor Frederick Barbarossa,[31] asleep under a stronghold in the Harz mountains which took material form in a pseudo-gothic castle incorporating a Romanesque ruin, designed by Bruno Schmitz in 1896. It was a popular tourist destination, reproduced in postcards.[32]

The sublime becomes an affirmation of destructive power, then, following a flaw in aesthetic theory to which Herbert Marcuse

draws attention in his essay 'The Affirmative Character of Culture' (written under the shadow of fascism in 1937). Marcuse writes that the 'insufferable mutability of a bad existence' produces a compensatory 'need for happiness in order to make such existence bearable'.[33] In Kantian aesthetics, Marcuse notes, the spectator renounces instinct – unmediated desire for joy – for its mediated form in art, a beauty which affords only sublimation. But this suggests that joy is found only in an ideal. Marcuse quotes Goethe at length, which I quote with a few ellipses:

> The human mind finds itself in a glorious state when it admires, when it worships, when it exalts an object and is exalted by it. Only it cannot long abode in this condition. The universal left it cold, the idea elevated it above itself. Now, however, it would like to return to itself. It would like to enjoy again the earlier inclination that it cherished... What would become of the mind in this condition if beauty did not intervene and happily solve the riddle! Only beauty gives life and warmth to the scientific; and by moderating the high and significant... beauty brings us closer to it. A beautiful work of art has come full circle; it is a sort of individual that we can embrace with affection, that we can appropriate.[34]

Marcuse comments that art represents reality as beautiful (and renders suffering acceptable), while, paradoxically, it reveals a joy which is outside the control of the regime. The dilemma wins (and I return to Marcuse below) but, against the rise of the market, aesthetic*ism* arose in Paris from the 1850s to the 1890s as what I think can be read as passive resistance.

An aesthetic life?

By the mid-nineteenth century, aesthetics had become a matter of taste rather than a matter of philosophy, and began to evolve into an aesthetic attitude of withdrawal from the dominant society, in which a supposedly superior taste or awareness became the artist's or writer's social contract. There were insoluble difficulties in Kant's theory, which was in any case overtaken by the rise of an art market in metropolitan cities such as Paris and Barcelona, in

which vested interests supplanted pure contemplation. In reaction to the institutional and commercial constraints of the art-world, Secessions arose in Vienna, Munich and Berlin in the 1890s, as signs of efforts by artists to claim autonomy and refuse the mediation of juries in the selection of public exhibitions. Autonomy may defensively echo a Cartesian isolation, but I want to argue that it is a condition for critique. Modern art is poised between the idea of the artist as autonomous individual, taking her or his state of psyche as subject matter in movements such as Symbolism, on one hand, and, on the other hand, a refusal of a dominant materialism in gestures which are obliquely but not overtly political. But I need to explain a little of the philosophical background to this before looking at its practice in the late nineteenth and early twentieth centuries, and then asking whether it is extended in relational aesthetics in the 1990s and 2000s.

Hans-Georg Gadamer identifies the paradox in Kant's aesthetics as the validation of aesthetic judgements as instances of a universal principle when 'good taste will never really attain empirical universality' and 'appealing to the prevailing taste misses the real nature of taste' in a refusal to 'submit to popular values...and simply imitate them'.[35] He explains that Kant locates the faculty of taste in the spectator's mind as a mediation of sensory perceptions according to an already existing rationality, or rational gaze, suggesting a paradoxical relation between the viewer's subjectivity and the objective status of the viewer's mediation of what is seen. For Kant, taste is aligned with morality – Beauty beside Goodness and Truth – so that the emergence of shared insights on the principles of an orderly society parallels a common ground of taste in art. Kant's insistence on Beauty's autonomy sets it apart from ordinary life, however, where social order is produced, but it also lends Beauty the status of an alternative reality in opposition to the vicissitudes of nature or the oppressions of a society which has not attained its rational potential. Marcuse takes up this idea in a 1968 paper, 'Society as a Work of Art', saying, 'The function of art...consists in bringing spiritual peace to humanity.'[36] He adds that art differs from reality and is independent of philosophy and science, re-affirming a consciousness in which new needs replace those which are reproduced in society: 'the beautiful exists in inseparable unity with order, but order in its sole *nonrepressive* sense....'[37] Marcuse concludes,

art itself can never become political without destroying itself, without violating its own essence, without abdicating itself. The contents and forms of art are never those of direct action, they are always only the language, images, and sounds of a world not yet in existence. Art can preserve the hope for and the memory of such a world only when it *remains itself*.[38]

Paradox permeates the discussion here (as it does the chapter); there is the Kantian idea of essence and art's agency – in creating access to an as-if-latent memory of a future life of joy – which requires its distancing from the realities in which its agency is to be exercised. Art does not change the world but it stands for an aesthetic dimension which is radically other to oppression and routine. Art, that is, offers glimpses of freedom when freedom is unattainable. This was also Ernst Bloch's hypothesis: that even in dark times art reminds the viewer of a latent vision of utopia.[39]

So far, the pursuit of beauty complements the aim of a free society, but is not political action. These are polarities – an active and a contemplative life – which are not exclusive but which tend to be seen as alternatives. After a disdain for aesthetics in the avant-garde culture of the late twentieth century, when socially engaged or community artists asserted the utility of their work in social reformation, perhaps Beauty has been rehabilitated. Sociologist Janet Wolff rehearses the dichotomy that, after Auschwitz (a horror which the spectator should see lest it happen again), horror is negated by the art which depicts it. She cites Bertold Brecht's estrangement – suspending the theatrical suspension of belief when actors are demonstrably actors – and film theorist Laura Mulvey's call to destroy Beauty, but she goes on to cite an exhibition, *Regarding Beauty*, in Washington in 1999, as indication of its critical re-appraisal when it is evident to artists and critics that 'the production and enjoyment of visual pleasure need not signify an abandonment of politics and critique'.[40] Gadamer identifies another way in which aesthetics carries a value which may be vital to an alternative social structure: its noninstrumentality. This is based on perceptions of harmony in the natural world but reflects the division between purposiveness and purpose in Kant. Art offers 'direct expression of the moral', while to observe a natural scene re-affirms that the order perceived is in the viewer's mind. Beauty asks for nothing, but if nature has no design (or designs on viewers),

beauty reveals the observing subject's rationality without the need for programmatic attainment. Gadamer embeds this discussion in his treatment of Kant's notion of genius (outside my scope), but he notes that an idea of a heightened sensibility which produces a heightened but parallel reality suggests a degree of immediacy in aesthetic experience which is of lasting significance.[41]

I want to draw out such a liberating possibility in the aestheticism of the nineteenth century when the avant-garde's initial politicization – as in Gustave Courbet's depiction of the dignity of labour in context of the 1848 revolution – turns inward. Following the defeat of the Paris Commune in 1871 and Courbet's imprisonment, financial ruin and death in exile in 1874, political art became understandably covert. In some kinds of abstraction, later it turned entirely inwards, which is hermetic withdrawal from society, or a mass public, but can be read as refusal of the values of that society.

The shift begins in the poetry of Charles Baudelaire in the 1850s, among other places, and is pervasive in the Symbolism and Decadence of Paris in the 1880s–1890s. The aesthetes may have affected faux-aristocratic poses – Baudelaire the dandy, for example – yet this is a withdrawal to make-believe which is also anti-metropolitan. Paris in the 1850s and 1860s was the site of boulevards lined with apartment blocks which cut through the city's working-class quarters in Baron Haussmann's remodelling of the city for Napoleon III. It was a speculators' paradise, and ushered in a city of visuality and vistas. As Walter Benjamin writes, 'Haussmann's urbanistic ideal was one of views in perspective down long street-vistas', of which the aim was to secure the city 'against civil war'. [42] Another sign of control was the white basilica of the Sacred Heart, towering over the hillside on which the Commune began. As geographer David Harvey observes, 'On sunny days it glistens from afar, and even on the gloomiest of days its domes seem to capture the smallest particles of light and radiate them outward in a white marble glow.'[43] But it is a fortification by other means,[44] a sublime repression in its ahistorical, pseudo-Byzantine style and superhuman scale.

At the same time, during the building of the basilica, groups of artists and writers met in cafés, or in domestic spaces, to evolve new literary and artistic languages. One such group around poet Stéphane Mallarmé met on Tuesday evenings in his apartment.

Mallarmé was not a widely read poet, and his writing is difficult, stripped to abstract sounds. Critic Edmund Wilson describes his weekly gatherings:

> There in the sitting room which was also the dining room on the fourth floor in the rue de Rome, where the whistle of locomotives came in through the windows to mingle with literary conversation, Mallarmé, with his shining pensive gaze from under his long lashes and always smoking a cigarette... would talk about the theory of poetry... He always reflected before he spoke and always put what he said in the form of a question. His wife sat beside him embroidering; his daughter answered the door.... He had proposed to himself an almost impossible object, and he pursued it without compromise or distraction. His whole life was dedicated to the effort to do something with the language of poetry which had never been done before.[45]

Among the visitors were the writers Paul Valery, André Gide, Oscar Wilde and W. B. Yeats, and the artists Odilon Redon and Paul Gauguin. Symbolism is usually read as a turning from the mundane to the purity of art, out of boredom (*ennui*) or from rejection *by* (more than of) the market. This is accurate and reflects aesthetic containment, but it has another reading as a revolution of consciousness. The aesthete refuses the values of commodity and productivity which shape modern society by creating conditions for an investigation of feeling and states of psyche which are a route to memories of joy, which are inherently revolutionary simply as instantiations of otherness and departure.

Marcuse advocated an art of beauty, nonviolence and serenity in his 1972 essay on ecology[46] and previously raised this possibility in a paper on French literature in the 1940s:

> Art is essentially unrealistic; the reality which it creates is alien and antagonistic to the other, realistic reality which it negates and contradicts – for the sake of the utopia that is to be real. But liberation is realistic, is political action. Consequently, in art, the content of freedom will show forth only indirectly, in and through something else which is not the goal [of liberation from productivity] but possesses the force to illuminate it.[47]

Writing on Baudelaire's poetry he reads it as expressing a sensuality which protests against 'the law or order of repression'.[48] Baudelaire, he argues, defines poetry in terms of a promise of happiness (*promesse du bonheur*). Of the poem 'Invitation au voyage' he writes, against a society 'based on the buying and selling of labour power' it is an 'absolute negation', a 'great refusal' and a 'utopia of real liberation'.[49]

For Gadamer, the call for aesthetic freedom is a rejection of a 'mechanistic society', while the rebellion of the youth movement – *Jugendstil* or *art nouveau* – against bourgeois culture 'was inspired by' the idea of heightened experience (*Erlebnis*).[50] For the writers of the 1880s and 1890s, notably J. K. Huysmans, it was a turning to an artificial life, epitomized in the novel *A Rebours*, in which an aristocratic aesthete, Floressas des Esseintes, retreats to the inward-looking realm of a suburban villa; he constructs a mouth organ in which the pipes are replaced by glasses of exotic liqueurs; he orders exotic flowers; his pet tortoise is gilded and jewel encrusted (it dies); and, setting out for England, he finds the sensations in the bar at the Gard du Nord enough and returns to the villa. To quote a short passage:

> His contempt for humanity grew fiercer, and at last he came to realise that the world is made up mostly of fools and scoundrels. It became perfectly clear to him that he could entertain no hope of finding in someone else the same aspirations and antipathies; no hope of linking up with a mind which ... took pleasure in a life of studious decrepitude; no hope of associating an intelligence as sharp and wayward as his own with that of any author or scholar.[51]

At this point aestheticism shifts into narcissism but I would argue that aestheticism remains a form of resistance, nonetheless. Henri Matisse drew on Baudelaire's 'Invitation au voyage' in a series of paintings in the mid-1900s, and such images fracture the world of routine. This is not only my view; writing on Adorno's *Minima Moralia*,[52] Bowie comments, 'The tension between conformity ... and individual initiative is inherent in modern art, but how much does this tension reveal about the social realm ... ?'[53] I will not venture an answer, but it appears that there is a possibility that the arts offer

glimpses of an imagined realm which counteracts that of the regime (capitalism). This opens a further possibility that, in ways which may not be specific, the arts stand as radical other to the systems which produce environmental and social injustices. Art and literature expose contradictions. They intervene practically (Chapter 5), descriptively (Chapter 6) and playfully or polemically (Chapter 7). And there are cases of alternative architecture which constitute the built form of a new society, enabling alternative power-relations while reducing eco-footprints (Chapter 8). This is important as a foundation for a new world within the existing world, not as a figment of future-foresight in fiction. Yet art's autonomy remains its claim to radical exception from the rule (from being ruled), and I end this section of the chapter with an enigmatic quotation from Julia Kristeva:

> Though marked by the indelible trace of the judging subject's presence, the concept of *negativity* leads this trace and presence elsewhere – to a place where they are produced by a struggle of heterogeneous antitheses.[54]

Relational aesthetics?

Finally, I want to return to the question hinted at earlier as to whether relational aesthetics – in the curating of Nicolas Bourriaud, informed by the philosophy of Jacques Rancière – extends the concept of aesthetics as an investigation of the subject poised on a potentially creative axis between withdrawal and engagement, between passive and active modes of resistance.

Loosely, the art curated under the (retrospective) label relational aesthetics tends to involve spectators in co-production of the work and/or in social relations within the work (which is likely to be performative) which mimic but obliquely critique those of the world outside the gallery. Bourriaud writes of the work of Rirkrit Tiravanija, for instance, as beyond categorization in terms such as 'sculpture' or 'installation', as it offers services in which those present engage – cooking food in the gallery, for instance – which constitute real interactivity as the social reality outside art offers 'more or less truncated channels of communication'.[55] I have

compressed Bourriaud's words considerably, but I think the argument is that a critical or at least sceptical perception of the dominant society occurs when its processes are extracted and re-presented in performative, interactive art. In a world based on trade and exchange, the processes of the market, or those of the service sector of immaterial trade and exchange, can be reproduced, but slightly skewed as art. This seems not far from Brecht's alienation, but it moves from representation (on stage) to life (in the street), as in Sophie Call's work which,

> consists... in describing her meetings with strangers. Whether she is following a passer-by, rummaging through hotel rooms after being employed as a chambermaid, or asking blind people what their definition of beauty is, she formalises ... a biographical experience which leads her to 'collaborate' with the people she meets.[56]

I have reservations as to how much agency these collaborators have in such art; again, I am reminded of Rancière's reservation as to the inhibition of antagonistic exchanges in art which – as in the case of suffering – renders what it depicts acceptable in the gallery's terms (cited in Chapter 1). But I need also to retain the idea of an axis of tension between activism and art's passive refusal of the norm, or of market values when it does that (necessarily outside the art market which, usually, includes the art curated by Bourriaud).

This is where Rancière is most helpful: in a characteristic ploy of advancing an idea or proposition and then retracting or adapting it, to draw out the tension rather than to produce a solution. The aim, as with Adorno, is to keep the contestation open. For instance, looking to classical aesthetics and its apprehension of the subject as human-nature, Rancière writes,

> The human nature of the representative order linked the rules of art to the laws of sensibility and the emotions of the latter to the perfections of art. But there was a division correlative to this linking whereby artworks were tied to celebrating worldly dignities... Nature, which yoked works to sensibilities, tied them to a division of the sensible which put artists in their place and set those concerned by art apart from those that it did not concern.... The word 'aesthetics' says, in fact, that this social

> nature was lost along with the other one. Sociology was born precisely of the desire to reconstitute that lost social nature.... For the good of science, however, it has continued to desire what the representative order desired,...that separate classes have distinct senses. Aesthetics is the thought of the new disorder. This disorder does not only imply that the hierarchy of subjects and of publics becomes blurred. It implies that artworks no longer refer to those who commissioned them...[but] relate to the 'genius' of peoples and present themselves...to the gaze of anyone at all. Human nature and social nature cease to be natural guarantees. Inventive activity and sensible emotion encounter one another 'freely', as two aspects of a nature which no longer attests to any hierarchy of active intelligence over sensible passivity. This gap...is the site of an unprecedented equality....But...these works are such only because their world, the world of nature fulfilling itself in culture, *is* no longer, or perhaps never *was*, except in the retrospection of thought.[57]

Modern art, the art of rationality, offers a new hope but simultaneously reduces that hope to the realm of art, which is next to that of illusion. But art is not illusionary, it has agency. As Rancière says,

> art and politics do not constitute two permanent, separate realities whereby the issue is to know whether or not they *ought* to be set in relation. They are two forms of distribution of the sensible, both of which are dependent on a specific regime of identification.[58]

If aesthetics, or the arts, have agency in relation to climate change, it is probably in critical acts of re-distribution and re-identification, within but beyond the regime of the art-world. Beauty is radically other to routine. But can it re-inflect a culture?

4

Ruins and Catastrophes

In his novel *After London*, first published in 1885, naturalist Richard Jeffries describes an abandoned city. London 'became green everywhere in the first spring'.[1] This is a regained Eden, yet one where evolution follows its own course; wheat mixes with couch grass and the stronger plants smother the weaker ones. In the autumn, the meadows are not mown. Seeds fly everywhere to be eaten by birds or sprout randomly as they fall. The following summer,

> the prostrate straw of the preceding year was concealed by the young green wheat and barley that sprang up from the grain sown by dropping from the ears, and by quantities of docks, thistles, oxeye daisies and similar plants. The matted grass grew up through the bleached straw. Charlock, too, hid the rotting roots in the fields under a blaze of yellow flower. The young spring meadow-grass could scarcely push its way up through the long dead grass and bennets of the year previous, but docks and thistles, sorrel, wild carrots, and nettles, found no such difficulty.[2]

Jeffries sets the splendour of the yellow charlock beside the smothering of the meadow grass by thistles. Brambles spread 15 yards from the hedgerows, but hawthorns, elm, ash, oak, sycamore and horse chestnut also sprout. Brambles and briars block the roads, which are as impassable as the fields:

> No fields, indeed, remained, for where the ground was dry, the thorns, briars, brambles, and saplings...filled the space, and

those thickets and the young trees had converted most part of the country into an immense forest. Where the ground was naturally moist, and the drains had become choked with willow roots, which...grow into a mass like the brush of a fox, sedges and flags and rushes covered it. Thorn bushes were there too, but not so tall; they were hung with lichen. Besides the flags and reeds, vast quantities of...cow-parsnips...rose five or six feet high, and the willow herb with its stout stem, almost as woody as a shrub, filled every approach.[3]

In the thirtieth year, everywhere is overtaken by uncontrolled growth. Railway embankments are overgrown and cuttings are blocked as the old machines seem like the works of giants (a description used of Roman remains in early medieval times). A lake covers much of central England. The survivors hunt in the forests, but London is submerged under a swamp 40 miles long, into which its buildings have collapsed:

There exhales from this oozy mass so fatal a vapour that no animal can endure it. The black water bears a greenish-brown floating scum, which for ever bubbles up from the putrid mud of the bottom. When the wind collects the miasma, and, as it were, presses it together, it becomes visible as a low cloud which hangs over the place. The cloud does not advance beyond the limit of the marsh, seeming to stay there by some constant attraction; and well it is for us that it does not, since at such times when the vapour is thickest, the very wildfowl leave the reeds, and fly from the poison. There are no fishes, neither can eels exist in the mud, nor even newts. It is dead.[4]

Blue flames shoot from the depths of the swamp; people say devils live there. The flesh of the dead has dissolved into black sand while their white skeletons clutch coins or treasure in their bony hands: looters.

Curator Christopher Woodward describes *After London* as Jeffries's 'instrument of revenge on a city he hated'.[5] He explains that Jeffries was brought up in rural Wiltshire but moved to Surbition (a south London suburb) to earn a living. Falling ill, he blamed 'putrid black water' in part of the city lacking proper drains, where children led 'miserable, tortured' lives.[6] In *The Great Snow* he writes of a London buried by snow, where polar bears hunt on the frozen Thames and the poor sack the West End in search of food. Jeffries

views urban and industrial growth as forces of darkness and misery, which is not untypical for the period, but his use of an evolutionary model for a posturban future differs from, say, Alfred Tennyson's image of a lost chivalric realm or Thomas Hardy's image of a rural Wessex (which was gone even as he wrote about it), although Hardy does describe London as a monster. James Greenwood, another late-nineteenth-century writer, observes the city's poverty and danger in *The Wilds of London* (1874),[7] but a more documentary description of urban poverty was given by Friedrich Engels after his visit to Manchester in the 1840s.[8]

Jeffries, however, is not a dystopian. He views the array of wild plants which flourish on the abandoned land of his novel with evident enjoyment and may have known of botanist Richard Deakin's description of 420 plant species found in the ruins of the Coliseum in Rome (1855). But Jeffries retains a distaste for urban squalor and uses a word, *miasma*, which has a different history from that of smoke and factory chimneys, and was already anachronistic as he used it in the 1880s. Although it is a diversion, I want to look at miasma before moving to literature's function as a means to create critical and heterogeneous urban- and land-scapes. In part this is because miasma contrasts with images of ruins in lacking any positive element. If images of ruins are seductive and lead to inaction, perhaps miasma had an opposite effect. Yet it was no more than a concept.

Miasma

By the 1880s it was known that diseases such as cholera were spread by contaminated water and not by a more mysterious miasma, but in eighteenth-century Paris, the bodies of the dead in shallow graves in churchyards were said to exhale a contagious miasma. As Ivan Illich writes, when people commonly urinated on walls, the aura of the dead was at first not a cause for concern[9] but became a threat in the course of a cultural turn, leading to the cleansing of the city, materially and symbolically. Duly, in 1737, an enquiry was established: 'The presence of the dead was suddenly perceived as a physical danger to the living' and burial within the city was suddenly deemed 'contrary to nature'.[10] Illich cites Philippe Aries that this denoted a heightened fear of mortality.[11] It was dealt with by siting cemeteries on the city's outskirts, beginning a process

which extended to deodorization when the bourgeoisie began to wash regularly and closet the expulsion of their bodily wastes in private chambers. Meanwhile the poor, lacking the means to do any of this, became carriers of odour and hence of a presumed contagion. As cleansing was institutionalized, the city became an odourless utopia in context of efforts to ' "clear" city space for the construction of a modern capital'.[12] Miasma disappeared. A new discipline of pneumatics arose (as museums are established once, what they collect is no longer extant). Pneumaticists collected gas in jars. A treatise estimated the weight of gas emitted in Paris;[13] the excrement which in classical times was a palliative for burns and sores[14] was now channelled into underground (as if secreted) sewers.

Alain Corbin writes of a 'revolutionised' attitude to city space and a new foreboding of putrefaction,[15] and sociologist Monica Degen views modernity's social distinctions as an outcome of the marginalization of natural or bodily processes.[16] Miasma did not exist except as an idea but its erasure indicates a new designation of elements of nature and human nature as dirt: the out of place. This occurs in the same period as the cultivation of a taste for ruins. Decay is the condition of the ruin as it is the condition of mortality, but if ruins also exhibit survival, or continuity, when their forms are not completely destroyed but stand despite the ravages of time and natural forces, heroically, does the literature of ecological catastrophe inherit this history? If so, it breeds apathy. But are there also imagined constraints on action to avert climate change which reproduce the myth of miasma?

A taste for ruins

Ruins are not dirt; they are out of time rather than out of place. In the late eighteenth and nineteenth centuries, upper-class travellers to Mediterranean countries encountered the ruins of classical civilizations. The regular forms of classical temples and palaces endured in the overgrowth, re-assuring as well as uncanny presences alluding to both the survival and the fall of past civilizations. Buried in the sands of Egypt, ruins hinted at lost mysteries. Shelley's poem 'Ozymandias' depicts a broken statue of an archaic tyrant as the remnant of his power while the 'level sands stretch far away'.[17] The sands appear limitless, a universal negation of power, while the fallen prowess of the mighty is a warning to contemporary rulers like King George (Figure 4.1).

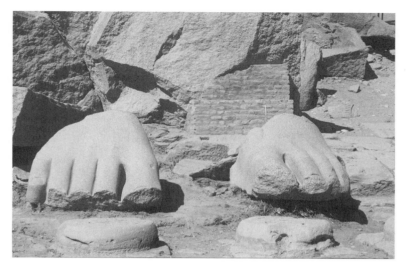

FIGURE 4.1 *The feet of Ramesses II, The Ramesseum, Thebes, Egypt, possible source for Shelley's 'Ozymandias'*

For historian Charles Merewether, ruins evoke 'a once glorious present ... revealing a place of origin no longer as it was'.[18] Ruins denote a breakdown in the ordering of things but their survival indicates a durability informing a multivalent sensibility which encompasses a beauty sensed in destruction. An example is the description of the burning of Moscow in Leo Tolstoy's *War and Peace*, which Russian scholar Andreas Schönle reads as revealing a wild dissolution of institutional structures in a social levelling enabled by catastrophe. Tolstoy likens the burnt city to a wrecked anthill, in which the ants run about haphazardly, while this 'existential dichotomy' allows both 'fully determined behaviour' and 'meaningless, random action'.[19] Schönle continues:

> In other words, as an index of the loss of the whole but also of the survival of some priceless remainder, ruins release the energy that contemporaries need to restore the foundation of their lives. Modernity's controlling and levelling mechanisms are swept aside ... and individuals reconnect with their 'diverse and personal' desires. In this collective fascination ... Muscovites articulate a spontaneous resistance to the ideology of modernity ... in an anarchically collective manner.[20]

The question then is whether or not that collective anarchy which implies self-organization at the social scale can be transposed to the wreck of certainties represented by impending global warming: a catastrophe to come (or beginning), not already experienced. If so, does this say something about the gap between knowledge of climate change and action to avert it?

Catastrophe

I want to set the interpretation of ruins beside the disaster fiction which has emerged around climate change. Literary historian Andreas Huysen asks if ruins can be authentic: 'The ruin of the twenty-first century is either detritus or restored age ... [as] real age has been eliminated by a reverse face lifting, whereby the new is made to look old.'[21] Perhaps accounts of global warming, merged with disaster movies and media spectacles, seem either remote or simply inauthentic. There is a growth industry in populist writing on climate change, too, as in Mark Lynas's *Six Degrees*: 'an apocalyptic primer of what to expect as the world heats up'.[22] Lynas predicts droughts after which 'whole areas are depopulated' and cities are 'little more than dusty ruins' which will be untouched for centuries.[23] Coastal cities such as London, Mumbai, Shanghai, Boston and New York become fortified islands with expensive sea defences, or are abandoned, and New Orleans will not be rebuilt more than once or twice. More disconcerting are the prospects of a carbon cycle feedback and the release of reserves of methane in Siberia. The end of the Permian era will be reproduced, says Lynas, if the rise in temperatures reaches six degrees: warm oceans do not absorb enough oxygen to support life; toxic gases extinguish life on land and, as at the end of the Permian, monsoons of sulphuric acid will strip the land of vegetation to wash 'rotting tree trunks and dead leaves into the already stagnant oceans'.[24]

So climate change has spawned a genre of catastrophe writing, but action is not taken to avert it. Slavoj Žižek explains this by the analogy of a man who thinks he is a seed; he goes to a clinic and is cured but, as he is about to leave, he sees a chicken at the door and turns back. The psychologist reminds him that he knows he is not a seed and he will not be eaten, but the patient asks if the chicken knows.[25] Žižek reads the chicken as 'the big Other which doesn't

know',[26] applying the metaphor to ecology: 'we know it, but the chicken doesn't know it...we can rely neither on the scientific mind nor on our common sense.'[27] His argument is not clear but perhaps common sense aspires to business-as-usual while big Others remain outside our consciousness of the real as abstractions (like Nature, but perhaps also like miasma but here in the form of a future not a present threat). I would argue, too, that the impact of narratives – fiction or documentary – of climate change is ineffective due to a blurring in the mass media when, Theodor W. Adorno writes,

> Information counts upon curiosity as the attitude with which the viewer approaches the product. The indiscretion formerly the prerogative of the most wretched of journalists has become part of the very essence of official culture. The information communicated by mass culture constantly winks at us.[28]

For Žižek, climate change constitutes a blind spot, while the big Other of Nature does not exist. Of course, Nature does exist, but as a cultural construct. As culture, it can be a vehicle for attraction even in images of a future dissolution of the world. This is an important issue: images of catastrophe are hypnotic and produce adrenalin in the brain, which is an addictive substance. The difference between climate change and previous apocalyptic imageries is that the latter offer redemption. Ruins do this as well, as fragments of the past which endure while they become part of a new reality (the comfort of the picturesque). Or, as in the Revelation of John on Patmos, destruction is a necessary prerequisite for a New Jerusalem. The end is a new beginning.

The end of the world brought by climate change, as geographer Erik Swyngedouw remarks, offers no redemption but is a scenario, he says, 'which few believe will happen'.[29] Geographer Cindi Katz writes, too, that climate change apocalypses are de-politicized or, when partially politicized, lead to a 'politics of self-sacrifice and self-denial, focused on the individual acts of consumers'.[30] She continues:

> The voluntarism which has become the mainstay of the environmental movement will hardly save the world, but it may perpetuate the social practices of predation that are the hallmark of advanced capitalism. And, in part, it is an apocalyptic reading of the problem that underwrites this redemptive form.[31]

I subscribe to that voluntarism in the form of a relatively simple life, but admit that this has little effect, and that radical state regulation is the only effective means to avert catastrophic climate change. Such regulation is remote, and what I see around me is a growth industry in books on climate change.

Wastelands

To interrogate catastrophe a little more I turn to fiction in the forms of two novels by J. G. Ballard, *The Drowned World* and *The Drought*. In *The Drowned World*, London is submerged, surrounded by lush, tropical lagoons. The cause is natural:

> The succession of gigantic geophysical upheavals which had transformed the Earth's climate had made their first impact some sixty or seventy years earlier. A series of violent and prolonged solar storms lasting several years caused by a sudden instability in the Sun had enlarged the Van Allen belts and diminished the Earth's gravitational hold upon the outer layers of the ionosphere. As these vanished into space, depleting the Earth's barrier against the full impact of solar radiation, temperatures began to climb steadily, the heated atmosphere expanding outwards into the ionosphere where the cycle was completed.[32]

A biological testing station occupies a two-storey steel drum. Communications with a base in Greenland are maintained by boat, and giant iguanas roam the ruins.

> Like an immense putrescent sore, the jungle lay exposed.... Giant groves of gymnosperms stretched in dense clumps along the rooftops of the submerged buildings, smothering the white rectangular outlines. Here and there an old concrete water tower protruded from the morass, or the remnants of a makeshift jetty still floated beside the hulk of a collapsing office block, overgrown with feathery acacias and flowering tamarisks. Narrow creeks, the canopies overhead turning them into green-lit tunnels, wound away from the larger lagoons, eventually joining the six hundred-yard-wide channels which broadened outwards across the former suburbs of the city. Everywhere the silt encroached,

shoring itself in huge banks against a railway viaduct or crescent of offices, oozing through a submerged arcade like the fetid contents of some latter-day Cloaca Maxima. Many of the smaller lakes were now filled by the silt, yellow discs of fungus-covered sludge from which a profuse tangle of competing plant forms emerged, walled gardens in an insane Eden.[33]

This has coincidental echoes of *After London*. But two dramas are played out in *The Drowned World*: a boat arrives to collect the last residents but Kerans, a scientist living in the top floor of a grand hotel, will not go. After mending his lover Beatrice's air-conditioning system, he runs through the risks of staying, accepting that food and fuel will last only a few months. He and others have had dreams suggesting a sense of return, paralleled by an evolutionary return in the lagoon as primordial life forms re-emerge. In the last days, pirates arrive, scavenging for art treasures to sell to the residual world government. Eventually, Kerans escapes, finds a boat, eats berries to survive and drifts in the lagoons where the noon temperature is 150 degrees (Fahrenheit).

> The wet sky was stained by the setting sun, the pale crimson mists tracing the hill crests in the distance. Pulling himself over the wet clay-like soil, he stumbled into what seemed to be the remains of a small temple. Tilting gate posts led towards a semicircle of shallow steps, where five ruined columns formed a ragged entrance.... At the far end of the nave the battered altar looked out over an uninterrupted view of the valley, where the sun sank slowly from sight, its giant orange disc veiled by the mists.[34]

Kerans finds Hardmann, a soldier who deserted the drowned city and is now semidelirious and half starved. Kerans feeds him berries and puts lotion on his sunburnt eyes; Hardmann goes on south towards a sun which is burning as well as drowning the world. Kerans waits two days and then follows him. He rests in a ruined apartment by a sandy lagoon, remembering Beatrice's 'quickening smile' as he scratches a message on the wall: '*27th day. Have rested and am moving south. All is well*'.[35] He knows no one will read it, and, after a few more days, he will be lost, 'a second Adam searching for the forgotten paradises of the reborn sun'.[36]

The drowned world is beautiful, its landscapes swathed in misty, warm pink and orange light. Survivors, like those of Tolstoy's Moscow, refuse the overdetermined orders represented by the drowned city and the quasi-state. Redemption is in taking charge of their own fate.

The Drought describes another postcatastrophe world:

> Ten years earlier a critical shortage of world food-stuffs had occurred when the seasonal rainfall had failed to materialise. One by one, areas as far apart as Saskatchewan and the Loire valley, Kazakhstan and the Madras tea country were turned into arid dust-basins. The following months brought little more than a few inches of rain, and after two years these farmlands were totally devastated. Once their populations had resettled themselves elsewhere, these new deserts were abandoned for good.[37]

The protagonist, Ransom, a doctor, re-reads government circulars informing him of the end of the drought, rain-seeding measures and the procedures for a mass evacuation to the coast. Ransom remains in his house surrounded by the trappings of a modern life: a radio, a fridge, canned food and a water tank on the roof. Other residents live out disordered lives protecting what reserves they have left, as bands roam the streets looking for salvage and conscripting stray people; an acquaintance of Ransom, Catherine, maintains a zoo, whose lions will wander later on the dunes. After visiting the zoo,

> Ransom set off across the street. The houses were empty, the garbage fires drifting from the gardens. The city was silent and the billows of the burning oil fires still rose into the air over his head. A door swung open, reflecting the sun with a sharp stab. Somewhere to his left there was a clatter as a lost dog overturned a refuse bin.[38]

There is sporadic violence. Ransom decides to go to the coast, leaving with a small group including Catherine. Cars litter the roads and armed gangs stop anyone moving. The group has a narrow escape and takes a boat:

> For an hour they followed the residue of the river as it wound across the lake. The channel narrowed, sometimes to little more than fifteen feet... Stranded yachts lay on the slopes, streaked

with the scum-lines of the receding water. The bed of the lake, almost drained, was now an inland beach of white dunes covered with pieces of blanched timber and driftwood along the bank the dried marsh-grass formed a burnt palisade.[39]

The city burns. They find a working car and eventually arrive at the cliffs above the coast where the distant sounds of machinery on the beach and the sight of galvanized iron roofs remind Ransom of a fun fair. But the site is overpopulated and small bands create their own anarchic subsistence in shanty towns and camps on the dunes while the official order seems remote and inadequate. Meanwhile:

> Under the empty winter sky the salt-dunes ran on for miles. Seldom varying more than a few feet from trough to crest, they shone damply in the cold air, the pools of brine disturbed by the inshore wind. Sometimes, in a distant foretaste of the spring to come, their crests would be touched with white streaks as a few crystals evaporated out into the sunlight, but by the early afternoon these began to deliquesce, and the grey flanks of the dunes would run with a pale light.[40]

Ballard again attributes the change to natural causes. Climate change is a provocation for the plot rather than its subject matter, which is the survivors' lives and love. His later novels are darker, mired in a realm of amoral, asocial capitalism, but *The Drowned World* and *The Drought* frame climate change as a narrative of human endurance against a radically other, uncaring Nature. Indeed, the planet – leaving aside what I regard as the nonsense of Gaia theory (the Earth as a single, living organism) – is inanimate, and not as such threatened.

Strange nature

John Wyndham's 1951 novel *The Day of the Triffids* begins when biologist William Masen is in hospital recovering from a triffid sting. Triffid stings are usually fatal but he has gained some resistance from previous research on triffid cultivation. As he walks through the wards, he finds that everyone else is blind while the bandages on his eyes have protected him from the effects of a comet. People wander disoriented, searching for food. The triffids were bred as a

source of food oil, and spread by a rogue shipment of seeds which went astray in Russia. They were farmed extensively, their long stems trimmed to prevent stinging. Triffids uproot themselves, walk and communicate by drumming. Uncontrolled, they proliferate.

After the comet's blinding impact, the strong press-gang the weak into work parties, asserting a primitive social Darwinism in the streets of London. Masen is attracted to Josella, whom he meets in a group of sighted survivors preparing to leave London, but is separated from her when a gang breaks into their hideout in London University. A plague kills most of the residual population. Masen and Coker (leader of the gang which broke into the hideout, now collaborating with Masen) drive lorries loaded with supplies through southern England:

> At first glimpse the place was as void of life as any other we had seen that day. The main shopping street... was bare and empty save for a couple of lorries drawn up on one side. I had led the way down it for perhaps twenty yards when a man stepped out from behind one of the lorries, and levelled a rifle. He fired deliberately over my head, and then lowered his aim.[41]

Eventually, Masen finds Josella and her blind parents in their house in rural Sussex. He farms the land around the house and controls the triffids with flame throwers and an electric fence. It works for a while, and for several months they establish a viable living, foraging supplies from towns. But a group of militarized survivors from Brighton arrives to take over. Masen feigns agreement but gets them drunk on home-brewed mead, allowing the family to escape. Eventually they reach a colony of survivors on the Isle of Wight, where, with the sea as boundary, triffids have been eliminated and society has begun again:

> We think now that we can see the way, but there is still a lot of work and research to be done before that day when we, or our children, or their children, will cross the narrow straits on the great crusade to drive the triffids back and back with ceaseless destruction until we have wiped the last one of them from the face of the land that they have usurped.[42]

This has echoes of wartime speeches, and the book was written in an England still recovering from the war, where bread was rationed.

Few of Wyndham's readers are likely to have foreseen the genetic modification of food or the cloning of a sheep called Dolly.

Like Ballard, Wyndham affirms the durability of human values, juxtaposed in this case to a regressive militarism. A similar regression is charted in John Christopher's novel *The Death of Grass*, in which a mysterious virus kills all forms of grass – including wheat and rice – to create 'pandemic panic'.[43] As he hears that attempts to kill the virus have probably failed, and the government procrastinates (or puts machine guns in place to control chaotic migration after rioting in the countries worst affected and diminution of world food stocks), John, the protagonist, takes his family to visit his brother in the Lake District. Then, on the next day, 'They encountered the first bare patch less than a hundred yards from the farmhouse.'[44] After that the book is a survivor's tale set in a landscape of social breakdown, shortages, violence and barren fields. David, John's brother, has fortified his farm against intruders with a group of local men and has maintained crops not susceptible to the virus; John and his family arrive there, but the book ends when he gains entry only by shooting his brother.

The survivor story has become a popular genre, informed by imminent nuclear war in the 1960s and by global warming now. Perhaps these stories act as a defence mechanism, and there has been a rise of survival culture and survival courses involving knives, camouflage clothing, killing wild creatures, and a command and control mentality. But while Wyndham's triffids were fantasy (and the social breakdown he imagines produced as much by comet-induced blindness as by triffids) and Christopher's end of grass resulted from virus infection (a natural cause like Ballard's climate shifts), Margaret Atwood's novels titled *Oryx and Crake* (2003) and *The Year of the Flood* (2009) are set in a postapocalyptic world produced by bioengineering and corporate totalitarianism.

Modified nature

In this world, the elite live in protected compounds and travel by special bullet trains. A mass precariat is provided with the opiates of commercialized sex and real-time, live executions on the Internet (brainfrizz.com and deathrowlive.com) and assisted suicide (nitee-nite.com), their role reduced to market fodder. Crake, a bioengineer, explains to his friend Jimmy, 'You can't

couple a minimum access to food with an expanding population indefinitely. *Homo sapiens* doesn't seem able to cut himself off at the supply end.'[45] Gangs run urban wastelands, but a covert network shelters individuals who follow an alternative lifestyle. *Oryx and Crake* consists in flashbacks to the days before Crake fixed the human problem by putting a lethal bio-toxin into a mass-market sex pill, interlaced with the story of Snowman, the mysterious figure who lives in a forest clearing by the sea. Global warming means that, after noon, roads are too hot to walk on. The seas have risen:

> Snowman in his tattered shirt sits hunched at the edge of the trees, where grass and vetch and sea grapes merge into sand. Now that it's cooler he feels less dejected. Also he's hungry. There's something to be said for hunger: at least it lets you know you're still alive.
>
> A breeze riffles the leaves overhead, insects rasp and trill; red light from the setting sun hits the tower blocks in the water, illuminating an unbroken pane here and there, as if a scattering of lamps has been turned on. Several of the buildings once held roof gardens, and now they're top heavy with overgrown shrubbery. Hundreds of birds are streaming across the sky towards them, roostward bound. Ibis? Herons? The black ones are cormorants, he knows that for sure. They settle down into the darkening foliage, croaking and squabbling. If he ever needs guano he'll know where to find it.[46]

This resembles Ballard's *The Drowned World* but transfers the plot to a scenario in which Snowman survives in company with a tribe of bioengineered little people, whose camp is protected by a magic ring of urine and whose sexual organs turn blue when they are in heat (another of Crake's fancies). They give Snowman fish but he needs other supplies:

> Now he's reached the Compounds. He passes the turnoff to CryoJeenyus, one of the smaller outfits: he'd like to have been a fly on the wall when the lights went out and two thousand frozen millionaires' heads awaiting resurrection began to melt in the dark. Next comes Genie-Gnomes, with the elfin mascot popping its pointy-eared head in and out of a test tube. The neon was on, he noted: the solar hookup must still be functioning, though not perfectly. Those signs were supposed to go on only at night.[47]

The dead lie in their houses. Laboratory creatures – Mo'hairs, in pastel shades, for instance, and pigs with quasi-human intelligence – live wild.

In *The Year of the Flood*, the same story is reconstructed through the experiences of a group of alternative dwellers, now in a brother- and sisterhood under the guidance of a new Adam, whose sermons for new Saints' days are inserted between chapters: Saint Rachel and All the Birds; Saint Chico Mendes, Martyr; Saint Terry and All Wayfarers; and Saint Julian and All Souls, to name a few. Toby (female) lives on the upper floor of a disused spa, and has made a garden to grow food from seeds collected by her sisterhood. The garden is attacked by pigs. Toby shoots one of them and, salvaging an onion and two radishes, walks into the overgrown clover, Queen Anne's lace, lavender, marjoram and lemon balm as, 'The field hums with pollinators: bumblebees, shining wasps, iridescent beetles. The sound is lulling. Stay here. Sink down. Go to sleep.'[48] This is a new idyll (like *After London*) yet full-strength nature is like God when still inhabited: 'Too much...and you overdose.'[49]

The survivors live out the last days primitively practicing the new religion and finding food, using supplies foraged in ruined buildings and evading a criminal gang who capture some of them and brutally kill one. Finally, Toby and her small group meet the tribe, who ask if Toby is a friend of Snowman.

> We step out from under the trees, into the open sunlight and the sound of the waves, and walk over the soft dry sand, down to the hard wet strip above the water's edge. The water slides up, then falls back with a gentle hiss, like a big snake breathing. Bright junk litters the shore: shards of plastic, empty cans, broken glass.[50]

The survivors are feeling, caring humans. Nonlaboratory nature thrives in coexistence with bioengineered freaks. Atwood describes a double apocalypse, of both climate change and bio-corporate totalitarianism, but these are stories, not reality.

Plastic litter, however, is real today. A. S. Byatt describes it:

> This was the Atlantic Gyre or the Caribbean Trash Vortex. It is said to be the size of Texas and moves slowly in the ocean. It is composed of human plastic waste, and beneath it, hidden under the movement of the sea surface, vast curtains of tiny particles

hang fathoms deep.... It contains also a silt of threads and fragments from the sumps of the world's washing machines.[51]

Sea birds feed fragments of plastic to their young, which die. Turtles choke on it. Byatt gives a harrowing list of deaths by plastic.

Catastrophes which change?

If doomsday happens, that's it. The survivor myth is not realistic but there is a genre in which a limited catastrophe leads to a sudden transformation of society. In the novel *In the Days of the Comet* (1906), H. G. Wells imagines that the Earth's population is temporarily rendered comatose by a cloud of dense gas as a comet hits the Earth: 'A luminous green has rolled about us.'[52] The story is set during a war but battle ships grow silent at the Great Change. The narrator had been involved in a love tangle and sets off across the dunes to shoot his rival. He runs through the grass, stumbles, goes on, until 'There was a noise and spinning in my brain, a vain resistance to a dark green curtain that was falling, falling, fold upon fold. Everything grew darker and darker.'[53] Waking, he is lost, lying in a barley field. The landscape is saturated with light and beauty:

> Nothing was dead, but everything had changed to beauty! And I stood for a time with clean and happy eyes looking at the intricate delicacy before me and marvelling how richly God had made his worlds...
> ...a lark had shot the stillness with his shining thread of song; one lark, and then presently another, invisibly, in the air, making out of that blue quiet a woven cloth of gold.[54]

Then,

> Men and women in the common life, finding themselves suddenly lit and exalted, capable of doing what had hitherto been impossible, incapable of doing what had hitherto been irresistible, happy, hopeful, unselfishly energetic, rejected altogether the supposition that this was merely a change in the blood and material texture of life.... this was the coming of a spirit, and nothing else would satisfy their need for explanations.[55]

The narrator settles his love affair amicably and advises the prime minister on how to sort out the world (as might have happened in Edwardian England). Wells's tale is attributed to a manuscript written by a grey-haired man in a tower but his aim was to convey a need for new social values, which again raises the question as to what makes the difference between knowing that climate change is real and taking action to avert it. In the television programme *Five Disasters Waiting to Happen* (2006), London is deluged; its streets are like canals; the tops of buildings are visible as rising seas flood every English port. The programme used visual technologies for a high degree of realism while adopting the look of a documentary. But a tabloid free-paper reviewed the programme as 'standard "global warming = bad" stuff' and as preaching austerity: 'No one likes being told off – we all know turning off the tap when we brush our teeth could supposedly help prevent the next flood in Shanghai.'[56] But what else?

First, the facts of future global warming are subsumed in the genre of the disaster movie. Second, the reference to Shanghai implies chaos theory – a version of complexity theory in which a butterfly flaps its wings in China to cause hurricanes in the Americas – and is a big Other in Žižek's terms (above). More accurately, the theory says that minor changes in the conditions in which an intervention is made produce major changes in its outcomes. Third, the global news industry is one of several sectors for whom business-as-usual is the preferred outlook. *Five Disasters* shows that climate change is part of that sector. This is confirmed by the publication in a tabloid newspaper in 2009 of a map of the habitable areas of the Earth after a temperature rise of four degrees: a northern fringe from Canada to a northern margin of Europe and most of Russia, New Zealand and a bit of Australia, Patagonia and the Antarctic.[57] The same map appeared in the popular science magazine *New Scientist*.[58] It is not that people do not know about climate change, but that they are reminded of it on an almost daily basis in ways which inure them to it. Swyngedouw argues that 'a widespread consensus has emerged over...the precarious environmental conditions that may lead to the premature end of civilisation as we know it'.[59] But far from galvanizing governments, publics or businesses into action, the issue is subsumed in a phantom public and political life:

> The political nature of matters of concern is disavowed to the extent that the facts in themselves are elevated, through a sort

of short-circuiting procedure, on to the terrain of the political, where climate change is framed as a global humanitarian cause. The matters of concern are thereby relegated to a terrain beyond dispute, to one that does not permit dissensus or disagreement. Scientific expertise becomes the foundation and guarantee for properly constituted politics/policies.[60]

Of course, policy should be informed by evidence but the point is that politics is a process of *contesting* values and the means to enact them is *historical*, produced through intervention. I agree with Swyngedouw when he continues that disaster is used in the management of fear to affirm dominant power relations.

This implies a universalized humanitarianism offering mass publics a new opiate in, for instance, saving the whale and other attractive species, but it conveniently hides the function of global capital in producing climate change. As suggested above, CO_2 becomes a fetish (however real the threat of increased emissions) which conceals the origin of its overproduction by the system which insists on business-as-usual and which appeals to populist common sense. Then transgovernmental agreements such as the Kyoto Protocol lead to new, complex ways of manipulating carbon markets and futures. Swyngedouw cites geographer Neil Smith's introduction of the term *Naturewash* to denote a process 'by which social transformations of nature are...acknowledged, but in which that socially changed nature becomes a new super-determinant of our social fate'.[61] Swyngedouw argues that the dominant consensus on climate change limits the articulation of 'conflicting and alternative trajectories of future socio-environmental' scripts, restricting the emergence of ideas of alternative human–human and human–nature relations.[62] Adorno's critique of mass culture comes to mind: 'Advertising becomes information when there is no longer anything to choose from...when at the same time the totality forces everyone who wishes to survive into consciously going along with the process.'[63]

Real life resembles – because it is scripted according to – the movies, but movies are made up, not real life (reserved for reality television in a media sphere hardly less frightening than Atwood's bio-corporate dystopia). What is perhaps more disturbing is the absence of redemption in a new fatalism which undoes the expulsion of mysterious Fate as determinant of human history in Enlightenment (an issue discussed in Chapter 5).

Nice endings

I want to end with a movie, *The Day after Tomorrow*. A sudden, massive drop in temperature means that most of the Northern Hemisphere is freezing. The British Royal Family (who appear for no obvious reason and are described as frail elderly people in nice clothes) are in a castle where the heating has broken down, but the helicopters despatched to evacuate them crash as their metal fractures in the extreme cold. In New York, meanwhile, a group of survivors takes refuge in the Public Library. They burn the books to remain alive. In the movie's subplot, a climate scientist, who understands the geothermal situation and is the father of one of the survivors in the library, tries to reach his son (who contacts him by mobile phone). Outside, there is a mass evacuation southwards; the president is in the last group to leave the White House but dies as the party's snowplough is engulfed and they walk fatalistically into the white desert. Another subplot concerns a search for antibiotics for a young woman injured in the rush to the library, entailing fighting wild wolves on a Russian ship washed up into the city. The young woman is also the girlfriend of the scientist's son. As they near New York, the father and a scientist companion find a buried MacDonalds under the snow, which still has food. They reach the library, and the father and son are reunited. Then, in Mexico, US citizens are, after long delays, allowed entry in a neat reversal of the usual situation (the film's only political point). At the end, the survivors in New York – lots more emerge from tower blocks – are rescued by army helicopters, rather like the cavalry arriving in a western, while two astronauts who have witnessed the saga from space are 'changed profoundly' as a return to normality means that they escape 'a lingering death, trapped and starving in the glory of the heavens'.[64] All very nice.

In a so-called real world, a report produced for the United States Department of Defense in 2004, 'An Abrupt Climate Change Scenario and Its Implications for United States National Security' (the Pentagon Report), announced that sudden changes in global climate conditions are as great a threat to national security as terrorism. The report was extensively leaked to the press, and predicted – as soon as 2012 – that Europe will suffer severe droughts plus a decrease in temperature, which will cause populations in Scandinavia to move

south. It also predicted that by 2020 there will be conflicts over water and food, and in 2007, violent storms will destroy coastal defences, so that cities such as The Hague in the Netherlands – a country much of which is below present sea levels – will be abandoned. As I write (in 2013) The Hague has not been abandoned. But sudden violent storms caused extensive damage in the southeast United States, and weather patterns are increasingly violent. Although much else in the report seems fanciful, I wonder if it was leaked to maintain a regime of control (as terrorism is used as an external threat, after the end of the Cold War) and to ensure that action on global warming is compromised by the diversion, or whether its underlying purpose was to seek a budget for military technologies which could also be claimed as climate defence. As I said (from Adorno), life gets more like the movies.

On Lyme beach, a young seagull guards a Tesco bag (Figure 4.2). It reminds me of Byatt's Caribbean Trash Vortex and the plastic-related deaths of birds and mammals, which could be avoided if the human addiction to plastic could be cured. It also reminds me of Atwood's hybrid creatures. But will the prevailing narratives of climate change make matters worse by presenting an apocalyptic picture which is addictive, or fatalistic, or subsumed in fiction and thereby rendered completely avoidable? Or, what else is possible?

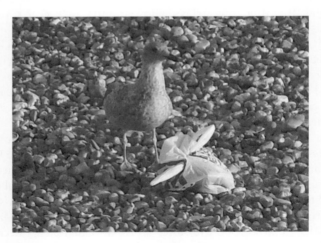

FIGURE 4.2 *A young seagull with a supermarket bag, Lyme Regis, 2011*

5

Regressions and Reclamations

The WEEE Man by Paul Bonomini (2005) at the Eden Project, in a 35-acre disused china clay pit in Cornwall, is an assemblage of Waste Electrical and Electronic Equipment (Figure 5.1). More than three tonnes of junk – microwaves, hairdryers, television sets, radios, computer screens and keyboards, among other items of built-in obsolescence – are used in a towering figure of Death standing before the twin geodesic domes which house African and Mediterranean biomes as the project's main attraction (Figure 5.2). Wiring and stray bits of electrical equipment hang out of *The WEEE Man*'s ribcage, over a further pile of waste equipment below. My first impression of *The WEEE Man* was that it looked like Death in the Four Horsemen of the Apocalypse who appear in the sky at the world's end. Conquest rides a white horse, War a red horse, Famine a black horse and Death rides what is often called a pale horse but, in the original Greek, is a yellow-green horse (from the same root as chlorine). But *The WEEE Man* is standing not riding. On reflection it reminded me of Jacob Epstein's *The Rock Drill* (1913–1915, dismantled; London, Tate), in which a bronze humanoid head and shoulders is set on a real drill. Epstein described it as a menacing, machine-like robot, and as the Frankenstein's monster with which he identified humanity at the outbreak of war in 1914. More recently, Frankenstein's monster has been aligned to the Frankenstein foods of genetic crop modification. But I wondered what effect all this had. The row upon row of cars parked outside

FIGURE 5.1 *Paul Bonomini,* WEEE Man, *mixed media (waste electrical products), 2005, The Eden Project, St Austell, Cornwall*

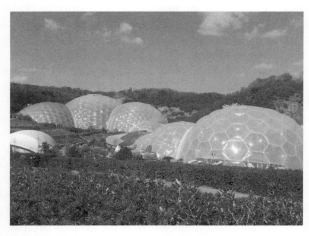

FIGURE 5.2 *The Eden Project, St Austell, Cornwall: Geodesic domes housing African and Mediterranean biomes*

the Eden Project implied the green message had not yet reached its visitors. Could *The WEEE Man* provoke shifts in patterns of consumption, or is it mere entertainment? Is the imagery from which *The WEEE Man* is derived remote, lost outside its biblical and medieval contexts, or found in comic books? As asked in the previous chapter, do apocalyptic images help avert catastrophe?

Re-enchantments

Looking at the mainstream art-world at the end of Modernism in the 1990s, critic Suzi Gablik is not optimistic. Citing artist Sandro Chia, she calls the art-world 'a suburb of Hell'.[1] Her reaction is to advocate a re-enchantment of the world through art (but not the mainstream art which is produced in that suburb). In *Has Modernism Failed?* (1984), Gablik argues that late modern art has retreated to a self-referential mode that precludes a means to engage non-art-world publics, in a society characterized by anomie.[2] As evidence, she cites British sculptors Gilbert & George, who exhibited a filmed performance in which they recite their negative traits at the 1982 Documenta exhibition. Gablik remarks, 'it is from his [sic] unfitness that the contemporary artist draws his power'.[3]

Gablik subsumes this unfitness in a tendency to replace tradition with compulsory innovation in the disillusionment produced by the 1914–1918 war (also the context for Epstein's *The Rock Drill*). Gablik writes, 'One of the social functions of tradition is to foster stability, and so to hinder change'.[4] This means that modern art is cast into a world that is no longer structured by authority – she does not specify what kind of authority or what constitutes it – and hence, to her, into disorder. Calling for a *return* to tradition-as-stability, Gablik is drawn to a notion of earlier (or other) societies as models of lost order:

> In primitive spiritual cosmology, power comes from the mysterious force of the cosmos. Art was a form of mediation, a means of establishing contact with this spirit world and participating in its creative energies. Seen from the standpoint of the individual, the sacred has always been something emphatically other than himself [sic], its power transmitted from a pool of ancestors and spirits to which the individual gives his allegiance, and

which in turn gives his life the only abiding significance it can have.... Our own secular ideology has led us to eclipse this sacred dimension...and to pursue immortality through the individual's own acts and works.[5]

Then, in *The Reenchantment of Art* (1991), Gablik restates her reaction against modernity by attacking its philosophical system as producing not only art which is self-referential but also destructive attitudes to the environment. She begins by attacking deconstruction theory:

This pervasive need of the deconstructive mind to know what is not possible anymore would seem to represent an absolute terminus in the 'disenchanted' modern world view: the self-checkmating of a now dysfunctional but apparently immovable dominant social structure. Deconstructive postmodernism does not ward off the truth of this reality, but tries to come to terms with its inevitability, in what are often ironic or parodic modes...[6]

A disenchanted world that is no longer home to the spirits which, according to the critique of deconstruction theory, do not exist is bound, she asserts, to be ecologically damaged. So,

In our present situation, the effectiveness of art needs to be judged by how well it overturns the perception of the world we have been taught, which has set our whole society on a course of biospheric destruction...we will see...a new paradigm based on the notion of *participation*, in which art will begin to redefine itself in terms of social relatedness and ecological healing...[7]

Participation has since become a recognized strand in contemporary art,[8] but is no guarantee of social or political revolution of the kind required to slow global warming; participatory art may be conducive to localized shifts of awareness, and in some cases is empowering, but the problem remains that the changes required do constitute a transformation in values (for which Gablik calls) but I suspect these changes are unlikely to be realized through a return to tradition.

Unpicking Gablik's diatribe exposes three difficulties: first, her allegiance is to an ahistorical art not unlike the timeless art (such as colour field painting) representing the cul-de-sac from which she

seeks an exit; Gablik is closer to Clement Greenberg (arch-critic of that art as art's ultimate self-realization on a reductive but dynamic trajectory)[9] except that she substitutes a mythicized past fused with an exotic elsewhere of shamanism for Greenberg's modernism. Second, Gablik looks to, or is captured by, an emotive realm found in indigenous societies practising animism, contextualized by the popularity of indigenous cultures among the hippy generation as affluent white nomads entered sweat-lodges and lived in tipis on the West Coast of North America in the 1960s.[10] Although well intentioned, this appropriates the cultures of other societies without recognition that their values evolved in conditions which were as historically specific (and nonreproducible) as those of present reality. To appeal to the power of the cosmos seems, too, to drop out of the political struggles in which power-to contests the power-over, which *is* environmentally destructive, falling into a delusional realm in which, as likely as not, the spirits are indifferent to human affairs.

Third, Gablik's references to disenchantment, I suggest, misunderstand the basis of modern critical thought; she sets a return to a consciousness found in myth and the realm of ancestors against a modern sense of self which, far from arising in anomie, is produced – as Hannah Arendt argues – amid the perceptions of others.[11] Disenchantment was a *liberation* from blind forces of control (mysterious Fate) and expressed a claim to agency (intervention in the conditions which condition human subjects), which is a more likely path to social well-being and environmental healing. Gablik claims, 'The remythologizing of consciousness... is not a regressive plunge into the premodern world' but changes 'how the modern self perceives who it truly is, when it stretches back and contacts much vaster realities' than those of consumer culture.[12] Consumerism certainly relies on delusion, but Gablik seems to lend objective status to remote realities which are at best imaginary and may well be disempowering.

In a dialectical model such as Marxism, the subject is an agent acting in the conditions within which her or his agency is exercised to re-inflect them. Such agency is limited, always contingent on that of others, but capitalism and colonialism are environmentally and socially damaging not because they deny Fate but because they reproduce its power over others. For sociologist Max Weber, capitalism disenchants the world through the imposition of alienating

labour. Gablik may be informed by his idea of a loss of wonder in industrialization but Weber does not propose a return to pre-industrial society but a re-organization within modern society. Political theorist Jane Bennett argues that rationalization denotes a range of processes which affirm 'the precise, regular, constant, and reliable' over the wild or idiosyncratic.[13] She adds that disenchantment has 'more than one moral valence',[14] citing sociologist Lawrence Scaff that rationality creates new 'modes of authority' for 'a cold and uninspiring world'.[15] This is close to what Theodor W. Adorno and Max Horkheimer argue: knowledge denotes a capacity for power over nature and humanity, and if 'the human mind, which overcomes superstition, is to hold sway over a disenchanted nature',[16] it frees society from the implacable mysteries of a remote fate. Myth is banished by reason but returns in various forms so that the task of theory is not regression to a prerational state but a continuing, never-completed revision of rationality from within. This is complex, but I must leave it there.

The second part of *The Reenchantment of Art* profiles art taken to support the critical path which Gablik advocates. Among artists cited, Lynne Hull makes wildlife habitats using found materials. In *Lightning Raptor Roost* (1991), a zigzag metal strip is added to a wooden pole topped by a twig and a bird nests on it.[17] Hull says that her work reflects living in Wyoming and her background as a potter; the loss of biodiversity is 'the most important survival challenge' to humans; and 'artistic creativity can be applied to real world problems... to survive, other species need a change in human values and attitudes'.[18] Dominique Mazeaud ritually collects litter from the Rio Grande as an exercise in connectivity: 'All rivers are connected... People function in the same way'.[19]

In *Conversations before the End of Time*, Gablik discusses Mazeaud's work with psychologist James Hillman. Hillman asks if it is art for art's sake, a gesture confirming the artist's social isolation. Gablik cites Mazeaud's conversations with passers-by; Hillman remains doubtful.[20] Gablik also interviews artists Rachel Dutton and Rob Olds, who say, 'Human beings have to change how they live with the earth, and they have to change soon'.[21] They plan to sell their possessions and go into the wilderness, and have taken a survival course; they can recognize the tracks of a deer (and if it had a full bladder when it passed). When Gablik asks how this helps them live in society, they say they extend their hearts to the deer. Gablik says that this is what happens when, 'the shaman *becomes*

the animal or becomes the tree'.[22] For Olds, 'Hunter-gatherers are the apex of human civilization. We need to go back to that point. All else is a bastardization and a plague...do it all the way, or not at all. Or we die'.[23] Dutton and Olds are presumed to have disappeared. I regard their gesture as self-harm, a case of art's social isolation and an appropriation or misunderstanding of hunter-gatherer culture. On that culture, anthropologist Tim Ingold writes, 'hunters and gatherers are self-conscious, intentional agents'[24] who enact cooperation as 'an acquired, *cultural* tradition' in 'an effective subsistence unit'.[25] This reads not too unlike Peter Kropotkin's idea of mutual aid, based on evidence of voluntary cooperation in pre-industrial societies,[26] and it suggests a close reading of conditions during the hunt, and a awareness of the actions of others in a common mode of operation which the artists' isolation prevents. Perhaps, if there is a lesson here, it is not unlike that offered by deconstruction theory: there are no ideal worlds but only fragments, ambivalences or attempts to be free which, however inadequate, are refusals of enchantment's chains. As to mutual aid, for Kropotkin this is transposed into the solidarity of industrial workers.

Localities

Through the 1990s, when notions of a universal return were widely rehearsed, notions of place were also proposed. Place was presented as being more than space, as quality tends to be better than quantity. The difficulties are that place-based communities may be far-fetched in mobile, industrial societies and that what is experienced is personal familiarity rather than a civic sense of place. Nonetheless, the local is one polarity on an axis connecting it to the global. If globalization is part of the problem, localism may be part of a solution.

Lucy Lippard's *Lure of the Local* (1997) combines a commentary on her relation to a coastal site in Maine; a discussion of contemporary localized, process-based art; and profiles of diverse art projects. Each element is set in a different part of the page. The book, it appears, deconstructs the concept of the book, after Lippard's association with conceptual art and the deconstruction of the art object since the 1960s. Identification with a specific place is viewed here as supporting shared values and attitudes in a social

group. Lippard writes that a family history or a home can show that the political is personal.[27] If community is an elusive idea, the search for 'home' is a search for a 'place to stand, something to hang on to'.[28] But the dominant image of home is idealized as a site of a domesticity reproducing the artificial life of consumerism, while an emphasis on domestic privacy produces an 'increased isolation of family units' as developers turn homes into alienating places in a society fragmented along cultural and class lines.[29] Lippard aligns this with a loss of common values and urges contact with oral traditions and recognition of tactile modes of apprehension as means to a sense of place. This implies a return to a pre-industrial mode of social interaction, but Lippard insists that conditions are analysed, too, via the explicitly modern constructs of gender and ethnicity.

Accepting that the land in which she seeks a sense of place is not hers alone but has had other owners, Lippard profiles *The Reconciliation Project* by Scott Parsons and David Greenlund at Sioux Falls, South Dakota, in 1992. Twenty-nine charred tipi frames were erected there, near the Nobel Peace Prize Forum, to protest that first-nation people were not invited to it. Spoof National Park Service historic site markers quoting first-nation writers were sited near the poles. The work was re-created in Denver for the Columbus Day parade, which was subsequently cancelled. Lippard writes,

> The ghostly monuments reached into the sky and cast long shadows over the earth [snow-covered in the photograph], combining visual poetry and harsh fact, directly affecting the cultural memories of those who experienced them, and overshadowing a bronze cowboy in the background. The artists intended this piece as a counter-memorial, '...a springboard o reconciliation...We wanted to imagine what apologies and historical accountability looked like'.[30]

The Lure of the Local also addresses homelessness, the white suburban frontier myth and the spread of environmental injustice. Lippard observes that the rise of the environmental justice movement followed a perception that a 'mostly white middle-class environmental movement did not care about minority communities'.[31] Toxic and nuclear waste is unevenly distributed near

poor and first-nation communities, who have been habitually defrauded of the value of their land. For instance, the Western Shoshone were offered the 1872 price for their land after it was used for nuclear tests. Tracts of land are designated as wilderness as if never occupied, too, or as survivors of a primordial past which is sufficiently remote to bear the imprint of a fantasized idyll or to represent an authenticity invoked by consumerism's unsatisfied wants. Lippard quotes Luther Standing Bear, however, that the Lakota never thought of their land as wilderness, but as a habitat, before what is known as the Wild West.[32]

Also in the terrain of land rights, Lippard profiles Dana Shuerholz's *Self-Portrait, Nevada Test Site* (1992), in which the artist photographs her shadow beyond the site's fence. A text panel beside the work says,

> I don't know the best way to make change. I write politicians. I vote. I organize. I make art/educate. I cry. I pray. I will never be silent because I believe in the deepest part of myself that no one is disposable and all life is valuable.[33]

Lippard identifies a 'history of human misery and death' in a land where 'piles of uranium tailings containing uncounted tons of radioactive waste are left lying within yards of [first-nation] homes and on grazing lands'.[34] I have sketched only a few elements of a (literally) layered book but the point which emerges is that environmental concerns are not separable from those of social justice. These issues are not addressed by a regression to a realm of fate, but in these cases are made visible in art.

Dealing with waste

A key area of environmental damage is the production and handling of waste. Lippard cites nuclear waste dumping but any large city produces vast quantities of rubbish to consign to landfill sites (although Curitiba, Brazil, for instance, has evolved recycling schemes which now handle a majority of their waste). The handling of waste, and social attitudes towards the people who handle it, pre-occupied Mierle Laderman Ukeles as artist in residence at New York City's

Department of Sanitation from the 1970s onwards. In *Handshake Ritual*, part of the *Touch Sanitation* project begun in 1976, she walked the city to personally shake hands with its garbage collectors:

> I tried to burn an image into the public's eye, by shaking, shaking, shaking hands, that this is a human system that keeps New York City alive, that when you throw something out, there's no 'out'. Rather there's a human being who has to lift it...dispose of it, 20,000 tones every day.[35]

The personal–political gesture and the work's performative aspect can be read in terms of feminist art critiques,[36] and recurred in *Wash* (1973) when Ukeles obsessively washed the pavement outside the A.I.R. Gallery (an artist-run women's cooperative) in New York. This was a more visible, in that sense public, site than the sanitation depots where Ukeles met the garbage collectors and brought passers-by inadvertently into the work. Art historian Patricia Phillips writes that it questioned the status of public space, the rights of individuals and the authoritarianism of cleanliness: 'how do the unspoken conventions of maintenance control a (reportedly) public space?...is the removal of homeless men and women from city parks and streets a compassionate initiative or an insidious demonstration of cleanliness as control?'[37] This was in context of the city's systematic removal of homeless people from prominent sites such as Grand Central station and Bryant Park, as a prelude to gentrification.[38]

As in some projects profiled by Lippard, social and environmental issues merge; Ukeles has raised issues of power, too, but her proposals for the Fresh Kills landfill site on Statten Island on which she worked from the 1980s until 9/11 – after which her office near Wall Street was closed due to ash contamination, and the landfill site used for debris from the World Trade Centre (including human remains) transported on the barges which once took garbage to the site – concerned the rehabilitation of a damaged zone. The site is close to an area of housing over which the smells of waste drifted. Ukeles produced a multiscreen installation using interviews with local people, ecologists and other professionals, to open up debate as to the site's future use and greening with networks of ventilation and drainage. Ukeles described the project (in 2002) as 'a model...of a power to take something that was rejected and return it'.[39] More recently, as a performative artwork, Ukeles undertook a series of live interviews in Brooklyn – with a museum cleaner, security guard,

sanitation worker, architect and planner, among others – to ask, 'How do you personally survive? What do you need to keep you going? What happens to your dreams and to your freedom when you do the things you need to do to keep surviving?'[40]

Thinking back to the model of an expanded field (Chapter 1), Ukeles's work is not-politics and not-social reformation, and it has a capacity to hand over part of the process of making to participants – although Ukeles creates the questions, the live interviews are co-produced by those interviewed in a way which is not predicted or edited – so that art is expanded in its authorship as well. Similarly, in a different context, Iain Borden has redefined architecture by writing about skateboarding as embodied architecture, a creative and skilful use of urban space which produces ephemeral forms no less open to academic or aesthetic investigation than buildings.[41] This handing-over appears to concretely refuse the artists' conventional (or mythicized) isolation, so that the divide between artists and audience (or designer and user) is collapsed in what might be termed cultural co-production or might be read as a potentially creative axis of tension between not-production and not-reception. I want to spend the rest of this chapter looking at cases of how this has been done in different places. Although the three cases (two beginning in art, one in architecture) are recent or current, this is not a new idea. Betty Beaumont's *Ocean Landmark* (1978–1980) is an underwater sculpture on the floor of the Atlantic, consisting of 500 tons of coal-ash waste which, through a process of natural evolution, has become the basis for a marine ecosystem. Coal fly-ash was processed into blocks in collaboration with a team of scientists seeking to stabilize it in water and was shipped to a site 40 miles from New York Harbour to be laid on the ocean floor. Listed as Fish Haven by the National Oceanographic and Atmospheric Administration, the site will go on evolving, out of human sight, until it becomes almost – but never completely – impossible to differentiate from its surroundings.

Incomplete sculptures: Industry and earth

Herman Prigann worked in the Ruhr and ex-East Germany in the 1990s–2000s. At Gelsenkirchen in the Ruhr, near his childhood home in an area devastated by bombing in the 1940s, he worked in a redundant mining site to create sculptures in a wooded landscape

park leading to a spiral pathway around a mound fashioned from the slag heap, topped by a structure like a ladder – *Himmelstreppe* (heaven-stairs) – made from slabs of concrete which were among the detritus of the site. The mound is black, not grassed over. In the woods, along winding paths, sculptures using found timber, stone and concrete are dispersed informally. Walking through the woods, the spectator suddenly confronts the mound and its stairs to the sky, like a ruin, as if it might have been thought possible to climb them to heaven (Figure 5.3).

FIGURE 5.3 *Herman Prigann*, Himmelstreppe *(Heaven-stairs), earthwork with concrete slabs, 1997, Gelsenkirchen*

The stairs might also suggest the ruin of modernism's utopian dream, and I think it was this as much as material remnants which Prigann sought to salvage. In Germany in the 1960s, he was associated with far-Left groups. He left for Morocco and Spain to avoid the attention of the authorities, living for a while in the Sahara. In conversations with him in 2001, I became aware of his deep commitment to the utopian dreams of the 1960s, but also his location of these dreams in a much longer history, back to Romanticism. At times, he seemed almost to echo Gablik's call for a return (but not to the same idyll) but this was always balanced, or corrected, by affirmation of modernity and its iconic representation: industry. The projects are not, therefore, a simple greening or cosmetic treatment of de-industrialized sites, and not a healing of any kind, but a production of monuments. As war memorials commemorate the dead of wars, they commemorate the death of industries on which many people depended for a livelihood and social life.

Before the project, the site in Gelsenkirchen was closed to the public, used for waste tipping, although trees began to grow from the 1970s. Following paths through the woodland, the spectator finds, here and there as if randomly, reminders of both the site's industrial past and its dereliction. Pieces of fine moulding from nineteenth-century buildings are used to mark the way strategically, as if to suggest a forgotten and overgrown landscape architecture or garden. In their de-contextualized state, they are uncanny. By the 1990s, art in woodland settings (such as the Forests of Dean and Grizedale in Britain) was not unusual; nor was art using found materials – the work of Andy Goldsworthy, Chris Drury and Roger Ackling, for instances[42] (Chapter 1) – but Prigann's is an explicitly industrial, not rural, project and I think should not be seen as equivalent to those more ephemeral and wayward practices.

Prigann (who died in 2008) usually began his projects by walking the site and gleaning local, incidental knowledge from unplanned encounters. He made proposals to submit for public discussion, and negotiated with landowners and funding bodies, especially the International Building Exhibition (IBA), which financed and curated the preservation of redundant industrial sites as open public monuments and leisure spaces in Germany. Each project was a dialectic, an intervention which changed the material condition and use of the site to reframe its meaning. Prigann was

concerned that de-industrialized places were not detritus; processes of insertion and deletion, adding or moving as well as removing material, were a catalyst to reflection on modernity or industry, both of which can be viewed as good or bad, presenting tensions of benefit and loss; affected by uneven distribution, these tensions remain open-ended.[43]

Prigann was not averse to myth, and some of his works play on archaic images of wood and fire. In *Feuerlinie* (Fireline, 1991), beacons were fired for one night in an area of redundant opencast lignite mining near Cottbus, near the German–Polish border. Prigann writes:

> Systematically burrowed through with enormous excavators ... a wavy, sandy, ochre-coloured wasteland until the horizon. Beyond it the power station that somehow gives this landscape's monstrosity some sense..... supply lines move into the land – white clouds form above the power station – the tall smokestacks – at the bottom of these giant valleys lies the coal ... raw materials of our civilization ...
>
> Only a few metres below the top layer lie scattered traces of the post-Ice Age culture of the nomads.... some live off the opencast mine, others lose their land to it – human beings live in uncertainty between the times.[44]

These are an artist's equivalent of field notes, carefully nonjudgemental and drawing out the heterogeneity of a site's connotations. They are personal, but not merely personal, as Prigann notes the contradictions of a site such as the loss of land which enables others to earn a living. Prigann was not concerned to make leisure parks but to imbue sites with visible signs of the questions they posed; modern industry was despoiling – as mines, chemical works, ironworks and so forth damage their sites – *and* beneficial, providing work and contributing to aspects of living which are taken for granted. He ensured that local people were employed and used waste materials such as concrete slabs and masonry. But, also repeatedly, he used plants, of the various species growing naturally in the area to grow on, then over, and eventually to more or less obliterate his earthworks.

At another site near Cottbus, Prigann designed a large earth ramp topped by an assembly of concrete slabs, some with steel

reinforcement cables poking out. Broom was planted on the slopes and will gradually cover them, from which the work is titled *Die gelde Rampe* (The Yellow Ramp, 1994) (Figures 5.4 and 5.5). The slabs are like a henge, hinting at archaic structures yet evidently part of a modern heritage. When I visited the site, after the abandonment of the opencast mine which the ramp overlooks, local people suspected outsiders (Westerners) of wanting to buy up properties at derisory prices. A road ended abruptly at the mine's edge, with a drop of several hundred feet. The broom was beginning to establish itself. The wind howled through the slabs.

Prigann stressed the importance to him of the plant growth which would overrun a work almost entirely in time. *Ring der Erinnerung* (Ring of Remembrance, 1993), for one example, is on the ex-border between East and West Germany. The area was affected by acid rain, and Prigann used dead pine trunks and earth to create a circular ramp with four entrances. Local granite slabs inscribed Aer, Aqua, Fauna, Flora and Terra are placed in the entrances and centre. The ramp was planted with brambles, which, by 2001, had already begun to cover it. The wood will rot away; the earth will be absorbed in the land underneath; the forest will encroach and wild growth will cover it

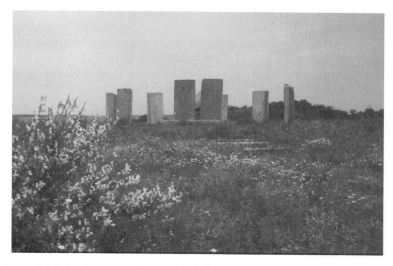

FIGURE 5.4 *Herman Prigann*, Die Gelbe Rampe *(Yellow Ramp), earthwork with concrete slabs and broom 1993–1994, near Cottbus, Germany*

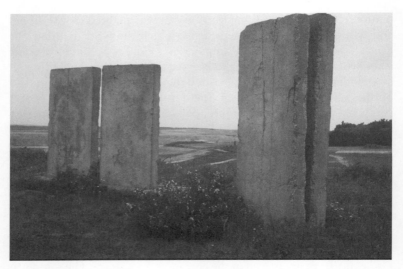

FIGURE 5.5 *Herman Prigann,* Die Gelbe Rampe *(Yellow Ramp), earthwork with concrete slabs and broom, 1993–1994, henge of concrete slabs*

all, but, in an aerial photograph, there will be signs of an interrupted drainage pattern, a slight inflection of the surface. The work will be gone but still there: 'Left to the natural process of succession, this object will be integrated...into the lucid, mixed forest that grows among the fir forest on the former border'.[45] I remember how strange it felt, and nine concrete border posts left within the circle; I also remember Prigann's refusal to be judgemental, over the two Germanies as over industry. Paula Llull writes,

> [He] was a politically committed social artist who advocated an integrated perspective...a cooperative approach...and the labour of the unemployed and recovering addicts, a constant, evolving commitment to raising awareness of the environment's intrinsic value. These three concepts – materialisation, multi-disciplinarity, and environmental awareness – came to the fore in [his] work...[46]

Given the role of overgrowth, Prigann's works cannot be completed and retain the tensions of the conditions in which they were created. That is not a contribution to debates on how to save the planet but,

to me, appears relevant in that the work is both dialectical and engaged in the social readjustment of European society after de-industrialization.

This aspect of Prigann's work differentiates it from other IBA projects. Emscher Park, for instance, outside Duisburg, is the site of industrial ruins which are preserved as monuments in a landscape beside the River Emscher and areas of woodland (much of it spontaneous growth) (Figure 5.6). The IBA aimed to regenerate the Ruhr, but has failed, creating only leisure spaces. A nearby ironworks in Duisburg North Landscape Park has been adapted as a diving site within one of its structures, with abseiling on the outside of another. Enlarged photographic images of industrial installations such as water towers, by Berndt and Hilda Becker, are displayed on the exterior of a wall overlooking the railway station where workers once arrived to begin their shifts. But industry is gone. The impression is generally one, German scholar Kerstin Barndt writes, of 'the culturisation of industrial ruins' linked to ecological measures such as the purification of the Emscher.[47] The culture in question is high art; Barndt remarks that with de-industrialization, 'the idea of a working class as a source of collective identity' has been abandoned.[48]

FIGURE 5.6 *Emscher Park, near Duisburg, Germany, 2013*

Autonomy and geopolitics in the Arctic

In October 2009, three architects – Richard Carbonnier from Canada, Giuseppe Mecca from Italy and Catherine Rannou from France – were selected as finalists in a design competition for a mobile media-based work/living unit which could function effectively in both extremely cold and temperate climates, using water and waste recycling systems and renewable energy. The brief was intended to induce innovative thinking rather than to lead to production, in a wider project by the Arctic Perspective Initiative (API). As circumpolar regions become more affected by climate change, API seeks to contribute to localized means of dealing with it:

> With progressively more access to these regions – and consequently more interest by domestic and foreign governments and corporations in their natural and economic resources – API is committed to the empowerment and sustainable development of Northern communities through the collaboration and combination of science, arts, engineering and culture.[49]

API was established by the Canadian artist Matthew Biederman and Slovenian artist and radio and theatre director Marko Peljhan. Biederman has worked with data systems since the mid-1990s, and Peljhan founded the arts and technology organization Projekt Atol in 1992. In contrast to a proliferation of diesel engines and generators, and other equipment linked to the region's exploitation, API insisted on green energy sources, but the aim was equally to use new communications technologies such as remote sensing and environmental data collection and aggregation, to assist local communities in maintaining their lifestyles and livelihoods in face of climate change. As they say,

> While providing an opportunity for research, the unit also enables a new technologically enhanced seasonal mobility ... local community members can live on the land while simultaneously collecting data and easily sharing stories and anecdotes through advanced communication technologies.[50]

API collaborated with the British organization The Arts Catalyst, which has a long-term interest in the politics of technology and had been a collaborator in Makrolab, a nomadic research station developed by Peljhan between 1997 and 2007. Of common interest to The Arts Catalyst and API are issues of 'interception and leakage, and of citizen appropriation of military and industrial technologies', in context of art–science interactions.[51] Makrolab's purpose was to be 'an independent, self-sufficient performance and research structure, an isolated outpost for survival and a critical reflection of societal conditions...in a hostile environment, both for humans and for technology'.[52] Makrolab worked in isolated sites in Scotland, Australia, Slovenia, Italy and Finland, drawing on telecommunications, climate data and migration patterns. API sought to extend this work in the Arctic, 'with the intent of adopting an inclusive and open working strategy' to engage Arctic communities who live a semi- or seasonally nomadic life.[53] For The Arts Catalyst, the project with API also touched on 'citizen science', which they see as necessarily (or justly) involving both data collection and analysis, hence the ability of communities to frame their own research questions using 'free or affordable tools...to study and improve their own environment through participatory sensing, monitoring and modeling activities'.[54]

The three designs for mobile units fused new technologies with elements derived from Inuit life. Rannou's design is informed by the dogsled, using a sleigh and lightweight pneumatic skin to form a tunnel-like space. Each unit provides living space for one person, but units can be linked together. There is an emergency ceramic heater but the design relies mainly on the insulating effect of the inflatable skin. Carbonnier drew on the form of plywood shelters (part of Arctic life since the last century, although not indigenous) but replaced plywood with a sandwich-shell using aluminium to sustain impacts during sea-ice crossings, in a unit housing two people, with minimum-impact waste, water and energy systems. Mecca uses the wood-and-leather technology of local buildings in a high-tech design incorporating an aluminium space frame and high-efficiency insulation materials, with space for two people and a sauna, although the weight of this structure prevents transport by skates or dogsled.[55] These, as said above, are ideas not projects to be realized; the wider aim of API is to co-develop and implement new communications technologies.

In a book based on Biederman and Peljhan's project, Nicola Triscott (director of The Arts Catalyst) writes,

> Where the development, use, and trajectory of technology leads society is a critical issue anywhere in the world. It has a particular urgency in the Arctic, where military, commercial, and political stakes are high. These stakes are amplified by the technological demands linked to the extreme climate.[56]

Traditional livelihoods are particularly vulnerable to climate change. As sea-ice retreats and hitherto stable areas become less so, detailed and real-time knowledge of conditions becomes vital to activities such as hunting, which are central to the traditional way of dwelling. This is a matter of everyday survival. It is equally a matter of data collection which feeds into larger pictures of climate change, and API, like The Arts Catalyst, were clear that (as stated above) local participants should use the project to evolve their own definitions of need and their own questions for science, not simply feed the climate-change machine.

As the project developed in 2009, Biederman and Peljhan undertook *field-exchange work* – a term used to differentiate this collaborative work from fieldwork in the social sciences, and from exploration – in Nunavit (a Canadian Arctic indigenous territory), erecting antennae and testing digital means of data collection, such as a small drone for airborne photography and remote sensing, at Ikpik, an abandoned Catholic settlement once intended as an alternative to government housing schemes (Figure 5.7). They started work towards a 'system of systems' for collecting and sharing data in collaboration with local communities, to be deployed in the settlements of Igloolik, Iqaluit and Mittimatalik (Pond Inlet) (Figure 5.8). The Common Data Processing and Display Unit (CDPDU) has operated in Igloolik, with additional stations in Santa Barbara and Ljubljana. Additionally, a prototype mobile hydroponic food-growing container using low- and renewable energy light-emitting diodes tuned to mimic the optimum light cycle for the crops grown has been developed. This is of particular importance, because all the fresh food consumed in the Arctic is imported (often produced by bioengineering). Piruqsivik (the hydroponic unit) will provide a community garden for Igloolik and free food.

FIGURE 5.7 *Arctic perspectives initiative: At Ikpik (Northwest coast of Baffin Island) preparing for orthophoto flights; Bramor UAS in foreground while Marko and Matthew install high-frequency radio antennae in the background (photo Nejc Trost, courtesy of API)*

FIGURE 5.8 *Arctic perspectives initiative: Lou Paula, Josh Kunuk, August Black and Zacharius Kunuk (left to right) prepare a qamutik for a trip to an outpost camp on Siurarjuk Peninsula to test the API Isagutaq (renewable power generation system) and perform live video stream discussion from the land for the Contemporary Nomadism event at Canada House, London (UK), in May 2010 (photo Matthew Biederman, courtesy of API)*

Social scientist Lassi Heininen writes of the increasing pressures on the Arctic as a site of large and only partially tapped resources. He regards the political landscape as a success inasmuch as international agreements such as the Arctic Environmental Protection Strategy of 1991 has so far not failed, while new institutions such as the Arctic Council set up in 1996 aim to ensure that the region is not militarized or destabilized.[57] Heininen sees climate change as increasing the region's vulnerability and shifting the attitudes of the eight states claiming Arctic territory towards its future exploitation. He is anxious that the dominant narratives of the Arctic are fixed in conventional concerns for security, with little regard for indigenous communities. Yet these communities have already used technologies of communication and environment as well as law 'across a range of scales, to exercise their engagement with, and stewarding of the environment'.[58] The question is how long the Arctic will be free from oil exploration; and whether institutional or state attitudes can encompass the handing-over of technologies, and power to shape their uses, piloted by the Arctic Perspectives Initiative.

Co-producing cities?

Biederman and Peljhan act as agents in negotiated and co-produced situations, equating the value of their knowledge of digital technologies with that of local, tacit knowledges of the environment. They engage with local cultures, and avoid conventional (white) readings of indigenous traditions in a shared concern for food, shelter and the maintenance of livelihoods and lifestyles in the changing conditions produced by climate change. Projects such as API are localized, and hence represent an alternative to the solutions imposed by transnational or globalized political and economic structures. From this arises a question as to how the insights gained from such practices be extended or scaled up to cities, or transposed to the affluent society.

In 2011, a workshop organized by the Urban Laboratory, University College London, compared current de-industrialization in the North to the economic downturn of the 1970s, when emerging, alternative cultural forms, especially music, indicated a resurgent creativity among the ruins, so to speak. The workshop concluded, however, that it was important 'to try to disrupt any

simple equation or romanticisation of hard times with vibrant urban culture' not least because, 'recent technological developments have reshaped if not short-circuited links between urban creativity and political action'.[59] In these conditions, architects face the difficulty that – if most major building schemes either involve iconic, signature architecture for transnational clients or, at the other end of the spectrum, are volume housing or industrial plant, and not designed but engineered – the architect's function needs renegotiation. In the South there are ample precedents, for instance in the work of Nabeel Hamdi;[60] but processes of co-producing the built environment have been less evident in the North, or in the countries of the new economies of Asia and Latin America. Architects Nishat Awan, Tatjana Schneider and Jeremy Till write of this in terms of spatial agency, not of design: informed by Henri Lefebvre's theories of space and his revisions of Marxism, they argue for spatial agency as a political process, and as a means whereby professionals give up the protective restrictions of institutionalized practice for the inclusion of nonprofessionals in making sites, and an idea of architecture as building. Awan, Schneider and Till write,

> Spatial does not so much replace architecture as a term, but radically expands it. It is now generally understood that space describes something more than the idea of empty stuff found between physical objects, or of the white expanses left between the black lines of architect's drawings. As the residue of the construction of those lines, space is abstracted and emptied of its social content, so better and easier to subject to control.[61]

In this context they cite the Brazilian group Arquitectura Nova from the 1960s who, 'turned their attention to the construction of buildings, and all the people involved in the processes, they believed that "it was through identification with building...that a radical architecture could be achieved."'[62]

Awan, Schneider and Till also cite the Chilean practice Elemental's housing scheme at Quinta Monroy, Iquique, begun in 2003. Required to plan for the city's last informal settlement's transition to a legitimate housing scheme for a hundred families, on land near the city centre and hence of high value (that had to be purchased), it was clear that the scheme could be achieved within the available budget only by part-building for dweller completion. Apartments were built

above houses to increase density, but gaps were left between each building to be filled in – diversely – by the families occupying the site. This incorporated an existing self-build tradition and enabled emotional ownership. Awan, Schneider and Till summarize:

> Elemental's insistence on referring to their housing work as urban projects is an indication of their desire to protect existing communities and to design neighbourhoods, rather than individual buildings. Theirs is a participative design process that responds to the individual needs and circumstances of each community. Through acknowledging what is available both economically and socially they act as spatial agents, transforming the meagre housing subsidy into a tool that can genuinely be used to address the huge housing deficit.[63]

But how does this relate to ecological aesthetics? First, I do not see ecological questions as other than social and political as well as environmental in content; this draws on Murray Bookchin's social ecology (Chapter 2) but more on evidence that environmental degradation is integral to an attitude which is also abusive of human rights (as in cases cited by Lippard). Second, a sustainable future is both social and political as well as environmental, requiring tools and processes for social equality and self-empowerment, as well as the reductions in carbon emissions necessary for survival. And third, in the case of Quinta Monroy, by staying where they were, the hundred families retained access to public transport, work, health and other facilities in the city's central zone, which are inherently advantageous environmentally – as in eliminating long commutes for work – and act as a model for affluent social groups. A fourth point is that by collapsing the divide between design and building, such projects imply a parallel collapse of other divides (social, environmental and so forth, or between writers and readers)[64] without assimilating marginalized groups to a majority solution.

Co-design or charisma?

In radical architecture and planning,[65] there are ample precedents now for alternative, socially grounded practices of co-production. Yet the spectre of the charismatic artist hovers in some discussions

of eco-art. Gablik's shamanism arises, if ambivalently, for instance, in the work of Joseph Beuys. Beuys set up the Office for Direct Democracy at Documenta in 1972,[66] arguing that everyone is an artist, and is political.[67] In another way, his charismatic presence at such events reflected (I surmise because I was not there) his own captivation by shamanism. Art critic Caroline Tisdall writes that he saw this as a corrective to rationalisation: 'richness... in a materialist world'.[68] She quotes Beuys at length; this is an extract:

> I take this form of ancient behaviour as the idea of transformation through concrete processes of life, nature and history. My intention is obviously not to return to such earlier cultures but to stress the idea of transformation and of substance. That is precisely what the shaman does in order to bring about change and development: his nature is therapeutic.
> Of course the shaman can operate genuinely only in a society that is still intact because it lies in an earlier stage of development. Our society is far from intact, but this too is a necessary stage.... So while shamanism marks a point in the past, it also indicates a possibility for historical development. It could be described as the deepest root of the idea of spiritual life...
> So when I appear as a kind of shamanistic figure, or allude to it, I do it to stress my belief in other priorities and the need to come up with a completely different plan for working with substances. For instance, in places like universities... it is necessary for a kind of enchanter to appear.[69]

Tisdall reads Beuys's enchantment activity as a reaction to the poverty of present-day life and the traumas of recent history, a therapeutic provocation against rationalists. For geographer Matthew Gandy, the rise of ecology in the 1970s provided Beuys with an 'ideal opportunity' to extend his model of social sculpture into an area of growing public concern'.[70] He remarks,

> The ecological supremacy espoused by Beuys is really a form of cultural supremacy in disguise. When Beuys and his followers demand a return to an ecologically based society, they are calling upon a specific set of historical and political traditions in environmental discourse: a conception of social reality which sits

comfortably within the dominant power relations that structure the current patterns of global resource use and the accelerated commodification of nature.[71]

There are tensions in Beuys's work, then, but the polarities of rationality and regression seem to permeate wider terrains of art and discourse. Jean-Luc Nancy writes that communism, too, has a regressive side as emblem of a desire to 'rediscover a place of community...beyond social divisions and beyond subordination to technopolitical dominion'.[72] This indicates the absence at least as much as it suggests the presence of community and solidarity, and Nancy argues that community takes place on an axis between immanence and absence (notably in awareness of mortality), assuming 'the impossibility of a communitarian being in the form of a subject'.[73] That subject, or self, emerged in early modernity as a subject who enjoys agency in a world whose contingencies and limits could be suspended (like the suspension of belief in modern theatre). It is, too, the subject who experiences the world and nature via the senses: the subject of aesthetics as a branch of modern rational philosophy (Chapter 3). Eco-aesthetics is a radical redefinition within that activating scenario.

6

Representations

Scientist Gabrielle Walker describes the Antarctic Peninsula as a fusion of several types of scenic beauty:

> Take the Alps, and cross them with the Grand Canyon. Stretch them both so that the mountains are higher, the cliffs sheerer, the glaciers wider and longer and bluer. Now put this glorious mix beside the sea, next to icebergs and penguins and seals and whales, and all within just two days' sail of civilisation.
>
> There you will find bright blue days or silent grey ones, when the water is eerily still. You can sail down narrow channels, only passable for a few weeks of the year, where mountains and ice plunge steeply down to the sea on either side, and researchers in field camps on the banks call up the ship's radio for the sake of a little contact with the outside world, or signal their greetings with waves or cartwheels.[1]

The Antarctic is also home to penguins, seals and whales. Humans can find a deep, monastic silence there, although Walker observes that the crossing from Ushuaia in Argentina – where hotels have names like The End of the Earth – is the stormiest in the world. But if the weather is fine,

> As the long lazy waves fetch up from the Pacific you will feel hour upon hour of rolling swell, rocking you like a cradle, like a lullaby.... And if you look outside, chances are that you'll see the grey-white form of an albatross gliding serenely beside the ship.

> If you have one of these crossings you will be infused with a sense of perpetual well-being, and sleep deeply and dreamlessly, however thin your mattress or your narrow bunk.[2]

On arrival, visitors see abundant life, now protected by stringent regulation against pollution by scientists or tourists. But the peninsular has not always been a place of harmony; Walker cites a late-nineteenth-century sealer's testimony to the US Congress: 'We killed everything, old and young, that we could get in gun shot of, excepting the black pups whose skins were unremarkable, and most all of these died of starvation.'[3]

Walker compares sealing to mining: 'go there, grab what you can and leave.'[4] She also notes that the Antarctic was once green, covered in trees and ferns. High levels of greenhouse gases produced a climate which became too hot for the dinosaurs; trees fell into swamps and rotted as the bodies of sea creatures were swallowed by the mud:

> And time passed, and the carbon in the trees and the bodies of the sea creatures was buried further and cooked and squeezed and chemically transformed into coal, oil and natural gas. The Earth had found a natural mechanism to suck carbon out of the air and bury it where the sun don't shine.[5]

The opening of Drake Passage enhanced the cooling process, isolating Antarctica from other land masses. It has cooled ever since, until now. As the krill (on which many creatures feed) declines, Salps – 'formless gelatinous blobs that are palatable to almost nothing'[6] – and king crabs move in, the latter 'ready to descend on an unsuspecting ecosystem that has lost the evolutionary ability to protect itself'.[7] And the ice sheets begin to fracture. Walker describes a journey to the Muller Ice Shelf:

> All around us there was ice: the great squared-off tabular bergs that had only recently broken off; medium-sized ones with rounded edges and longer histories; and small chunks, with odder shapes. You could see what you wanted in these natural sculptures: a mermaid, a horse's head, swans with their necks entwined, dragons.
>
> But their shapes also told real stories if you knew how to read them. With a practised eye you could see where, as they had melted

from below, they had become repeatedly unstable and flipped over and then flipped again. There were shelves of ice jutting out in mid-air, where old water lines had once been, or sides rippled with lines created by bubbles of air that had once escaped from the melting ice below the water, and bobbled their way to the surface.[8]

Walker also describes a scientific expedition to the Larsen B ice sheet, one of the largest. All seems well until 'Larsen B...suddenly became shot through with cracks and the ice turned to rubble'.[9] Five hundred million tonnes of ice breaks into icebergs and eventually melts into the southern oceans, where it contributes to rising sea levels.

The dignity of endangered species

In the 1980s, the most prominent environmental issues were species depletion and a widening hole in the ozone layer.[10] Matters improved with the Montreal Protocol, which banned the use of chlorofluorocarbons (CFCs), but the banning of CFCs coincided with globalization and the beginnings of anxieties over carbon dioxide emissions. As campaigns to save some species gained popular support, scientific research reported the fragility of the geographically bounded environments in which many species of butterflies and moths, or corals, lived.[11]

In an attempt to engage local groups in conservation, Common Ground, an ecological charity, initiated projects relating to local ecosystems. Among them, the *New Milestones* project began in 1985, aiming to link 'people, landscape, history, nature [and] culture' to the arts at a local scale.[12] A leaflet describes the project as follows:

> Rarely is attention paid to the commonplace and familiar aspects of our local surroundings. They are often overlooked or taken for granted but have great emotional value and meaning for the people who know them well. By recognising and sharing their feelings about their place, it is hoped that communities will find new ways to take an active part in caring for their locality.[13]

In 1986, sculptor Peter Randall-Page was commissioned to make a work for the Weld Estate, near the popular beauty spot of Lulworth Cove in Dorset (Figure 6.1). Daunted by the scale of the rolling

FIGURE 6.1 *Peter Randall-Page*, New Milestones, *Purbeck limestone, near Lulworth, Dorset, 1986 (photograph 2012)*

coastal landscape, he sought to create a work 'which would relate to the intimacy of human scale...[and] refocus the senses before returning to the enormity of the land'.[14] The outcome was a series of three carved shell forms, set in niches in sections of a dry-stone wall (made in collaboration with a local craftsperson), by a public bridleway. The shell forms are based on the fossils of shells found in the local limestone, which was used for the sculptures. They are not labelled and can be read as art or not, noticed or passed by. Setting the forms in niches achieves Randall-Page's intention of reflecting a human scale, and invites walkers to pause and reflect momentarily before moving on into the landscape. I have sometimes seen wildflowers placed in the niches. In 2012, the walls were in good order after 26 years, just a few stones working loose; one of the carvings had been removed following damage, but the others were in fine condition, slightly smoothed by being touched.

In 1988, for European Year of the Environment, Randall-Page carved three larger forms, each more than a metre long, based on endangered species. *Still Life* consists of a chrysalis, a shell and the seed pod of a spindle tree in Kilkenny limestone (an unusually hard limestone, with a white fleck in its blue–grey surface). Photographed on Dartmoor (Figure 6.2), the forms assume a strange grandeur; in reality they are small enough to be easily passed by or trodden underfoot. Its scale lends *Still Life* the appearance of a public monument – and it was commissioned for a development site in Basingstoke, Hampshire – but, to me, the work does not read like the street-level likenesses (usually in bronze) of film stars and literary figures which have become a well-known sight in urban streets. If the conventional function of the monument is to remind a society's members of the values they are required to observe, *Still Life* transposes this mode not only to natural forms but also to a reversal of the fragility of the forms depicted in the use of stone, with its seemingly timeless quality. This echoes the use of monuments to prop up insecure regimes, but this is nature not a social order, and the point is that nature, often taken as a timeless realm outside the vicissitudes of human societies, is now threatened with encroaching extinction. *Still Life* presents fragile and endangered ecologies in a paradoxically permanent material.

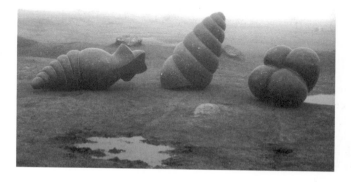

FIGURE 6.2 Peter Randall-Page, Still Life, *Kilkenny limestone, 1988 (photographed on Dartmoor, courtesy of the artist)*

In conversation with curator Clare Lilley in 2006, Randall-Page claims that art, religion and science emanate from a common root in the need to 'find order and meaning' which leads to a tendency to self-rationalization in a coherent image, but they tend also to anthropomorphize nature: 'there is not a topographical feature, an outcrop or mountain that is not...named.'[15] I think this reflects the tension in aesthetics between an observing subject and a realm – Nature – of observation, of which the subject is part but also, in the separation of the observer from the observed, apart. As geographer Doreen Massey has argued, sight is the sense which most distances its objects to offer mastery over them,[16] but stone-carving is a tangible mode, working with not against the material: 'not so much cutting the stone...more like a controlled erosion'.[17] Perhaps this reflects the tension in evolution between evident (retrospectively observed) order and random mutation:

> I have become increasingly interested in setting up working processes that involve combining an ordering principle, or set of formal rules, with a degree of random variation, leaving room for improvisation, invention and play between these polarities. Having studied natural phenomena in general and organic form in particular...I have become aware that the forms that nature produces result from a dynamic tension between a tendency towards self-ordering and an equally strong tendency for random variation; indeed, the process of evolution itself depends on these two principles.[18]

Evolution, indeed, depends on proliferation and mutation, as well as progressive and selective adaptation, and perhaps, just as there are dynamic tensions within such processes, there is a creative tension between the projection of order onto natural forms in human vision and the intrinsic ordering in natural forms which shapes human perceptions. This is, in a way, a reworking of the Cartesian search for certainty: nature is seen as a source of order which, once it is seen, is taken to be a characteristic of human nature and is then projected onto natural forms, as onto a landscape taken to be an ordered scene. This constructed equilibrium is upset by the finding that evolution is devoid of design (Chapter 2). Once perceived, the order of, say, a sunflower seed-head with its spiral patterns is undeniable. Yet this order does not stand for a universe – or a planet in it and its habitat – which is either predictable or permanent.

In 2007, Randall-Page carved *Seed* in grey–white Cornish granite (Figure 6.3) for the Eden project in Cornwall. Approaching three metres in height, *Seed* is located at the centre of the Core, an educational building designed by Jolyon Brewis of Grimshaw Architects. Among the exhibits is a car inscribed with the carbon emissions produced by its use for a family holiday. *Seed* is reached via a narrow corridor and set in a white-walled circular space, which it nearly fills. The space is described as a pod, but to me it seems more like a chapel or the centre of a grotto. In collaboration with the architect, Randall-Page used the Fibonacci series of numbers – 1, 1, 2, 3, 5, 8, 13 ... found in the pattern of a sunflower seed-head – to determine the positions of the round, swelling forms which cover the sculpture's surface. The design of the roof follows the same pattern. In one way, this restates a neoclassical aesthetic: a model of ordering

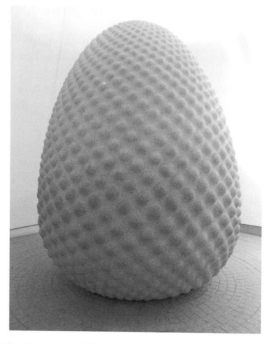

FIGURE 6.3 *Peter Randall-Page,* Seed, *Cornish granite, 2007, The Eden Project, St Austell, Cornwall*

derived from natural observation is abstracted in mathematics and geometry and used as the basis of construction; in another way, however, it plays on the ambivalence with which such ordering is, or is not, reflected in the spectator's consciousness. Order, then, is present in the classification of the natural world, and may be present and absent in differing degrees in the spectator's state of psyche through which all perceptions of that world are mediated.

The contemplative and the uncanny

Modernism also plays on chance and order, especially in certain kinds of abstraction. Artists Matthew Dalziel and Louise Scullion (Dalziel + Scullion) use photography, video and gallery installation to play on a tension implicit in modern art between autonomy – freedom from the appearances of optical perception – and a continued drawing on the perceived world in forms such as photographic representation. While stone-carving can lend natural forms a monumental quality, photographic and video representation seems naturalistic; photography, however, frames its objects to distance them. Writer Oliver Lowenstein notes this tension in references in the work of Dalziel + Scullion to natural forms and non-human creatures, which recalibrate 'the balance of these estrangements from nature with a relationship to the natural world'.[19] Curator Keith Hartley writes that their work is informed by the modernist dream of clean lines and rational analysis, 'and the heroic attempt to turn that dream into reality'.[20] The attempt failed, but the response implicit in these works is not a rejection of rationality; rather, it is more a complex and layered re-presentation through seemingly simple but always mediated visual means of the dynamic of alienation and empathy. Encounters with landscape are inflected, that is, by cumulative experiences and deductions, by cultural frameworks and by unexpected appearances. Writing in *More Than Us*, an account of a conference organized by Dalziel + Scullion in Inverness in 2006, Lowenstein writes,

> The environmental sphere today is split between realities: a division over how the world is to be perceived. It involves both understanding and sensibility, and from it issues the ontological

question as to how we are to be in the world. On one side is the rational, the logical and the scientific... on the other is the romantic, the wondrous, the enchanted.[21]

I agree: there is a perceptual split; Dalziel + Scullion produce work which is more interesting than a call for re-enchantment (Chapter 5), using gallery installations to record contemplative experiences while also interrogating the viewer's relation to the ecologies observed.

For example, *Endlessly* (1996) consists of two video loops, one of the sea in real time and the other of the changing light on a graveyard sculpture from dawn to dusk, speeded up to a 30-minute loop, both back-projected onto parallel screens. I saw this work in Edinburgh some years ago and remember being completely spellbound by it, drawn into the juxtaposition of a cycle of light and a seemingly unending, repetitive pattern of waves. My reading of this work was informed by my reading of oceanic space in modern painting (such as the work of Mark Rothko) as a representation of ambivalent states,[22] but it was also an effort to extend into the captivating spaces of the waves and the sky (while I knew I was in an art museum). This may affirm not only that representations are exactly that – representations, not the real thing – but also, more importantly, that there is no real thing in human perception as an original or authentic nature prior to mediation by language. Origin is a theoretical limit outside human experience. What I see is mediated by my cognition, just as what an artist makes is mediated by art's history and social context.

Working within this constraint appears a continuing concern for Dalziel + Scullion as they present the re-presentation of people, places, artefacts and natural sights such as the shores and endless waves. In *Drift* (2001), an installation of large still photographs standing floor to ceiling, the forces that produce the glacial valleys of Jostedalsbreen, Norway, are shown in sequence from a wooded valley to a moraine field and then the glacier (Figure 6.4). Juxtaposing the natural and its imitation, *Habitat* (2001) is a 15-minute video depicting penguins as they occupy their concrete nests on a false seashore at Bergen zoo. The video is projected onto adjacent walls of a space containing chairs for the visitor to occupy in a no less artificial version of a space of domesticity (heightened by a carpet) (Figure 6.5). This establishes a creative tension between distance

FIGURE 6.4 *Matthew Dalziel and Louise Scullion,* Drift, *installation, 2001 (courtesy of the artists)*

FIGURE 6.5 *Matthew Dalziel and Louise Scullion,* Habitat, *installation, 2001 (courtesy of the artists)*

and immersion, as well as between photographic representation and reality. Hartley suggests that these works (and others) represent nature as 'raw and majestic' but also as a 'domesticated' presence which has been reduced to the manipulable.[23]

A recent project, *Ha'ri'er Tweed*, is a response to the balance of issues in land management in remote areas where shooting estates are a major employer. Producing a tweed bag based on a kind frequently used by gillies at shoots, Dalziel + Scullion narrate the stories of the hen harrier and the red grouse, both found in such sites. The harrier is a predator of grouse chicks but estates need a supply of chicks for their shoots. Hence a conflict arises between conserving the harrier as a protected species and maintaining grouse numbers. The bag's exterior is specially woven in the grey–blue colours of the hen harrier, its interior in those of the red grouse. That may sound neat, a simple equilibrium, but the project focuses on the dialectical tensions of an endangered local economy as well as of a fragile ecology.

Cape farewell

The projects discussed above are localized by site or situation and recall Lippard's call for a sense of place (Chapter 5). In contrast, *Cape Farewell*, coordinated since 2003 by video artist David Buckland, appeals to unidentified publics by media publicity and in high-profile exhibitions (e.g. at the Natural History Museum, London in 2006, and the National Maritime Museum, London in 2011). The project website states:

> Since 2003 Cape Farewell has led eight expeditions to the Arctic, and one to the Peruvian Andes, taking artists, scientists, educators and communicators to experience the effects of climate change firsthand. By physically sailing to the heart of the debate, Cape Farewell aims to draw people's attention to the effects of ocean currents on us and our climate – revealing the workings of this crucial part of the planet through scientific experiments, film, live web broadcasts, events, exhibitions and the insight of artists and educators. From these expeditions has sprung an incredible body of artworks, exhibitions, publications and educational resources. Each journey is a catalyst for all our subsequent activity.[24]

I quote the paragraph in full to avoid misrepresentation. Expeditions take place on the sailing vessel *Noorderlicht*, which would be a low-carbon mode of travel except that it is necessary to fly to Spitsbergen to join the ship. Many artists and writers participated, sailing around the Svalbard archipelago in the ice-free summer season or on static expeditions earlier in the year when the vessel remains moored in the ice.

These 'crews'[25] enjoy interdisciplinary conversations on board and explore the ice, making work either *in situ* or afterwards. In March 2005, artists Antony Gormley, Rachel Whiteread and Heather Ackroyd, dancer Siobhan Davies and writer Ian McEwen (among others) took part in a static expedition, taking daily excursions from the ship's side, from which work was shown at the Natural History Museum. Another outcome was McEwen's novel, *Solar*, which tells the story of Michael Beard's joining the ship on a static expedition. Beard's contribution to science is minor but he has risen to leadership of a government solar energy project. In that role he is invited to a 'well-appointed, toastily heated vessel of richly carpeted oak-panelled corridors...frozen into a semi-remote fjord, a long snowmobile ride north of Longyearbyen', joining a group of 20 artists and scientists who will see a 'dramatically retreating glacier' which calves 'mansion-sized blocks of ice' onto the shore of the fjord.[26] Beard can see global warming for himself (and escape his chaotic private life). He flies to Norway, but his flight to Longyearbyen is delayed and he arrives in the early hours. He consumes all the snacks in the minibar and is woken at eight to be told that everyone else is ready for the skidoo trip to the ship. There is no coffee and no breakfast, but he drinks a pint of almost freezing tap water. He puts on his kit and sets off. Part way through the journey, he has an unfortunate experience (which is the book's main joke, which I will not reveal). On arrival at the ship it transpires that Beard is the only scientist. The convenor, Barry Pickett, 'a benign and wizened fellow' who records natural sounds, reminds the gathering: 'We are a social species...we cannot survive without some basic rules....The first concerns the boot room.'[27] At the evening meal, Beard sits next to an ice sculptor from Majorca, who eloquently questions him on quantum mechanics. This reminds Beard that he has 'done no serious science in years'.[28] He also knows that the design of a quadruple-helix rooftop wind turbine which is his centre's key project (which he did not design himself) is fatally

flawed. Beard goes to see the glacier but does little else in his week on the ship. He also senses that the crew's conversations shift from disappointment (after Rio and Kyoto) to a form of alarmism in response to recent evidence of climate change:

> The Gulf Stream would vanish, Europeans would freeze to death...the Amazon would be a desert...Beard had heard these predictions before and believed none of them. And if he had, he would not have been alarmed. A childless man of a certain age at the end of his fifth marriage could afford a touch of nihilism....the biosphere would soldier on, and in a mere ten million years teem with strange new forms.[29]

Beard has a verbal spat with a novelist who says that Heisenberg's Uncertainty Principle can be applied to ethics, until Pickett moves on the conversation. The boot room gets worse.

All this reads as a negative impression of Buckland's (Pickett's) art–science collaboration on climate change. The scientist regards the artists as messy in their thinking and their habits; he is sceptical on the importance of climate change in a longer timescale; and his work is already a bound-to-fail solution. McEwen presents life on the ship as a holiday in spectacular scenery, where suitably moralizing notions can be entertained over the evening wine. I leave the novel there. It is a novel, not a factual account or a documentary. Yet, as a participant, McEwen has based part of the plot on his own experience, with much elaboration.

I do not doubt the good intentions of all involved in *Cape Farewell*, but I remember seeing Buckland's own work, a video loop of melting and breaking ice with an image of a naked pregnant woman projected, as if supernaturally, walking on the ice beyond the ship. Leaving aside the objectification of the woman as symbol of renewal, I was captivated by the image of the ice as it heaved and fractured to a dramatic sound-track. The difference between this experience and that of *Endlessly* (above), however, was that Buckland does not present a dialectic. He uses one screen, with water continuously running down it, in a proscenium-like architecture of spectacle. I was captivated by the image, watching the loop three times, but by the image alone and not the rising sea levels produced by the ice as it melts, nor the causes of global warming (which include aviation). The pictures were enticing. That was it. I would

not mention this – my experience, of no particular consequence – but it came to mind when I read about the Noorderlicht again in a weekend newspaper's travel section. Anyone can go there for £1840 for five days, or £1250 for one night and a skidoo expedition, plus flights. Other trips to Spitsbergen use luxury cruise liners. Journalist Kevin Rushby writes of his stay on the Noorderlicht in March 2010 that it was 'imbued with adventure, redolent with the traditions of Shackleton and Nansen, something to conjure faded sepia images...of explorers with icy beards'.[30]

Shackleton is best known for his expedition to the South Pole in 1908–1909. He was remarkably unheroic, turning back before reaching the pole in order to save the lives of the men: better to be 'a live donkey than a dead lion'.[31] One of the differences now between the Arctic and the Antarctic is that controls against pollution are stringent in the latter while the Arctic, as historian Gale Christianson writes, is a flat waste of 'snow, sky and horizon...no living thing stirs. Dry as desert sand, the air is bitterly cold and bears no smells.'[32] Indeed, as writer Sarah Wheeler says, the Svalbard archipelago has never had any indigenous population or permanent settlers; it presents biologists with unique field opportunities.[33] But Svalbard is not quite a desert now, as pollutants such as polychlorinated biphenyls (coolants, insulators and hydraulic fluids) have begun to invade the food chain and as airborne pollutants render the region 'a sink for globally migrating airborne mercury, a heavy-metal neurotoxin released by coal-burning power plants and chemical factories'.[34] Rushby notes that the only feature in Longyearbyen is 'the huge dark satanic [coal-fired] power plant'.[35] In this featureless land, he finds that within an hour, 'I am in love with that power station. I adore its 24-hour lights and plume of smoke. I love the steady grumble as it devours fossil fuels to keep me warm.'[36]

Oil

Aviation fuel comes from oil. Oil is brought from oilfields in the Middle East, the Caspian Sea, Nigeria, Venezuela and other sites to refineries and distribution centres in the North by fleets of tankers and pipelines. Both methods are potentially dangerous. A number of tankers have run aground causing massive spills. On 18 March 1967, the Torrey Canyon ran aground on rocks off the southwest of Britain, spilling 32 million gallons of oil to devastate 50 miles of

French and 120 miles of British coastlines, with a 270-square-mile slick. Further damage to marine life was done by the detergents used to disperse the slick. On 24 March 1989, the Exxon Valdez grounded on Bligh Reef in Prince William Sound, Alaska, spilling at least eleven million US gallons of oil and polluting 1300 miles of coastline. A $5 billion judgement against the owners was awarded in 1994 but reduced in US court appeals to $507.5 million in 2008. In the Niger Delta, pipelines are on the land surface. Local people have derived little if any benefit from the country's oil wealth, pollution is widespread, deaths occur regularly from accidents during informal siphoning of oil by local people and armed resistance has emerged. Andrew Rowell and James Marriott write:

> For forty years the communities have complained about their plight. Often their protests have been met with ruthless military forced that has left thousands dead and countless others injured or homeless. Children as young as ten have been raped or tortured. Whole villages and towns have been destroyed. It is difficult to summarise the suffering of the Delta people in words. After one attack on the town of Odi in 1992, Nigerian Senate President Chuba Okadigbo said simply, 'The facts speak for themselves. There is no need for speech because there is nobody to speak with.'[37]

Transnational companies, nation-states and private security forces all ensure the flow of oil to the North and the flow of profits into company accounts. Writer and Ogoni activist Ken Saro-Wiwa described a protest in the early 1990s as 'anti Shell ... anti-Federal government, because as far as we are concerned the two are in league to destroy the Ogoni people'.[38] Saro-Wiwa was hanged in 1995 with eight other Ogonis: Barinem Kiobel, John Kpunien, Baribor Bera, Saturday Dobee, Felix Nwate, Nordu Eawo, Paul Levura and Daniel Gbokoo.

Alliances between medium-developed states and transnational companies dominate the oil industry. A recent example is the construction of the Baku-Tbilisi-Ceyhan (BTC) pipeline from Azerbaijan to the Turkish Mediterranean coast (Figure 6.6), which has produced multiple human rights abuses and environmental damage. In *The Oil Road*, James Marriott and Mika Minio-Paluello of the arts–environment–human rights group called Platform, in London, describe a journey along the 1955-kilometre route of the

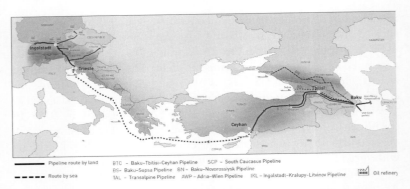

FIGURE 6.6 *Map of the BTC oil pipeline (courtesy of Platform)*

pipeline, meeting local people and activists, in 2009. The book is described as a travelogue, which might imply that Marriott and Minio-Paluello are tourists (although they avoid all flights). But the book is also a catalogue of concerns and demonstrates that the building of the pipeline is more than a construction project:

> BTC was already under construction throughout the twelve years prior to the public campaign [against the project]. Any industrial project of this scale takes decades to realise and is built in phases, many of them overlapping. It is constructed in politics and law, in public finance and private finance, in engineering design and social impact studies. Much of this work runs concurrently with the building of oil platforms at sea, and the laying of the pipelines across the steppe and through the forests. Surrounding all of this is the constant construction of what is known in the industry as the social licence to operate, through actions such as the sponsorship of museums, or the financing of community investment programmes.[39]

On their travels, Marriott and Minio-Paluello meet several oil company public relations and community investment operatives, and some government spokespeople, who re-assure them that the company, BP (styling itself as Beyond Petroleum in the 2000s), has adopted a version of social work and environmental conservation. Nature conservation is particularly useful:

> Spur-thighed tortoises are one of Azerbaijan's endangered species, vulnerable because they hibernate underground in winter and

can be injured during earthworks. A BP survey revealed that the tortoises were to be found on this stretch of the Caspian coast and that care would be needed to ensure their breeding grounds were not disturbed during the construction of the terminal... BP's efforts for the tortoises received considerable publicity. Photos of the creatures sheltering in the gloved hand of a BP community liaison officer were to be seen in numerous internal and external company publications. The eight tortoises found during construction were moved to a special enclosure.[40]

The image of an environmentally caring company mitigates its other image as part of a global system of environmental destruction through the continued use of fossil fuels.[41]

At the same time, some instances of nature conservation involving reserves are repressive mechanisms for the containment of local communities practicing traditional, often mobile, agriculture.[42] This occurs parallel to the impacts of construction projects on local ecologies and economies, while the worst impacts are felt by the poorest groups. Marriott and Minio-Paluello observe from a train crossing eastern Turkey that BTC runs beside the River Firat, which feeds into the Euphrates; the two rivers, of water and oil, 'do not flow peacefully alongside one another' because 'one is slowly choking the other. The mighty Euphrates is drying up.'[43] International relations commentator Peter Newell writes that oil and mining companies tend to operate in areas 'inhabited by indigenous and tribal peoples,' producing a political ecology in which 'social divisions and relations of race, class and gender are brought to bear upon... resource conflict'.[44] BTC passes through remote areas where traditional agricultures depend on a delicate balance of forces and land rights rest on informally held and inherited titles rather than modern legal documentation. *The Oil Road* describes the affliction of such communities when their land is in the pipeline's way.

Legally, oil companies must research the environmental impact of construction schemes and observe the rights of individuals and groups. But findings can be adapted, as Marriott and Minio-Paluello find on a visit to Hacalli, Azerbaijan, in April, 2009, where they meet a family whose house is over the pipeline but, for BP, occupies a different place on their map. Topsoil was removed from a 40-metre wide section of land. As machines arrived to weld the pipes and bury them,

These smallholders who live mostly off their farms were unable to use their fields. Once the project was complete and the topsoil reinstated, the land was returned to the farmers. Every landowner was supposed to receive compensation for not being able to grow their crops for several years, equivalent to their lost income; but fourteen families in the village did not receive any compensation at all. It seems that BP made some payments, but to the wrong people.[45]

Human rights campaigner Mayis Gulaliyev, who accompanied Marriott and Minio-Paluello on this leg of their journey, explains that BP mapped the land incorrectly, siting farms off the route to save $4000 in compensation per family. The families complained to the authorities but their cases were dismissed. They persist, and are now assisted by the UK organisation The Corner House; they have also met a UK civil servant to discuss a possible complaint to the Organisation for Economic Cooperation and Development. But as the family tell Marriott and Minio-Paluello this, the authorities arrive and insist on seeing everyone's documents. There is a stand-off while BTC security is consulted. The police leave when it transpires that no one is going to back down. For Marriott and Minio-Paluello, the event exposes the security imposed by an industrial infrastructure with whose operations government agencies are complicit and 'the restrictions placed on local villagers in standing up for their rights'.[46] They note, too, that Gulaliyev's monitoring reports, commissioned by the Open Society Institute, were internally suppressed.[47]

Reading *The Oil Road*, I have the impression that BP maintains its public image by putting pressure on any source of nonconformity; and it does this via governments and NGOs which are suitably distanced from its own operations. Marriott and Minio-Paluello suggest that as issues emerge organizations or factions are set against each other, to reproduce the colonial strategy of indirect rule elaborated in 1922 by Lord Lugard, governor general of Nigeria, to explain the Royal Niger Company's ability to control the palm oil trade via a small number of white officers and a network of local strongmen.[48] BP's in-house publication *Horizon* exhibits 'a sense of corporate optimism that strangely echoes the strident positivism of Soviet literature', while features on the pipeline show an engineering world where progress is always good, every

problem can be solved and advance comes through technology.⁴⁹ As Marriott and Minio-Paluello remark,

> The sheer scale of the carbon the company [BP] delivers to the atmosphere needs to be understood. In 2006 the UK's annual domestic emissions constituted 2.5 per cent of those of the entire world. In the same year BP's total emissions represented 5.6 per cent of the global total... over twice the combined amount of carbon dioxide produced by 62 million British citizens. These raw statistics indicate that, if the company were to truly go 'Beyond Petroleum', it would... retire those assets that deliver carbon to the atmosphere, such as its tanker fleet, the BTC pipeline and the Azeri-Chriag-Gunashli oilfield.⁵⁰

Meanwhile, Platform continues to campaign against the global human rights abuses of the oil industry, as well as its contribution to global warming, through events, guided walks through London's financial district, small group discussions, publications and their extensive website. One of their aims is to alert potential investors to the risks of oil exploration.

Initially, Platform set up meetings reproducing the format of an oil company's annual meeting, rehearsing data and raising financial questions. Now they organize meetings and seminars for financial advisors and institutional investors in their own name, 'showing that there is another perspective on their oil and gas projects than the ones the corporations give', and are 'asked to present our analysis at events set up by the institutional investors themselves'.⁵¹

Another aim is to make it socially unacceptable to work for an oil company. Platform is relaxed about how it is described – as an arts group or a human rights organization⁵² – which echoes (but benignly) the crossing of other boundaries: those of nation-states by companies; those of inherited land rights by the authorities; and those of politics, economics, social formation and culture in environmentalism.

Climate refugees

As yet, cities such as London, Frankfurt and New York have felt limited effects of climate change. Financial empires are shielded against fluctuations as rises and falls in speculative markets are

equally profitable. The price of oil rises and falls like the price of food, but the negative impacts are mainly confined to poor countries or marginal populations. The rise of sea levels and increasing violence of weather also tend to afflict the poor more than the rich.

Arriving in Shishmaref, Alaska, photographers Guy-Pierre Chomette and Hélène David find 'all eyes, full of impatience, are turned to the sea.... It's now early November – and still no pack ice. Fierce gusts of wind threaten to pummel the village at any moment.'[53] The village's semaphore station has fallen into the sea as the coast erodes. Storms arrive suddenly now. A six-metre wide strip of coastline has disappeared (on an island 5 kilometres by 400 metres). Chomette continues:

> Alaska is getting warmer at an ever quickening rate... The Shishmaref Inupiat say they can now hunt seal by boat in early December.[54] The permafrost is losing its hardness; hence the waves take it more easily. The six hundred inhabitants of Shishmaref are considering moving to nearby towns such as Nome, or to the mainland where (it is proposed) the village could be recreated on an as yet uninhabited site at Tin Creek, costing $200 million which they do not have. This is related in *Climate Refugees*, from the French photographers' collective Argos. Other stories describe flooding and soil salinity in Bangladesh, a shrinking Lake Chad, rising seas in Tuvalu in the Pacific, and the erosion of glaciers in Nepal.[55]

In another narrative, Chomette describes the encroachment of a rising ocean on the Maldives (with photographs by Guillaume Collange). In the capital, Malé, sand has been replaced by a blanket of concrete under 'a forest of high-rises' contradicting the tourist postcard image of a deserted beach with palm trees.[56] The main difficulties, apart from tourism, are flooding and coastal erosion. The archipelago's coral reefs are eroding, while development destabilizes the island's relation to these reefs. Natural erosion was accompanied by accretions elsewhere, but erosion is now gaining ground and the ocean's warming threatens the coral's future. A rise of three degrees for six weeks in 1998 caused an unprecedented bleaching of coral, which could take two or three decades to recover naturally. A growth in tourism has produced new tourist-only settlements constructed by transnational companies – locals

are banned; tourists need a permit to visit inhabited islands – which further destabilizes the islands' ecologies. The coral, meanwhile, is the main tourist attraction:

> Tourists are having breakfasts in the panoramic restaurant hanging over a huge lagoon with dependably emerald waters. The place has a palpable ambiance of luxury and relaxation. About three quarters of these tourists have come to the Maldives to dive on the coral reef, equipped with scuba tanks of compressed air or just a mask and snorkel. Any Maldivian will tell you that... this seafloor is still one of the most beautiful in the world. We quickly realise that this is a delicate topic. The authorities hate reading in the foreign press that scuba diving... is not what it once was, and only a foolhardy Maldivian would imply as much to visiting journalists.[57]

Tourism is as insistent on conformity as oil. But the photographers wonder what will happen 30 or 40 years ahead if the beaches are washed away. At the same time, the government has initiated a Population Resettlement and Development Plan covering eighty or so islands, in part as a response to widespread damage by the tsunami of December, 2004. Some groups are resistant to leaving the islands on which their families have lived for generations, but they have seen strange things: a change in wind direction, which began in 1995, for instance; their traditional calendar of weather patterns, dividing the year into 26 mini-seasons, seems defunct.[58]

The concept of the climate refugee questions the definition of refugee status adopted by the United Nations in 1951, based on persecution and statelessness. *Climate Refugees* raises this in context of the plight of communities who become landless through climate change. It has been compared to Al Gore's film *An Inconvenient Truth*,[59] but this may not be accurate because there is a quality of witness in first-person narratives in *Climate Refugees* as in *The Oil Road*. Although *Climate Refugees* has been criticized for being 'pseudo-ethnographic'[60] rather than presenting theoretical positions, I might retort that the aesthetic quality of its images gains a public for the issues of human rights and environmental degradation, which the book presents. Perhaps what is missing (evident in *The Oil Road*) is an overt call for justice. In that way, like *Cape Farewell*, it may be that *Climate Refugees* de-politicizes

its content. A more engaged and long-term approach is evident in the Arctic Perspectives Initiative's work (Chapter 5).

Business-as-usual

Given the growth in media coverage of climate change, a degree of scepticism has emerged. McEwen trades on this. So does Michael Palin in his novel, *The Truth*, which tells the story of an environmentalist working in India, tracked down by a sympathetic journalist on the trail of environmental destruction, who is ultimately revealed to be in the pay of a transnational company.[61] Of course, it is only a novel, as is *Solar*; but novels, like art exhibitions and films, feed into wider cultures and the shared attitudes of a society at a specific historical juncture. I have no solution to offer but would suggest that cynicism is a kind of helplessness. Looking for alternatives, I am drawn towards two polarities. Newell (cited above) writes of the 'conflictive and collaborative' work of activists as companies 'promote acts of corporate responsibility'.[62] At the same time, most of the work I discuss is included because I think it has aesthetic quality. Hartley (cited above) writes of Dalziel and Scullion's work that it invites the viewer to 'pause and consider' her or his relation to the natural order, and to experience 'a still intact universe beyond' by which to be lifted out of the 'contingent reality' of the present.[63] Certainly, the present is contingent; and it cannot be evaded. Organizations such as Oil Watch and Corporate Watch, and books like *The Oil Road*, ensure that some of the contradictions of transnational commerce are exposed. But Newell sees such efforts as inadequate in the absence of appropriate action by states,[64] arguing that states have a nominal capacity to protect rights and to ensure access to information, but are unwilling or unable to be proactive so that corporate irresponsibility 'continues to be the norm... because of the lack of incentives and inducements to behave differently'.[65]

In the Niger Delta, Basil Nnamdi, Obari Gomba and Frank Ugiomoh record that a transnational oil company has 'got away with environmental assault on the region'.[66] They also note the commemoration of Saro-Wiwa's execution by poets and artists who have 'stood in the trench' while oil companies promote themselves aesthetically.[67] Is aesthetics greenwash? In corporate publicity it

is, but I would differentiate that use of seductive images from a critical aesthetics which exposes contradictions *and* offers access to moments of wonder and glimpses of another world. But that world is *this* world transformed either in an imagined alternative scenario or practically, if as yet marginally, within the present ordering of society. Activism and aesthetics, then, are connected, not as mutually excluding opposites, but instead as the polarities of a common axis of potentially creative tension.

7

Interruptions

For the exhibition *Natural Reality*, in Aachen, Germany, in 1999 (Chapter 1), Eve Andrée Laramée and her assistant Duane Griffin produced three trucks bearing landscapes (Figure 7.1). The largest contained small trees, shrubs and a grass bank on a truck painted green and inscribed:

> Reality must take precedence over public relations
> for Nature cannot be fooled.

FIGURE 7.1 *Eve Andrée Laramée and Duane Griffin,* Parks on Trucks, *mixed media, Aachen, 1999*

The work plays on ambiguities of nature, culture, reality and representation in the urban park. Parks, that is, are 'cultivated, controlled and aestheticized' while the notion of an 'untouched nature' becomes unreal in contrast.[1] The trucks were parked at points around the city as static exhibits to avoid the obvious irony of carrying green messages on vehicles burning the fossil fuel which is a key contributor to global warming. The text is in English, possibly in order to address a global public, but is also a quote from North American physicist Richard Feynman, who argues that commerce masks the real unsustainability of what it calls green consumerism through greenwash. The message of the truck is that, regardless of any subterfuges, the nature which society values enough to distribute in parks and gardens, and which is threatened by an absence of green ways of dwelling, has another side in the rise of global temperatures as the natural reaction to rising carbon emissions.

Writing on this work, curator Heike Strelow cites other works which play on culture–nature ambiguities including Robert Smithson's plan for a floating island to be towed around Manhattan (1970), Nils Udo's proposal for forests on rails (1986) and Mark Dion's *Tropical Rainforest Preserves* (1990). She remarks that Laramée blurs 'contradictions between nature and culture' to redetermine their boundaries.[2] The smallest of the three trucks was painted white and carried the inscription

$$CO_2 + 2H_2O + Light > -CHOH- + H_2O + 2O_2$$

in reference to the natural process of photosynthesis, by which carbon is absorbed by plants. It was planted with corn, 'one of the oldest cultigens' which denotes a cultural evolution 'from prehistoric time until the present day'.[3] Culture – defined as cultivation[4] – relies on nature *and* human technology. The third truck carried a medicinal garden, inscribed

Gift of Nature

There is ambiguity here, too, as Laramée uses the word *Gift* for both its English and German meanings. The former is benign, but the latter means poison or venom, and all the plants used in this garden are poisonous, to be used only medicinally. This references the herb garden established in Aachen in the ninth century by Emperor

Charlemagne, although not quite accurately since Charlemagne issued an edict which listed all the plants to be grown on his estates, first the rose and the lily and then a variety of herbs and vegetables including those used medicinally.

I begin the chapter with this example because it demonstrates one way in which art brings ecological issues to a wider public than that reached by scientific data. The messages on the trucks are warnings, and I am cautious about eco-apocalypses, in Chapter 4 citing geographer Cindy Katz on the 'politics of self-sacrifice and self-denial' and the focus on the individual acts of consumers.[5] But the trucks seem to present an attractive, noncontentious message – a gift – while connecting it to contentions over the categorization of nature within the dominant culture. I read this as a polemical intervention, aiming more to provoke argument than to advocate solutions. This is one example of what I mean by an *interruption* (a term I use because intervention appears to be overused, describing almost any artwork which uses space outside a gallery or museum, and some within those sites, regardless of political or social content). Of course, that criticism implies a lack of identification, too, of the conditions or situations in which an intervention is made, so I need to identify the ground in which the interruptions discussed below are made. Broadly, their terrain is the corporate and cultural appropriation of the land, natural resources and habitats by capital in a period of de-regulation and of a disregard of the state's role in safeguarding the commonwealth and common well-being. But, as the next case shows, this is a layered terrain in which different interests claim and counterclaim public benefit.

Banned!

On 4 October 2007, a project by artist Alex Murdin was banned by the National Trust because they saw it as antitourist.[6] The project, *Inclusive Path*, consists of three boards, each showing life-size photographic images: one is of a standing male, the second a disabled male and the third of two children. All are wearing outdoor clothing, set against a rocky backdrop typical of the scenery of the area. Holes were cut to enable people to pose for photographs by inserting their own faces, as they can in similar cut-outs at seaside resorts (Figure 7.2), and 249 people participated by posing behind

FIGURE 7.2 *Alex Murdin,* Inclusive Path, *outdoor photographic installation, 2007 (courtesy of the artist)*

the boards. The intention was to site them on the village green at Grasmere in the English Lake District, but it transpired that the site was not a public space but owned by the National Trust. Murdin always intended to show the work first in Keswick, but the National Trust's refusal to allow a project which it saw as threatening its economic (rather than conservation) remit was used to generate media interest as part of the work. The image of a news page was added to the portfolio of the work on its website.

Murdin describes the project as challenging the ecological gaze. Critical of the notion (which he says is found in deep ecology) of an original state of nature to which one day it may be possible to return, as of the notion of a world without humans which such a concept implies, he cites Slavoj Žižek that the planet is now so modified by human intervention that its cessation – if nature could merely be left alone – would be cataclysmic. He quotes Žižek on the idea that television nature programmes reinforce the picture of a world without humans:

> The fantastic narrative always involves the *impossible gaze* by means of which the subject is already present at the scene of its

own absence. When the subject directly identifies its own gaze with the *object a* [a Lacanian term for what is desired in the Other, or in the love object], the paradoxical implication of this identification is that the *object a* disappears from the field of vision. This brings us to the core of a Lacanian notion of utopia: a vision of desire functioning without an *object a* and its twists and loops. It is utopian not only to think that one can reach full, unencumbered incestuous enjoyment; for it is no less utopian to think that one can renounce enjoyment without the renunciation generating its own surplus – enjoyment.[7]

I will leave aside Žižek's drawing on Lacan, and the surpluses of his writing, but it is enough here to say that pictures of natural scenes in which the human photographer seems not to be there – as if the camera is an immaterial conduit of vision – conjure a world as if prehuman or primordial, and this *ur*-nature is possibly part of the attraction of rugged landscapes which show no obvious traces of human manipulation. Yet the Lake District is the object of human manipulation in geographical, legal and cultural terms. The gaze which attempts to erase the observer from the act of observation is impossible not only philosophically but in practical terms, too, because the contingencies which determine that the act of observation takes place include access to the site as well as the cultural and historical legacies imported by observers.

Murdin sees a representation of the supposed absence of human presence in nature in herman de vries's *Sancturarium* projects (1993–2003), where a circular brick wall or wrought iron railing separates a small enclosure of parkland to be left to natural growth, while the land outside it is managed in the usual way. Through a viewing aperture, the enclosed space seems like a keyhole view of unmanaged nature. Yet Murdin visited the *Sanctaurium* in Munster, Germany, in 2007 to find the wall covered in graffiti, and the enclosure containing a thicket of brambles into which litter had been thrown. I mention de vries in Chapter 1, but this would be more like the abandoned landscape described by Richard Jeffries in *After London* (Chapter 4) were it not for the litter. Murdin writes that local people may find this case of wild nature less attractive than the luxuriant landscape images they see in the media. That may or may not be so, but I find the case interesting (although I have not seen it) in its contrast of a notion of wild nature as a state of primal innocence to an encounter with ordinary life in a society

in which all nature is managed according to prevailing concepts of landscape, and in some cases taken paradoxically as a sign both of civilization and of a supposed eternity in which humans have no presence.

The conservation of areas such as the Lake District brings this to a head when the presence of tourists and ramblers damages the scenery which they have come to see in what they hope will be a pristine condition. But, again, matters are not simple. Walking in national parks and areas of land owned by bodies such as the National Trust was not always possible as landowners protected such sites against intruders (other than their own shooting parties). Murdin's proposed *One Mile Wild* (2009) draws on the historical example of mass trespass at Kinder Scout, Derbyshire, in 1932 when the British Workers' Sports Federation organized a walk over privately owned moorland. Through public campaigns and legal changes, access to such places is now open, producing an emerging rambling culture. Today, with public access, the moors are suffering erosion. Murdin reads the impossible gaze here, too, as restoration of the site requires exclusionary zones, to create a 'permanent state of managed naturalness'.[8] In response, he proposed a one-square-mile zone of exclusion, and a legal framework by which to manage its unmanaged status as an 'act of subtraction'.[9] The proposal was refused. Perhaps proposals which the artist knows are unlikely to be accepted by commissioning and funding bodies in an art-and-environment world contingent on public investment and corporate sponsorship still have a polemical value, even if their publication or exhibition reaches a mainly radical-art public (which is still a constituency, both linked to and overlapping with others).

A polemic of limits?

Matthew Cornford and David Cross (Cornford & Cross) have to date proposed 11 projects for public and gallery sites which stretch the brief or the commissioning body's ideas for the scheme to a point at which they are rejected. Other proposals have been realized – and are cited below – but rejected proposals have been exhibited, not as failures, but as elements in a dialectic of art's relation to the politics and economics which govern what cultural work is permitted to be presented to an audience and what is not. In one

way, this is an aspect of a contemporary cultural condition in which non-gallery projects, installations and work which does not include any conventional art medium (like painting) are commonplace. In another way, the exhibition of refused ideas follows from artists' efforts in the 1890s to take over the responsibility for their futures by rejecting exhibition juries and withdrawing from established organizations, and more recently by artists' use of redundant industrial buildings to provide studios, not as attics in which to be romantically misunderstood, but as sites of creative interaction, community and, in open studio events, direct public access without the mediation of the dealer or museum curator.

Since the 1990s, curating has also moved towards this kind of autonomy, as artists curate group shows and engage in projects drawing on anthropological and ethnographic material from local publics. This autonomy is no less contingent on social and economic conditions than any other kind, but the independent turn in curating, so to speak, indicates an aspiration to a direct engagement with people and places, perhaps aligned to the idea of direct democracy or to a sense that too much mediation renders visual culture dull and institutional. At the same time, the material of institutional and bureaucratic processes has become another subject matter for art.[10] For example, Andrea Fraser's installation, *Information Room* (1998, Bern, Kunsthalle), consisted of the removal of the museum's archives, in cardboard box files, from the store to a base of wooden pallets in the gallery space. Visitors started to go through the boxes, fishing out bits and pieces to cause havoc in a previously ordered system while exercising their right to public information. Fraser comments, 'After a few weeks it really became a very big mess. It was great.'[11] The papers were then placed in files on shelves, but with their spines to the wall, so that although access was allowed it was without the guide of an index. Literary historian Sven Spieker comments, 'There is always a blind spot in our interaction with archives, and it is precisely this blind spot to which the archive in play devotes itself.'[12]

In 2004, Cornford & Cross contributed to the Pancevo Biennal in Serbia and Montenegro. Playing here, too, on notions of access and transparency, they re-arranged documents to completely block a doorway in *How Buildings Learn* (2001/2004). They write,

> The archive material spanned a hundred years and more – wax-sealed and worm-eaten ledgers; legal texts in German;

long-forgotten fiscal and financial transactions; medical records of injuries and illnesses; Communist Party membership cards in faded files detailing the minutiae of people's lives. Yet what was missing... was any record of the decade-long ethnic war in former Yugoslavia.[13]

Cornford & Cross see the work as playing on an axis between the futility of all effort and the careful and difficult process of relating history to memory. *Open Day* (1991) shows a rusting steel girder obstructing the exit from the recently completed M20 motorway in Kent (Figure 7.3). This work exists as an image, not a record of an activist blocking of the road (as carried out by groups such as Reclaim the Streets in the 1990s).[14] It is a glimpse of a utopian moment, a world without cars, and nonetheless an inviting prospect, if not to motorists. It is contingent on a suspension of disbelief – placing archives in public space similarly suspends disbelief in institutional controls over access to information – and is thereby an equivalent to a theatrical gesture. Similarly, *New Holland* (1997) suspends the practicalities of architecture by siting a light industrial shed outside Norman Foster's Sainsbury Centre for Visual Arts at the University of East Anglia.

FIGURE 7.3 *Cornford & Cross*, Open Day, *steel girder on newly completed motorway, 1991 (courtesy of the artists)*

The polemic is based on introducing complexity to the comfortable relationship between Foster's architecture and the nearby bronze by Henry Moore. Cornford & Cross write,

> *New Holland* exploited tensions between the English Romantic representations of landscape exemplified by Moore's sculpture, the space age 'functionalism' of Foster's architecture, and the realities of modern agriculture in Norfolk's intensive turkey farms. The structure was entirely appropriate yet uncomfortably out of place in its physical setting and institutional context. We positioned the work to question the Sainsbury Centre, yet the piece was not created in terms of a simple opposition: instead, *New Holland* occupied a space of controlled rebellion.[15]

The shed spanned the space between, but divided, the Sainsbury Centre's glass façade and Moore's sculpture of a reclining figure – signifying technocratic patriarchy and figure-into-landscape as a universal feminine – while insisting on the reality of mass-produced food in the site of a tradition of pastoral imagery. *Polemic* is a widely used critical tool in the arts, the word's root derived from the Greek word for war (*polemos*); *New Holland* uses it to address the issues of mass food production, a nature packaged by culture and architecture as a statement of values taken to denote civilization in a society which exhibits elements which, when exposed, do not fit the mask. Thumping out from inside the shed, House and Garage music, of a kind associated with illegal raves, is intentionally aggressive.

Some other works by Cornford & Cross exhibit a gentler tone but are no less provocative, in some cases suggesting utopian rather than dystopian worlds. *Coming Up for Air* (2001) was a proposal for a temporary public art project for the Chasewater Park reservoir in Staffordshire (Figure 7.4). Again, the relation of landscape to the activities which take place in it is questioned, in this case by a proposal to site a large, industrial chimney, possibly made in concrete and with no detailing, in the lake: 'The scale of the chimney would have been informed by current public health decision-making processes, taking account of the type and quantity of emissions, the physical geography of the location, and the distribution and density of settlements in the fallout area.'[16] An illustration of the proposal shows the chimney emitting smoke.

FIGURE 7.4 Cornford & Cross, Coming Up for Air, *proposal, 2001 (courtesy of the artists)*

Chasewater is in the Black Country, previously a highly industrialized area with potteries and metal-working trades, coal mining and canals. Cannock Chase was denuded of trees to meet the needs of furnaces in the eighteenth century, and the valley was dammed in 1797 to form a reservoir. The artists write that 'coal-mining transformed the landscape and began industrial society's dependence on fossil fuel, which continues to drive consumerist ideology today'.[17] The eighteenth century was the period when the Agricultural Revolution gave rise to the Industrial Revolution. Land enclosures increased; hiring fairs were introduced and work on the land was made impermanent as machines replaced people, fuelling an exodus to the towns as farm workers and their families were turned out and took to the roads, but there were also genuine improvements in drainage, crop rotation and animal husbandry. It was also the period of the picturesque in art and of the architectural folly in the landscaped garden of a grand house. Today, with de-industrialization, a factory chimney symbolizes a time which once provided work but is encapsulated in history. To erect a new chimney in a de-industrialized area is like building a folly except that, here, in the water, it might have suggested a dialectic of submergence and re-emergence. Or it might be a sign of the submergence and

re-emergence of solidarity among industrial workers, although that might be stretching the proposal too far when it already stretches the brief for a public art project beyond conventions.

The work's tile, *Coming Up for Air*, derives from that of a novel by George Orwell[18] narrating the efforts of a middle-aged insurance salesman from an outer-London suburb to find the place of his childhood in what was once a village but has since been built up. Going there, he recognizes very little, and no one remembers him. He returns home to find his marriage has dissolved. It is a sad but funny book, and its point is that the idyll does not exist. Cornford reads it as 'a bleak and pessimistic novel' published on the eve of war, and notes the protagonist's attempt to find a pond where he once fished (which has become a rubbish tip) as an early reference to environmental degradation; Cross writes that he felt a 'shock of recognition' in Orwell's descriptions of commuting, the labour-saving gadgets which fill the suburban house (on which the mortgage payments must be kept up) and the quest for escape as the motor car seemed then to give freedom from the dulling routines of ordinary lives.[19]

Orwell is referenced again in *The Lion and the Unicorn* (2008) (Figure 7.5), in which Cornford & Cross placed 14,000 kg of British coal onto the floor of the Wolverhampton Art Gallery, and switched off the lights. They write,

> It is generally accepted that the Industrial Revolution originated in the West Midlands. This revolution was at first powered by renewable energy. But it was coal that provided the phenomenal power that allowed people to overcome many physical limitations of the body and the environment. The result has been the most radical transformation of our economy, society and culture since history began.
>
> The physical form of this installation...was an expression of limitations: the maximum safe load on the gallery floor is 14000Kg, and the minimum legal width for a safety access way is 1500mm....the work pointed to a limitation so large that it seems beyond our frame of vision: the limit to industrial growth. This is determined by the earth's ecological carrying capacity, the ability of all living systems to absorb the waste products of human activity. The earth's climate system is being destroyed by burning fossil fuels, including the coal used to generate the electricity that powers the gallery lights.[20]

FIGURE 7.5 *Cornford & Cross*, The Lion and the Unicorn, *installation, 2008 (courtesy of the artists)*

Orwell's essay 'The Lion and the Unicorn: Socialism and the English Genius'[21] begins by describing what he regards as an English tendency to improvisation, the decay of the ruling class and the expansion of the middle class, and then argues for socialism on the grounds not only of ethics but because 'private capitalism...*does not work*'.[22] This requires a radical shift of power; nationalization of land, mines, transport and banks (an interesting idea today); and a limit on personal income so that the highest is no more than ten times the lowest. For Cross, the significance of Orwell's essay is that it emphasizes the solidarity of interests and individuals outside institutional structures; he also regards switching off the gallery lights as 'a way of drawing attention to the ideological nature of electric light as the prime element of contemporary visual culture'.[23] The presence of coal in an unlighted gallery suggests a stark and forlorn reality, on the eve now not of war but of the dismantling of the postwar welfare state, as mining in the Black Country around Wolverhampton, as elsewhere across Britain, is almost finished after the industry's destruction for political reasons since the 1980s. It is also a statement of form and material, but, as Cornford says, 'our projects...may make reference to environmental, historical,

political and social concerns...[but] do not set out to be precise in their meaning. To do so would militate against their ambitions as art.'[24] This restates art's autonomy but in terms of engagement with the tensions between different readings of a space or a situation, and of continuous critical reflection on the work's limits and contingencies.

A green cloud

In February 2008, Helen Evans and Heike Hanson – the artists' group HeHe in Paris – produced *Nuage Vert*, a temporary project in which a laser beam projected a green outline of a cloud onto the real emissions cloud of the Salmisaari combined heat and power plant in the district of Ruoholahti, Helsinki. On the final night, the 29th of February, residents were invited through a leaflet campaign, talks in schools, posters in community sites and press coverage to unplug some of their electrical appliances for an hour. In collaboration with the power company, fluctuations in electricity use were measured and translated into changes in the size of the laser projection (Figure 7.6). The green cloud increased in size as emissions fell, reflecting the extent of public participation in a reduction of the district's carbon footprint (800 KVA, equivalent to the energy produced by a windmill). Although the event was temporary, it may be hoped that seeing the extent of collective action for an hour could produce a lingering memory and an awareness of the material possibility to reduce emissions. This contrasts with the immateriality in which climate change is presented through scientific data and with the use of apocalyptic imagery. Evans writes,

> In the past decade new buzz words have entered into media discourse and everyday language: ecological visualisation, carbon offsets, eco footprints, food miles, etc. These abstractions signify our attempts to quantify individual responsibilities and to find ways of facing up to the very real challenges of climate change and the exploitation of finite natural resources. *Nuage Vert* is based on the idea that public forms can embody an ecological project, materialising environmental issues so that they become a subject within our collective daily lives....A city-scale light installation projected onto the ultimate icon of industrial production alerts the public, generates discussion and can persuade people to

FIGURE 7.6 *HeHe*, Nuage Vert, *laser projection, Helsinki, 2008 (courtesy of the artists)*

change patterns of consumption. *Nuage Vert* is ambiguous, as it does not offer a simple moralistic message but tries to confront the city dweller with an evocative spectacle, which is open to interpretation... Turning a factory emission cloud green inevitably leads to questions being asked. It shifts the discourse about climate change and carbon emissions from abstract immaterial models... to the tangible reality of urban life.[25]

Ambiguity appears crucial here and that is why I think *Nuage Vert* is interesting. The terms used in its title – *green* and *cloud* – are both open to multiple readings, while the size of the cloud projected

onto the chimney's emissions increases as electricity consumption decreases. There is an element of the uncanny, too, in the sight of a green cloud.

Green was the hue which Johann Wolfgang von Goethe recommended for domestic interiors as the most welcoming; it has connotations of growth and Springtime, is the colour of grass and has been adopted by environmental movements such as Greenpeace and the Green Party. But, as said in Chapter 2, green is also the colour of unearthly presence in séances and the colour of rot. Decay, too, has a spectrum of material form and association, from the pleasant associations of moss (which grows on rotten wood) and lichen (denoting clean air) to the colour of slime. Meat which has taken a green tinge is not fit for human consumption, and the phosphorescent green of the sea, with white sparks, figures in Samuel Taylor Coleridge's narrative poem *The Ancient Mariner* as a sign of mortality. Literary historian Richard Cronin explains that Coleridge had read Joseph Priestley's *Optics*, which includes a chapter titled 'The Putrescence of the Sea', in which he links the green colour to the 'rotting of myriads of microscopic sea organisms'.[26] The phosphorescence is a ghostly parody of the purity of white light and an emblem of the rotting which awaits all flesh (lent moral force by the mariner's tale). Cronin elaborates, from the colour theory of the period, that 'the painter's cool colours, from green to purple, are associated with the blackness of Death'.[27] In the dark (blue–black) night sky over Helsinki, the green cloud is out of place. It is neither smoke nor a cloud, but is projected onto a cloud denoting a global process of dereliction.

Clouds, too, have positive and negative associations. In landscape art, they are a necessary complement to the solidity of rocks and the seeming fixity of human figures. In Romantic painting they assume a more turbulent role, and for J. M. W. Turner they stream and swirl in a world of vortices and maelstroms, in which humans are as ephemeral as the waves. William Wordsworth wandered lonely as a cloud – although this is odd because, as inanimate entities, clouds are not lonely, and are usually seen more than one at a time – but thereby imbues the cloud with a human emotion, perhaps the taste for solitude. But clouds have a negative side as they obscure the light of reason. J. F. K. Henrion's 1962 poster for the Campaign for Nuclear Disarmament montages a skull onto the mushroom cloud

of an atomic explosion. In the age of media buzz and abstraction to which Evans refers, at least one website today markets posters of an airbrushed nuclear explosion, describing it as 'great for adding some decoration to any space at school or in your home'.[28] Yet the green cloud over Helsinki has a positive side, however uncanny it is, inasmuch as its expansion mirrors that of a green consciousness.

Nuage Vert has continued since Helsinki in two ways. First, HeHe collected a large number of posters depicting factory chimneys and exhibited them first at Mains d'Oeuvres in the working-class district of Saint-Ouen, Paris, in 2009, and then at Galerie Ars Longa, Paris, in 2011. In the posters, emissions from the chimneys become fists, flags, trees or background for a message. Many state solidarity and a history of workers' attempts to gain and regain their rights. One dates from 1968 (produced by Atelier Populaire), another from 2009 and from the protests at the Copenhagen climate conference; in another, German Chancellor Angela Merkel is depicted by Klaus Staeck with glowing eyes emerging from the clouds of a cooling tower at an atomic power station. Second, efforts continue to re-enact the project in Paris. In 2010, a one-night event brought the green cloud to the waste incineration site at Ivry-sur-Seine. In Saint-Ouen, however, the bureaucratic complexities have blocked HeHe's attempts to project the cloud over a chimney owned by the waste authority there. Although *Nuage Vert* was at first validated by the civil aviation authority, and the energy company was prepared to collaborate in it as an art project, the Prefecture prohibited it at the request of the local authority which claimed, 'there is no indication or guarantee that the proposed green smoke will be perceived clearly and positively by the population.'[29] The project's correspondence trail is now part of the project itself.

Deep waters

In *Is There a Horizon in the Deep Water?* commissioned by Invisible Dust[30] for the Cambridge Science Festival in 2011, HeHe staged a model-scale performance of the Deepwater Horizon rig explosion and oil spill in the Gulf of Mexico in 2010. At the time, they were artists-in-residence at the University of East Anglia, and working with atmospheric chemist professor Peter Brimblecombe. At Jesus Green Lido in Cambridge, on the 17th of March, a toy

oil-drilling platform appeared to explode. Sirens wailed, a message to abandon ship was played repeatedly and clouds of smoke filled the air as a live video of the scene was projected behind the toy in the water (Figure 7.7). On screen, without the evidence of size and containment, the scene took on a greater semblance of reality.

The Guardian carried a review a few days later by journalist Jessica Lack, under the headline 'Can Art Help Us Understand Environmental Disaster?'[31] Lack took a sympathetic view of the work, commenting that the model rig – which had been quite difficult to source – would be the envy of any Lego enthusiast and that, although the performance was not a Hollywood disaster epic but more comic, it evoked a certain horror in the clouds of smoke, dying green lights, siren and repeated call to abandon ship. I was not there but, from a video of it, can imagine it did. The article drew fourteen comments, nearly all hostile. Among them was a suggestion to learn something about science and a denial that art can (with reference to the article's title) shed light on environmental catastrophe coupled with an assertion that it tells a lot about the self-importance of artists and the credulity of journalists who write about them. I should make clear that these were comments on the article, not the work as such, and I have little interest in

FIGURE 7.7 *HeHe*, Is There a Horizon in the Deep Water? *model oil platform, performance, Cambridge, 2011 (courtesy of the artists)*

the blogosphere (a preserve of the time-rich and opinionated). But I do not dismiss the comments because two points were raised which warrant attention. The first was that the Deepwater Horizon explosion killed 11 people. One person listed their names and ages; another asked if they were represented by Lego people. The issue is how art represents death. The evidence of memorials to both the 1914–1918 war and the Holocaust is that, above a certain scale, it cannot: most of the memorials are blank slabs, and when they are figurative they tend to be either stereotyped or otherwise banal. Perhaps when an event is too present in news coverage something similar applies or the vocabulary does not exist in a society which tends to camouflage death and can deal with it only in abstractions. The second point is that toys were used. This was a practical decision on the part of the artists seeking a material, not merely virtual, element in the work, and playing characteristically on the ambivalence of the elements employed and on readings of miniature representation. An association with toys may have seemed insensitive to some; to others it was effective as a polemic or a purposive confrontation, when the activities of the global oil industry are responsible for an increasing number of spills as well as this disaster – a failure of construction and management shared by a number of companies, followed by denials and inept efforts to minimize the public relations and financial damage – and the carbon emissions which produce global warming.

My own view is that art cannot change the world – it is part of it, and the conditions of its production are always present in an artwork, even when it evokes other responses – but that, in the cases cited above, it might contribute to facing the forces and trajectories which appear to bring the world to the edge of destruction. In some cases, this is achieved obliquely, through use of the uncanny and the unexpected, or through interruptions of routine and predictability. There are other ways, too (as in Chapters 6 and 8), but the boundary between art and activism is not rigid but fluid and endlessly negotiable.

Re-industrializing Tate

At about 11.30 on the morning of 7 July 2012, members of the art group Liberate Tate, which works closely with Platform (Chapter 6), carried a 16.5-metre wind turbine blade into the Turbine Hall of Tate Modern, the gallery's main public space. The performance

was titled *The Gift* (Figure 7.8). A turbine in a turbine hall is appropriate, and could remind spectators that renewable energy sources can replace the fossil fuels used by power stations such as that re-used by Tate. But in this case the interruption was aimed at Tate's sponsorship by an oil company once calling itself Beyond Petroleum. Liberate Tate writes,

> Liberate Tate makes performance interventions into Tate's relationship with BP. As artists, we do not want the creativity of our networks to be used by an international oil company like BP. For a small amount of sponsorship, Tate gives BP the 'art wash' it desperately needs in the wake of the Gulf of Mexico disaster [Deepwater Horizon] and the controversy around tar sands projects [in Canada]. Tate can do without this money – which it would find easy to replace – and as a public body should heed the call of members and visitors who do not want their gallery tainted by BP.[32]

The turbine blade, brought from a de-commissioned site in Wales and weighing one and a half tonnes, was carried to Tate across the Millennium Bridge, and then given to Tate staff with a request

FIGURE 7.8 *Liberate Tate,* The Gift, *performance, Tate Modern, London, 2013 (courtesy of Liberate Tate, photo Martin LeSanto-Smith)*

that it be gifted to the gallery's permanent collection. In December 2011, Tate's director, Sir Nicholas Serota, received a petition signed by 8000 Tate members asking him to refuse BP's sponsorship. Still, Serota asserted that '[t]he fact that BP had one major incident in 2010 [Deepwater Horizion] does not mean we should not be taking support from them'.[33] But Liberate Tate point out that the Deepwater Horizon disaster did not end in 2010, and many legal issues as well claims for damages arising from it remain (at the time of writing) unresolved.

At the same time, and like other transnational oil companies, BP is expanding its operations to exploit the oil-tar sands of Canada, Alaska and Russia, a project made easier as the sea-ice recedes due to global warming caused by, particularly, the burning of fossil fuels such as oil, and it continues to drill at Prudhoe Bay, Alaska, scene of one of the world's largest oil spills in 2006. *The Gift* was a provocation rather than a practical proposition, using the model of the gift to a public collection to introduce a public issue into art's politics. More than a thousand people subsequently signed another petition asking that the blade should be accepted for the collection. The petition stated, 'Through your relationship with BP, Tate is forcing climate-conscious gallery goers into an uncomfortable position of complicity with the oil company.'[34] At its meeting in September 2012, Tate's Board of Trustees declined *The Gift*. Perhaps they knew the word in German.

The controversy spread. In April 2011, a group of 170 writers, artists and composers signed a letter to *The Guardian* drawing attention to the backing of oil companies for dubious regimes and their increased exploitation of the Arctic, adding that, even in a period of cuts in the arts budget, arts sponsorship remained an ethical issue. The signatories – including Lucy Lippard, Melanie Klein and Rebecca Solnit – urged Tate to 'demonstrate its commitment to a sustainable future by ending its sponsorship relationship with BP'.[35] Platform has also questioned the operations of oil companies, targeting Shell and BP. For instance, at BP's annual meeting for shareholders in 2008, Greg Muttitt, 'from the Platform Human Rights group', questioned the company's oil sands operations and plans for investment in Iraq on the ground that they represented high risks for investors.[36] Individual artists have also made works pointedly critical of the oil industry, such as Ruppe Koselleck's *Tar Squares*, which use oil from the Deepwater Horizon spill in what

looks like Malevich black squares over the inscription, for instance, 'Crude oil painting with Edding and Bangor Beach rubbish. 100€ = 10 shares. Will take over BP by selling its own waste.'[37]

James Marriott of Platform, author of *The Oil Road* (Chapter 6), writes that it is particularly through arts sponsorship that oil companies gain public approval, distracting attention from their operations. 'An oil corporation', he writes, 'combines the mindset of an engineering company and a bank. It constantly faces the practical challenges of extracting, transporting and processing oil and gas, shifting the geology of distant lands to the cars and turbines of its customers.'[38] Since constructing an oil platform is so expensive that it requires production to continue for two or three decades to be profitable, social or political unrest is a direct threat to that profitability. A 'social licence to operate' is important, 'engendering support for a company's activities' in communities near installations and in financial centres such as London through a positive public relations image.[39] Sponsoring major arts institutions is part of this, too, attempting to annex their prestige and noncontroversial status through high culture's alignment to a supposedly universal value. An outcome of such sponsorship may be a remark such as 'BP is a great company' – as was stated at the end of a speech at a Tate event – on which art historian Julian Stallabrass comments, 'The obvious contradiction ... is that the alliance of art and oil pollutes the very ideals which it hopes to exploit.'[40]

Members of Liberate Tate sought to expose the contradiction by gate-crashing a Tate Britain party in 2011. In *Human Cost*, featured on the front page of *The Financial Times* (22 April 2011), a male member of Liberate Tate lays on the floor of the central hall of Tate Britain as two women dressed in black pour a substance looking like oil over him from cans bearing the BP logo (Figure 7.9). In June 2010, in *Toni and Bobby*, two female members of Liberate Tate, wearing nice flowery dresses, arrived at another Tate party celebrating 20 years of oil sponsorship only to find that, in the middle of the party, something looking like oil was dripping down their legs and from their expensive handbags. The names Toni and Bobby mimic BP's past and present CEOs, Tony Hayward and Bob Dudley. The black substance was molasses but the effect was realistic, and was used, with feathers, in *Licence to Spill* (the overall event of which *Toni and Bobby* was part) as quantities of it were poured down the steps outside Tate Britain.

FIGURE 7.9 *Liberate Tate*, Human Cost, *performance, Tate Britain, London, 2011 (courtesy of Liberate Tate, photo Amy Scaife)*

Human Cost and *Licence to Spill* are, as the titles denote, artworks. Asked by curator Steven Lam to speak about 'performance and sculptural interventions' in which Liberate Tate works with iconography that evokes, and relies on, 'an invasion of the natural into the pristine and sterile walls of a museum', Liberate Tate replied:

> Bringing natural materials into the Tate galleries is a decision to return what is repressed in Tate's relationship with BP to the gallery spaces of the Tate itself. In a haze of ecological schizophrenia, Tate is pushing its museum credentials as a flagship for sustainability, while at the same time taking money from a company that is damaging our ecosystems.
> ...
> As BP was spilling oil in the Gulf of Mexico, Tate and BP were celebrating...we carried vats of black liquid with BP's notorious sunflower logo stuck onto them. We appeared, as if from nowhere...disappearing as quickly as we arrived. Nearly a year later we made *Human Cost*...The performance lasted eighty-seven minutes, echoing the number of days it took BP to stop the gush of oil into the Gulf of Mexico.
> Our choice to use or allude to certain raw materials could be said to be Beuysian because the fluid ingredient of an oil-like substance plays a key role, almost like a performer itself. While the presence of these materials may suggest 'the natural', it also highlights how that presence is a performance.[41]

There are echoes of past sculptural concepts such as truth to materials and monumentality as well, but perhaps it is the interruption of routine which arrests the attention of those present.

Eves of destruction

Rudoplh Bahro wrote that awareness of the capacity for total destruction was felt in Germany in the 1990s, '*at least subliminally, most people know this*'.[42] Bahro also notes a tendency to abide by the law. He continues:

> And yet we carry on living just as we have been doing. While we are not behaving with free will, we are not behaving against

our own will: that is, we are behaving as if we *wanted* to wipe ourselves out.... we are trapped in our habits and fears, in the inertia of our minds and hearts... we have fashioned an external prison out of the diffuse material of these habits and fears, a great heap of external constraints and dependencies, into 'material constraints' which say to us, 'you can't behave any other way!'[43]

As with the iconography of clouds after Hiroshima, that of oil spills, forest fires, floods and other aspects of climate change and its causes takes on a weary aspect through reproduction in mass media. The projects and events profiled in this chapter all take a polemical approach, but polemics takes different forms, from playing on the ambivalences of perception and reception to direct attacks on, or interruptions of, well-rehearsed scenarios. The outcomes are disruptive and not always popular with spectators, but activist and academic Derek Wall quotes Berry, an activist in the antiflight group Plane Stupid, that 'when there is a need for radical social change, asking those in power nicely to relinquish some control doesn't get us very far'.[44] Since I am not an activist and cannot speak for those who are, I quote Berry at length:

> Dealing with climate change is our collective responsibility. We can't leave it up to the powerful to solve it; they got us into this mess... and the money they made... will make sure they're the last ones to be affected by it. Corporate and market-based solutions, like carbon trading and green taxation, are as much about keeping those in power where they are as tackling rising greenhouse gas emissions. Direct action is about recognizing the false solutions and building real alternatives; about being the change we want to see in the world. [...] We passionately believe in direct action but we also believe that it must be justifiable and this is why we complement it with horizontal organization, direct democracy and consensus to decide what action to take.[45]

Platform, Liberate Tate and Art not Oil hover between art and activism (although both are expanded fields, whose borders overlap). Reality, as Laramée says (above), must take precedence over public relations. Reality, however, is not monolithic but plural, multifaceted and open to interpretations which are inflected, perhaps, by art which fractures the uniformity of routine and

the conformity it breeds. Aesthetics does not, Jill Bennett writes, 'function as a reciprocal exchange' and art does not occupy a position in a moral narrative;[46] nonetheless, art evokes emotional and intellectual responses. If it has a disruptive or revolutionary force, it is in its fracturing of stock representations of reality. This is a long revolution: no crowds carrying red banners or storming Winter Palaces now, but direct action is growing, in Occupy worldwide and in local refusals of the dominant culture (Figure 7.10).

FIGURE 7.10 *Wall-painting, Stokes Croft, Bristol, 2011*

8

Cultures and Climate Change

For many years, Deborah Duffin has made sculpture from recycled materials such as wire, plastic ring pulls, the tops of juice containers, packaging and other items from ordinary consumption. In 1995 she was commissioned by British Telecommunications (BT) to make a sculpture using wires and small parts – many brightly coloured – from a redundant telephone exchange after the shift from analogue to digital technology. Duffin writes, 'I was suddenly presented with a vast studio full of multi-coloured wires and electrical components tightly tied together. As I dismantled these huge packages – which were heavier than myself – I felt like a kid let loose in a gigantic sweet shop. My work exploded with colour.'[1]

Since then, she has collected material to recycle into art, weaving wire, plastic and packaging into multicoloured, complex and often organic-seeming forms such as spirals (Figure 8.1). I see two aspects to this practice: the first is aesthetic, part of the development of an artist's work over a period of years, drawing on the work of others as seen in exhibitions and through direct contact, and on art history. *Trespass* (1991), for example, consisted of a woven wire mesh protruding from the overhanging section of a blocked-up Victorian fireplace, with larger forms in wire emerging from cupboards on either side (at the Adam Gallery, London).[2] The second aspect is specific to contemporary concerns for recycling and avoiding waste, or a revaluing of materials which are not junked but investigated for

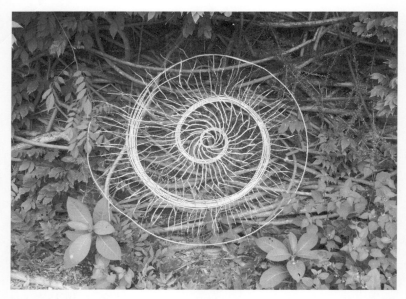

FIGURE 8.1 *Deborah Duffin*, Red-flecked White Spiral, *galvanized and telephone wire, electrical sleeving and mixed plastic packaging, 2011 (courtesy of the artist)*

their aesthetic possibilities, their recycling into art contributing to a low-waste culture. Duffin writes that she has always been 'a bit of a scavenger...never happier than when collecting wood, blackberries, windfall apples; the sight of a full skip sends waves of anticipation down my spine'.[3] Scavenging was part of her practice in London in the 1980s: 'I scoured the streets of Whitechapel, Soho and Covent Garden for rubbish piled high at the end of the day, arriving home with armfuls of paper, cardboard and sundry materials that went into my work.'[4] Then,

> The commission from BT opened my eyes to a whole new dimension and drew my attention to the huge waste of glorious materials...At around the same time, I was working towards reducing my own waste: most things I could not recycle were plastics – in a huge range of colours, textures and consistencies. I started to think about how they might be incorporated into my

work. I began to collect bottle tops, ring pulls and packaging. I was beginning to see a relationship between my drawings and these materials – every day I came across something new that I could use as a metaphor for the quality of a line, the shape of a mark, or the colour I had just experimented with on paper. I was also seeing the streets once again as a giant materials supplier – I found builders ties, plastic bottles and broken car reflectors – the remains of some unfortunate accident. My walks became a hunt for treasure and a source of inspiration. I am now a repository for interesting rubbish from friends, neighbours and local shops; even strangers contact me with things they think 'I might be interested in.'[5]

The range of materials expands, and new-found elements are assimilated in the development of the work (Figure 8.2).

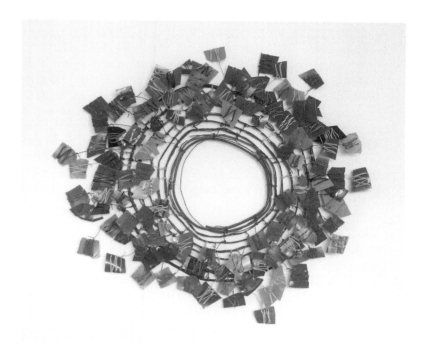

FIGURE 8.2 *Deborah Duffin*, Multicoloured Circle, *electrical wire, cut-up plastic bottle tops, lids and food containers, 2012 (courtesy of the artist)*

The use of found materials could be compared with Doninique Mazeaud's regular collection of rubbish from the Rio Grande (Chapter 5), but while Mazeaud sees the act of collecting *as* her artwork, Duffin uses the resulting material (some of it sorted by type and colour in large sweet jars) to make work in the more traditional form of the art-object. Her statement continues:

> In creating the pieces, a marriage of making and form is essential: the techniques used to construct the work also form the elements of drawing; the end result transcends its materials, as form and technique combine to create a cacophony of visual sound. Colour is explored and utilised in the manner of the painter – mixing several colours to create the desired effect – the result, a rich and subtle symphony of colour, texture and form.
>
> Meanwhile I draw the natural world – evidence of time, growth and living systems – through the drawing of markings on shells and stones, the wind-blown ripples on water or the undulations of rock formations. These I translate into a concrete manifestation of the life force flowing through everything.
>
> My work with recycled materials takes these forms into another dimension – drawing in space: along a wall, hanging from a tree or a beam, entwined around a branch or a pillar. The pieces are malleable and can often be re-formed to suit a new venue, site or situation. I have used pieces in installations both static and moving – as suspended pieces turn gently in any passing breeze – from the weather or of human creation. In this way, the work engages an audience, as viewers stand mesmerised by the changing shapes, relationships and ambience created before their eyes.[6]

The work of Eva Hesse and Shirazeh Houshiary has been influential for Duffin, in context of a recognition in the 1980s and 1990s of women's presence in art and the art-world. She sees Hesse as producing forms denoting a feminine sensitivity, in contrast to the vogue for heavy steel girders and slab-like forms of most male sculptors at the time, and Houshiary, as using wire in woven, rhythmic forms suggesting three-dimensional drawing.

A comparison could also be with the work of Tony Cragg in the 1970s. Cragg used found material such as bits of furniture, household objects and plastic toys, combined into sculpture. He

also used flat pieces of bright-coloured plastic in two-dimensional assemblages mounted on paper, such as *Union Jack* (1981) and *Britain Seen from the North* (1981). These were more polemical statements: the national flag fragmented and made from litter; the map turned on its side to refute the dominant perspective. A more distant comparison is with Arte Povera in Italy in the late 1960s, beginning with an exhibition curated by the critic Germano Celant in Genoa in 1967.[7] But while Cragg used found objects for their visual quality – an extension of the truth-to-materials approach proposed by Henry Moore in the 1940s – Arte Povera was a politicized movement in context of the rise of affluence amid continuing austerity in postwar Italy. Duffin's work responds to a comparable but different, more recent context when recycling has become part of a green society. As producers and supermarkets continue to package their goods excessively, and the materials used can be either dismissed and sent to landfill sites or recycled in new ways, art is a means to make recycling visible. Of course, consumers can refuse to accept excess packaging by leaving it at the checkout, but, thinking of Herman Prigann's acceptance of the ambivalence of modern industry in his use of industrial detritus such as concrete slabs in his land reclamation projects (Chapter 5), the aesthetic recycling of plastic and packaging can be an extension of sculptural practice *and* an oblique comment on waste.

A culture of recycling?

Is recycling now part of a cultural shift from the excess of an affluent society to a more conserving attitude? There is evidence that it is a rising trend, in car boot sales, charity shops, informal exchange, Freecycle (an Internet means to redistribute used goods for free via local networks) and searching for out-of-date food in supermarket skips. In part, this is an intentional secession from the dominant economy (as intentional communities seceded from cities in the 1960s). It extends the black economy through free redistribution, but is becoming a *parallel* economy which also includes Local Economy Trading Schemes (LETS) and local currencies, where the money spent is likely to recirculate locally. Similarly, money spent in charity shops goes into health or elderly care or transnational aid rather than to shareholders. Health and elderly care are part of the

welfare state, and it can be objected that encroachment by charities assists the neoliberal attempt to dismantle the postwar welfare settlement, and not all aid – sometimes called overseas development, linked to trade and the assimilation of so-called developing societies to the global North – is helpful to those in need: it may be tied to imports of goods and expertise from the North or adaptation of indigenous crafts for Northern markets. But I have seen simple water pumps made in India installed in villages in Burkina Faso to provide clean water for people who previously had irregular access to it. This contrasts with the free food, in sacks marked Gift of the People of the United States, sold in markets and undercutting local farmers. The pumps were installed, too, by an international charity which hands over project management locally, while, in contrast, elsewhere in Africa water is being privatized and priced out of the reach of poor communities. Erik Swyngedouw describes the use of local water resources for global profit in Ecuador,[8] and geographer Alex Loftus writes of the connection between 'the trickling taps of township residents' and the 'untouchable tabernacles hiding the crouching, greedy gods of the Johannesburg Stock Exchange'.[9] Money spent in charity shops does not feed such tabernacles.

Geographers Nicky Gregson and Louise Crewe chart the expansion of charity shops in post-1980s Britain, rising from around 3200 in 1990 to 6500 in 1999.[10] They are also interested in the reasons which lead consumers into such places, including thrift, retro style and Oxfam-chic, and a refusal of mass-market products (until they are no longer mass-marketed). When they began their research in 1994, they saw the world of second-hand shops as illuminating,

> the alternative... potentially another critical moment in consumption, one that went beyond consumer boycotts and campaigns, that was located in a 'red'-'green' nexus, in which the act of purchase could be simultaneously anti-consumerist and anti-corporate and pro-re-use: both a critique of manufacturers' product cycles and an acknowledgement of the temporal durability of things.[11]

What they found, however, was that 'second-hand has become more closely entwined with exchange and consumption in the first cycle'.[12] They observed that as bargains, brands were able to preserve their prestige, and questions of environmental degradation,

waste and the politics of commodity production were seldom raised in interviews with consumers.

They also argue that recycling has a negative impact on first-cycle (new) production and hence on employment (in the case of clothing this is now predominantly in the South). Gregson and Crewe conclude that recycling via the second-hand economy is becoming a deepening of the main economy and not its replacement, particularly if specialist retro-shops are part of the equation (selling goods which cannot by definition be first-cycle, blurring into the antique trade). But they add that, despite their main finding, 'there are hints' that some 'second-hand worlds' are aligned with a moral economy.[13] That was in the 1990s. Today it may be that, on one hand, charity shops have grown closer to a normative business model by competing with other charity shops and in the unequal competition between charity bookshops and local book traders whose stock is not donated. On the other hand, I would argue, the growth of Freecycle and other local, semivisible means of redistribution do represent a rise in alternative values. A parallel can be drawn with the rising consumption of local organic vegetable boxes, through which consumers buy into a feeling of belonging to a network.[14] All this might represent the beginning of a cultural shift and may be enhanced by post-2008 austerity in the North. There are implications for employment in the South, but the conditions of that employment tend to be deplorable (which is why transnational capital is there).

Besides, it is not a question of all one and none of the other but of both in a varying balance: when recycling is environmentally beneficial – by not using finite resources for production or sending material to landfill sites – it also denotes ethical commitment. In Stokes Croft, Bristol, there is a Free Shop – reviving precedents from the counterculture of the 1960s when groups such as the Diggers opened them in San Francisco and New York – as well as an anti-supermarket wall painting (Chapter 7).

Reclaiming cultures

Above, I present two realities: one of art made with recycled materials by an artist who does feel an investment in the ethical economy of recycling, another of recycling as an economy in the

ordinary sense. I have argued speculatively that an economy of recycling is an incipient culture of recycling, using the term *culture* in its anthropological sense. This is not to say there is a causal relation between art and culture, or culture and economy, but that, for instance, a culture of recycling and an economy of recycling are elements in a wider shift of attitude. I want to widen the argument by looking to events and processes which appear to operate across the border between culture as the arts and cultures as articulations of common values. This matters because the claim made for some art classified as eco-art is that it has a causal relation to a green society, acting as an avant-garde. Apart from the direct effects of recycling, this implies a shift of awareness. I agree that visual culture has some effect, but, like alternative economies, I would say not as leading a trend but as part of it. If there is a green imaginary, however, its sources are complex, diverse and, to a significant extent, outside art. Indeed, if eco-art is to find a public it requires something of such a shift to have already occurred. Since art and politics are expanded fields – where art is contingent on social and political attitudes, and Occupy represents a new not-politics (Chapter 1) – it follows that the evidence for such a shift will be found between art and the cultures of everyday life.

Everyday festivals

In July 2010, the rural arts organization Littoral, based in Lancashire and the Lake District, organized a Scything Festival at the Cylinders Estate at Elterwater in Cumbria. This included workshops for beginners and families covering the use and care of scythes, and the scything of the upland meadows of the region; presentations on meadows, haymaking and community agriculture; and children's eco-art opportunities (Figure 8.3). The greener world, here, is that of traditional agriculture and the tacit knowledge of craftspeople. This can be seen as regressive, in that a de-industrialized period is not a return to a pre-industrial one but requires quite new approaches to deal with the fallout of capitalism's inherent instabilities. However, at the same time, it is positive in revaluing those skills and that knowledge, and in refusing to junk those skills and that knowledge like industrial detritus.

FIGURE 8.3 *Littoral, Scything Festival, Cylinders Estate, Elterwater, Langdale, Cumbria, 2010 (courtesy of Littoral)*

Littoral regards agriculture as central to *culture* – as the word's derivation confirms, from *colere* (to inhabit, cultivate, protect or honour)[15] – and states a commitment to 'the notions of deep practice, the immersive aesthetic and an art and policy sphere as alternatives to current public art...practice and theory'.[16] The organization seeks long-term, embedded relations between artists and rural communities, seeing rural communities as marginalized today, and seeks to support creative work which falls outside the interests of the mainstream art-world through grassroots negotiation with local groups, trades unions, health and care providers and rural organizations as well as with artists. Art exhibits in rural places are part of this – such as Chris Drury's installation of sheep wool in a barn interior at Abbeystead, Bowland, in 1999 – but interactive events such as the Scything Festival are equally important.

Ian Hunter, co-director of Littoral with Celia Larner, writes that he is intrigued by the idea that cities were or are 'cradles of progressive political action' while he recognizes, too, that 'historically, we can see that such impulses were embedded with agriculture and the discourse of rurality...might still spring up there again, unexpectedly and with considerable potency'.[17] The Tolpuddle Martyrs demonstrate this historically, as does the radical

content of John Clare's poetry or John Constable's painting, and the poster for the Scything Festival quotes John Berger, who lives in rural southeast France. Berger says, 'When I came here I was mostly with the old peasants, because the younger ones had gone, and they became my teachers. It was like my university. I learned to tap a scythe, and...a whole constellation of sense and value about life.'[18] He has written with deep humanity on art since the television programme *Ways of Seeing* brought him to prominence in the 1960s, and his move to a rural way of life is no less politicized than the views on property, gender and ethnicity as factors determining art which he expressed in *Ways of Seeing*, because, I suggest, material culture is tangible and is at the core of working-class life in rural communities. That may be a romantic view, I admit, whereas closeness to the land means toil and discomfort. But I think Berger's decision to live a rural life, participating in its cycles of work, is a kind of social Realism. Berger writes as much when he comments on the work of Jean-François Millet: 'He chose to paint peasants because he was one; and because...he instinctively hated the false elegance of the beau monde.'[19]

There is another history, however, in which to situate the Scything Festival: the history of free festivals and Fairs in England in the 1960s and 1970s. These are sometimes called the Fairs of Albion, a country identified in the Albion Free State manifesto as '*the other England of Peace and Love*, which William Blake foresaw in vision – a country freed of dark satanic mills and sinister Big-Brother machinations'.[20] The text goes on: 'The dispossessed people of this country need *Land* – for diverse needs, permanent free festival sites, collectives, and cities of Life and Love...We beware of substitutes: Beware! *Reality's a substitute for Utopia*.'[21] Many of the festivals – before the growth of un-free festivals – were based on music, but some on rural life. The rural life concerned was in part an imagined life, eliding the hardships faced by agricultural workers in the early twentieth century (and prevalence of dispossession and malnutrition in the eighteenth and nineteenth centuries), but it was also a material creation, a living event, in the East Anglian Fairs of the 1970s (called Albion Fairs after 1978). George McKay describes them as 'a cross between revivals of historic folk events and displays of (to some extent, subversive) energy by younger country people'.[22] McKay quotes Sandra, an organizer of the Fairs, on 'the importance

of the relationship with local people and their involvement in the fairs'.[23] East Anglian Fairs took place at Barsham in Suffolk, Bungay House, and Rougham, 'attracting thousands from local villages and towns alike'.[24] They were popular, participatory and informally evolving events:

> kids watching Punch and Judy...the vicar doing the rounds, people haggling at stalls selling jewellery, second-hand clothes, flicking through campaign leaflets from Green Deserts, Libetarian Education. In the evening from a marquee or the big top comes music...Country because that's where we are...Late night it's chillums and hot knives in a truck, joints and brandy coffee passed round fires, people tripping on acid avoiding the too-packed beer tent selling lovely flat warm ale. Self-designed and traditional ceremonies celebrating fertility, the elements, rooted in nature and ecology, are watched and participated in in the darkness and before sunrise.[25]

What I recognize in accounts of the Fairs is a radical self-determination.

The period of the Fairs was, too, the period of the British folk music revival, which can with some accuracy be called a Communist plot. Music historian Michael Brocken writes that the two key figures in this revival before its electro-folk phase, Bert Lloyd and Ewan MacColl, were Marxists; indeed, Lloyd was an 'inveterate Marxist'.[26] Brocken quotes Lloyd that 'what we nowadays call English folksong is something that came out of social upheaval...with a class just establishing itself in society with sticks, if necessary, and rusty swords'.[27] I must leave it there, but the point is that the radicalism which Hunter sees as potentially springing up in rural society (above) was evident in not-so-distant past as well as in the days of the Tolpuddle Martyrs. This is not to romanticize the countryside as it is increasingly appropriated as an urban middle-class resource but to identify a radicalism common to both rural and industrial working-class solidarity. At the same time, as Georgina Boyes argues, in the eighteenth century, a sanitized image of rural labour was appended to the picturesque and 'the countryside and its workers were presented as a locus of spiritual values in a rapidly industrialising urban age'.[28] Such mythicized images tend to be persistent.

Common grounds

Visiting the stone circle at Avebury, Wiltshire, in October 2012, I noticed that one of a group of four mature trees was festooned with coloured ribbons. I asked a group of local teenagers sitting under it what they knew. They said it was called the Wishing Tree, but that it was not local people who tied ribbons to its branches but visitors, or people at a recent (not-free) music festival. Walking towards Silbury Hill, I saw another tree similarly decorated. Revisiting Avebury in May 2013, the ribbons had gone from the Wishing Tree, which stood on National Trust land, but the tree near Silbury Hill carried straw hearts and beads as well as a large number of bright ribbons (Figure 8.4).

I have seen this phenomenon in one other place: the Geghard Monastery, Armenia, where strips of cloth are tied to trees in a dry valley behind the monastery. Arshile Gorky depicts a similar scene in *The Garden of Sochi* (1941, New York, Museum of Modern Art), drawing on memories of his father's orchard at

FIGURE 8.4 *Wishing Tree near Silbury Hill, Wiltshire, May 2013*

Khorkhom, where people tied strips of cloth to the Holy Tree. In Armenia this is a living culture. The strips of cloth are prayers, like those which are written on slips of paper to place in side-chapels in Catholic churches in Europe to seek the intercession of a particular saint. After the Reformation, such customs declined in England but their inclusive emotionality has been revived in forms such as tree- and well-dressing, and more emphatically in New Age culture.

Tree-dressing was adopted by Common Ground (Chapter 6) in the late 1980s in the form of participatory events in which trees were decorated, usually in colourful ways, as a means to value them and discourage cutting them down. Artists were involved – Fran Cottell and Terry Watts in *Skylight*, a tree-dressing in the London Borough of Merton in 1992, for example[29] – but not always. Common Ground piloted the idea in the hope that local groups would simply take it over. There is no list of places where the idea was taken up but Common Ground's director at the time, Sue Clifford, thought Avebury was not one of their project sites.[30] This suggests that the Wishing Tree represents a spontaneous expression of values common enough, not locally in this case, to see the tree dressed and re-dressed over a period, and introducing a colloquial name for the tree. Of course, once a custom is visible it can be contagious. This occurs outside consumerism and denotes a need to break away from the dulling regime and unsatisfying consumption of mass culture. If this produces a desire for some immaterial dimension or evokes a search for authenticity in a world of artificiality and manipulation, then I would argue that it stands for a perceived lack in present conditions and not a quality of a supernatural realm (I am a rationalist). I would also argue, as in Chapter 5, that there is no social or political benefit in the uncritical appropriation or imitation of archaic or indigenous cultures. Further, I might add that, in Germany in the 1930s, Nazi culture not only stole the torch-lit parade and banners of the old Left but also appropriated myths and folk tales told around the campfire in the dark, to evoke a doctrine of blood-and-soil.[31] Morris Dancing, although seemingly less contentious, also had far-Right associations in England in the 1930s.[32] After that, there is something gentle in tree-dressing. If it contributes to forest conservation, it has a positive environmental impact, but I suspect its main value for those taking part is being there among others in a common culture of their own making.

Common Ground treads a delicate, at times tentative, path through this terrain. For example, it promoted community orchards from 1992 onwards as a way to conserve native apple tree varieties (which agri-business consigns to uneconomic production) and foster community interaction. A leaflet states:

> A Community Orchard is a place where local and other varieties of top fruit are grown by and for local people. They provide fruit to share, places to enjoy and show how well we can live with nature as a friend and collaborator.... Community Orchards are a wise way of sharing the land and a positive gift to those who follow.[33]

There are issues around who constitutes the 'we', as of what is nature; still, there are practical arguments for conserving crop varieties suited to a local soil and climate, and a need for low-impact alternatives to agri-business and supermarket distribution (which have unsustainable eco-footprints). Common Ground notes that 63 per cent of English orchards are now lost.[34] Planting a few trees contributes marginally to dealing with carbon emissions but orchards may revive interest in fresh food while free food resonates with 1960s counterculture and contemporary avant-gardening in inner-city areas.[35]

Five years earlier, Common Ground's Parish Maps project invited local groups to make maps of their village or urban neighbourhood. This aimed to 'encourage communities to chart the familiar things which they value in their own surroundings, and give active expression to their affection for the everyday and commonplace whether in town or country'.[36] The project was launched with an exhibition of maps made by professional artists – among the 18 invited by Common Ground were Conrad Atkinson, Helen Chadwick, Steven Farthing, Balraj Khanna, Simon Lewty, David Nash and Stephen Willats – and handed over to community initiatives. By 1996, around 1500 local maps had been produced, mainly two-dimensional and depicting a central space for a cartographic representation of a parish or village, surrounded by images of local scenes and landmarks selected by those who made the map. Geographers David Crouch and David Matless contrast two maps from Oxfordshire: Charlbury and Standlake. The former 'is a consciously factual map, with carefully drawn and painted images naturalistically presenting events and things' and was produced 'as an item of local cultural capital ... showing the best side

of Charlbury: "we wanted it to look like an old painting...it's like a wedding photograph...to show its best qualities"'.[37] Standlake used the same format 'to open up an imagined space...diverse colour sketches positioned in 70 six-inch squares making an uneven border'.[38] Concern over nearby gravel workings arose while the map was being produced, and these were represented in it; Crouch and Matless conclude that this map 'opened up an aesthetic criticism...and widened the sense of what might be given aesthetic value...in humdrum everyday diversity'.[39] They also note that Charlbury's map did not include the council estates on the edge of the village. From these and other cases they find that

> The map can become a site for struggle as well as celebration, bringing out social difference by providing one public imaginative space on which to work. Even the most outwardly conciliatory and harmonious of Parish Maps might act as a blanket thrown over difference which, in covering it, keeps it warm and stewing. The map exercises conflicting senses of the dimensions and character of a place, with the scope and nature of this geography itself becoming an active cultural figure in local politics, confirming or reshaping the contours of place.[40]

To me, the construct of a sense of place is overused, an abstraction to which art is co-opted as a cosmetic solution to problems caused by policy failures. In contrast, as Crouch and Matless say, Parish Maps problematized the act of representation by expressing differences over what is valued in a locality viewed differently by different publics. If environmental issues cannot be separated from economic and political issues, mapping is a form of claiming an emotional ownership of a site and perhaps of its future scenario. That scenario will tend to be a collage of hopes and fears, not all universally expressed but more often contested.

Bits of paper

Artist Kurt Schwitters fused everyday items such as tram tickets, sweet wrappers, stamps, bits of torn envelope, newspaper and other material more often discarded as litter in collages. In some cases he used fragmented reproductions of artworks as well. The material

is arranged on an aesthetic basis, not to make any statement – the words in a newspaper allow recognition but are not used to spell out messages – or to describe a place such as Schwitters's native Hannover or, later, adopted Ambleside in the English Lake District. Looking at a Schwitters collage, it is not interesting to try to separate out what is Culture (art) and what is culture (everyday life and its enactments or representations within common conditions). In *Mz 601* (1923, private collection), the number 23 stands out slightly above and to the left of centre; at the top is an exhibition entrance ticket (in French), next to a piece of newsprint, a ticket to Amsterdam, and other fragments. Under 23 is 281 in smaller letters. In other places are handwriting; a piece of yellow, squared paper; rectangles of solid red (painted on); and the artist's name at bottom left printed on a neat scrap of paper. The number 23 is the year of composition, which seems fortuitous compared to the multiplicity of sensations which characterize urban experience, according to the prevailing artistic language of the time (drawn from Cubism) in a form of abstraction which retains but de-contextualizes the immediately recognizable.

Schwitters visited Berlin in 1919, meeting artists and writers associated with DaDa (an intentionally meaningless word). Some of the Dadaists took an openly political stance while Schwitters reflected that the social turmoil after Germany's defeat in 1918, and the attempted Communist rising of January 1919, affected him deeply: 'Everything had broken down...new things had to be made from fragments...new art forms out of the remains of a former culture.'[41] I think this means that culture (in the broad sense) is actively redistributed (not just passively allowed to sediment, as it always does) in art, and art, meanwhile, is one of countless currents in culture, all of which are ephemeral while some yet linger, or are later reproduced.

Schwitters called his work *Merz* – a word created by chance from a fragment stating *Kommerz und Privatbank*[42] – denoting a combination of all possible materials. The work of Cragg and Duffin (above) does this in another context, although Schwitters himself extended the project into a total environment in his house in Hannover (destroyed). Fleeing Nazi Germany, and after a period in Norway and then internment as an enemy alien in Britain, he moved to Ambleside, where he made his last *Merzbau* (Merz house) in a barn in Langdale, lent to him for the purpose by the landscape gardener Harry Pierce. To make a living he tried selling landscape

paintings to tourists. Only one wall of the barn was completed (Newcastle, Hatton Gallery) but the barn, now empty, remains and there is a plan to convert the site into a study centre on art, rural culture, ecology and sustainability (Figure 8.5). It is a quiet place away from the noise of consumerism; in such places, in a process of contemplation somewhere between that of the art museum and that of the monastery, other better lives can be glimpsed in anticipation.

If at this point it seems that this chapter has itself become something of a collage, going in all directions – art from rubbish; second-hand economies; rural skills and Fairs; orchards and maps; collage – this is my intention. My aim has been to establish tensions between art and culture, and to argue that they interact but not causally or neatly. In the next section I discuss the do-it-yourself (DIY) culture of self-build housing as a counterforce to the housing market and a vehicle for new social and environmental relations, before remembering a visit to the Social Work Research Centre (Barefoot College), Tilonia, Rajasthan. That will bring me to the idea of voluntary simplicity.

FIGURE 8.5 *The Merz Barn, Ambleside, Cumbria, 2012*

In the woods

Outside the Barbican Art Gallery, London, during the exhibition *Radical Nature: Art and Architecture for a Changing Planet 1969–2009* (Chapter 1), stood a double, intersecting geodesic dome. The geodesic dome was an architectural device brought to prominence in the 1960s by Richard Buckminster Fuller, but Fuller specified metal and transparent plastic for a geodesic dome's construction (as used in his design for the US pavilion at the 1967 Expo, Montreal). But here, Heather and Ivan Morison have built the domes in wood, using tiles of pine, larch and sweet chestnut from the annual felling at Tatton Park in Staffordshire (Figure 8.6). Titled *I Am so Sorry, Goodbye...* the domes were opened as a tea room, dispensing hibiscus tea during the exhibition. They reference the improvised domes made by alternative communities on the West Coast of North America in the late 1960s, some of which adopted the geodesic dome as a low-cost and low-energy model (except that

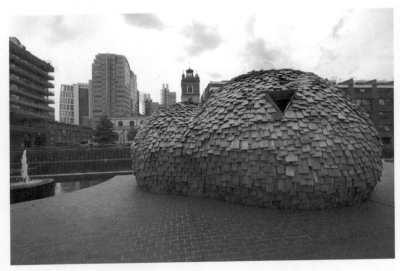

FIGURE 8.6 *Heather and Ivan Morrison, I Am, so Sorry, Goodbye..., wood, 2009, for* Radical Nature: Art and Architecture for a Changing Planet 1969–2009, *Barbican Art Gallery, London (photo Lyndon Douglas, courtesy of Barbican Art Gallery)*

they were not always watertight). Those domes do not survive, although some of the communities do. But a small transparent hemisphere at the top of the Morison's construction suggests a spaceship, as if to leave Earth for a place away from impending catastrophe. Inside are tables and stools made from timber in rustic style. There is a DIY feel to the piece and a hunt of the fusion of fantasy and hope in some alternative culture.

In another work, *Tales of Space and Time* (2008), the Morisons exhibited a de-commissioned fire engine customized in wood, containing a stove, a small library and the basic requirements for self-sufficiency on the road, at the 2008 Folkestone Triennale. Critic Jonathan Griffin wrote that it 'embodied a jauntily over-optimistic attitude to surviving the end of the world, simultaneously mocking the "art will save us all" attitude of some contemporary civic reformers. Art won't save Folkestone. I hope something does though – something real, something solid.'[43] While these works indicate the fallacy of escaping the environmental crisis, or any other end-of-the-world scenario, they also show the persistence of escapism and its fusing, at times, with more grounded efforts to live an alternative life, not after but within the dominant society (as was the case in intentional communities).[44] As art historian Simon Sadler writes, 'the counter-culture's linkage of theory and practice aimed to ground politics in real matter, real places, in temporality and praxis, in the rethinking of myth, technology, self, and nature'.[45] This did not happen only on the West Coast of North America and did not stop. There are now thousands of alternative and ecological settlements around the world.[46]

To cite one example, Tinker's Bubble, Little Norton in rural Somerset, is a community of eleven adults and two children living and working in self-built wooden structures amid 46 acres of woodland, fields and orchards. Tinker's Bubble is nearly self-sufficient in food, has solar and wind power and uses no fossil fuels (the latter being a core value for the cooperative who own the land). An income is derived from sustainably felling and milling timber, mainly larch and fir, using a steam-driven engine in the barn. There is a horse to help with heavy moving, and a cow for milk. After years living in benders, the group eventually gained planning permission for a small group of self-build dwellings. This required long and intricate negotiations, and permission was for temporary dwellings only, although renewed for a further ten years in 2005.[47]

In response to the question as to how many people could ever live the life of Tinker's Bubble, I would say that the question needs to be rephrased. Such settlements will always be marginal and are usually small scale, but they extend the horizon of the possible in ways which, gradually and unevenly, experimentally, inflect the majority society (if not the dominant political ideology, which may eventually be replaced). In this way, small, localized self-build and non-fossil fuel projects are not *signposts* to a new, green society; *they are that incipient society*. The question, then, is how elements of these social and environmental experiments can inflect the prevailing (urban) culture.

In the cities

Self-build housing appeared in Lewisham, south London, in the 1970s, using a design by Walter Segal.[48] At a United Nations seminar on Uncontrolled Urban Settlements (called shanty towns then, but now informal settlements) in 1966, development architect John Turner advocated provision of plots with basic services for urban self-build housing in the Third World (the South).[49] Turner's research demonstrated that informal settlements were more flexible and notably more beneficial for health, livelihood and family stability than standard government housing schemes. Since then, informal settlements have gained recognition as sustainable solutions to housing shortages and have been partly legalized in Latin America[50] and South Africa.[51] It is easy to imagine an extension of self-build in countries where, as in South Africa, building became an inherent skill in township life; it is less often recognized that self-build has a history in the North, as in Lewisham.

One category of DIY living is the plotlands of southern England, where urban families with little resource acquired plots on which to build cabins and chalets in the 1930s. These 'Arcadian' communities were an alternative to the suburbs, linked to a growth in smallholdings from the 1910s onwards when land prices were relatively low. Dennis Hardy and Colin Ward view the plotlands as 'an expression of revolt against the inequalities of urban-based capitalism, and a preference for political and geographical dispersal'.[52] In the twenty-first century, a growth of self-build housing might be anticipated as an equivalent reaction to austerity.

Another demonstration of DIY settlement – in a cosmopolitan, urban situation – is Ashley Vale, Bristol (or The Yard), on the site of a redundant scaffolding yard two miles from the city centre. This was once an area of watercress beds, in a triangular valley bordered by two railway embankments and accessed via a tunnel under one of them. The new housing by Ashley Vale Action Group faces onto nineteenth-century terraced housing in an area which was already an enclave of alternative lifestyles with an urban farm, a Millennium Wood, and a self-build house reminiscent of Antoni Gaudí's organic architecture. When the scaffolding yard closed and a developer proposed housing on the site in 2001, the land was acquired by the group and divided into plots. Special mortgages were arranged for first-time buyers, and the plots sold either for complete self-build or with built shells for self-completion. They retained the existing concrete base of the yard, and converted an office building for a mix of communal and residential spaces. There are 31 houses in various styles, all using a timber-frame and cladding system like that developed by Segal. They and the refurbished office block meet high environmental standards, the latter winning the South West Green Energy Award for housing in 2000 (Figure 8.7). The group outline the scheme's benefits,

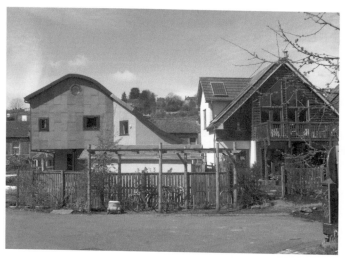

FIGURE 8.7 *Self-build houses at Ashley Vale, Bristol (photograph 2013)*

Light-weight timber framed houses that could be supported by the existing concrete raft proved very efficient and adaptable to individual needs. Sustainability has been addressed in various ways, including insulating to better than Building Regulations requirements, and installing solar panels and a community pellet boiler for the six apartments. The self-builders formed a close bond, helping, advising and assisting one another; they feel they have built a community along with their homes.[53]

As Simon Fairlie argues, although there is no inherent connection between self-build and low-impact, 'the two often go hand in hand' because self-builders seek to reduce costs and tend to be critical of conventional building methods.[54]

Equally significant is the way such schemes redress power relations between dwellers and providers. Architect Jeremy Till recalls a meeting on the design of a community centre in a 'blighted neighbourhood' where a prevailing notion that 'we give you money; you give us back improvements' negated the hope 'that fractured territories can be re-consolidated'.[55] Till advocates a negotiated balance of power between users and architects.[56] Even if this does not 'dissolve the power structures and inequalities' of the situation,[57] it may offer transformative experiences for some of those involved (which they may translate into other situations). Till writes, 'Hope is not discovered in the clouds' but 'founded in the interstices of the given'.[58] A sign saying Vote Green (shortly before local elections but perhaps permanent) at the entrance to St Werburghs allotments, next to Ashley Vale, suggests hope and also translates into political commitment (Figure 8.8).

But can localized, necessarily small-scale schemes – the 31 houses at Ashley Vale seem like a big project – translate into a greener society? The first point is that, again, all such projects extend the horizon of the possible, and create a cumulative demonstration of a new society based on a fusion of alternative tools and alternative values. The second point is, obviously, that only a minority of people in a crowded, complex, largely urbanized society will live like that in the foreseeable future, and some may not wish or be able to, but a less obvious extension of this sense of limitation is that within the everyday realities faced in such a society some steps, once they have been demonstrated, can appear viable. To pursue this argument I want to look briefly at two further cases, one in England and the other in the southern United States.

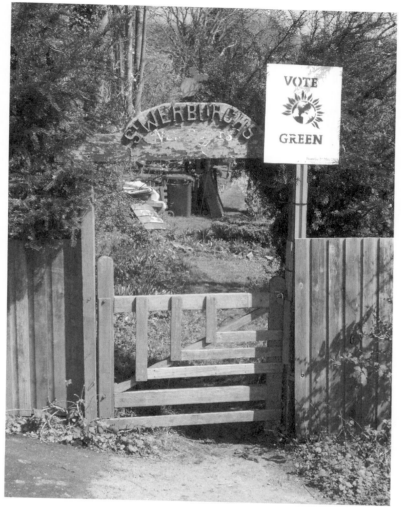

FIGURE 8.8 *Vote Green sign, St Werburghs allotments, Bristol (photograph 2013)*

Hockerton Housing Project describes itself as 'the U. K.'s first earth sheltered, self-sufficient ecological housing development'.[59] Hockerton is a community of five households in the English East Midlands, who occupy a new-built, low-rise terrace beside a

small lake. Each house has a glassed area on the lake side, like a greenhouse, with earth-sheltering on the other side to reduce the development's visual impact and conserve heat. The greenfield site was acquired in advance by one of the participants, who drew in other families by personal contacts and through advertising. Not everyone stayed through the planning process, which included a land management plan as well as environmental impact studies and applications for planning permission. The project embodies co-housing – whereby homes are private but land, water and energy are shared – and sustainability – houses consume between 15 and 25 per cent of average electricity use – in a micro-community.[60] Collective billing for electricity saves money, for example, and, perhaps most importantly, land use provides up to 80 per cent of the fruit and vegetables consumed by the group of households. There are chickens for eggs, and a sheep for grazing and meat. Water is harvested, separating drinking and non-drinking supplies with different treatment regimes, in both cases avoiding chemicals through a natural reed-bed system but not overtreating water used for vegetable plots. All food grown on the site is collectively produced and shared within the co-housing agreement, and energy is provided by two solar installations (installed in 2002 and 2012) and two wind turbines (erected in 2002 and 2004). The project's website sums up, 'We bring sustainability to life through our inspiring homes and our affordable, low-tech efficient buildings.'[61]

Looking further back, and to a response to an environmental emergency, floods in 1993 devastated the small town of Pattonsburg, Missouri (founded in 1845). As the Grand River rose, efforts to contain it using earth-moving equipment failed. Buildings in the town centre were flooded. Then it happened again within a few days of the clear-up. Pattonsburg had been flooded 30 times before, and a dam had been proposed in the 1970s, but when a new highway was built several miles away, taking away much of its passing trade, the town began to decline to the point that its population, once around 2000, shrank to 316 in the 1990s. Following a long campaign by local residents, a plan was developed to move the town to higher ground. Looking to a precedent in Soldier's Grove, Wisconsin, where such a measure was piloted after a flood in 1978, the proposed new town was to be sustainable. Environmentalist Steve Lerner cites architect Robert Berkebile's holistic approach, for example, to building materials,

He learned that not only does the manufacture of aluminium require large amounts of energy but that one of the key ingredients... is bauxite, an ore frequently mined from beneath tropical rain forest. On another building... he learned that the marble [from Minnesota] had been shipped to Mexico to be cut and then to Italy to be polished... In the process of reviewing all the materials used in his buildings, Berkebile became an expert on the environmental costs of building materials and various construction methods.[62]

After a visit to Soldier's Grove, residents engaged in action planning for the new settlement, looking at water conservation, natural means of storm drainage, provision of green space as a flood plain, passive solar gain from building alignment, pedestrianization, housing for older people in the centre close to shops and high standards for energy conservation. There is an agreed town building code but a proposal to require clothes lines to be screened by vine arbours was rejected. This is a minor detail which, I think, raises an interesting issue: many aspirational settlements (from Disney's pseudo-colonial Celebration, Florida, to the Prince of Wales's equation of past architectural styles with an orderly life at Poundbury, Dorset) have such codes limiting behaviour as well as visual appearance. But at Pattonsburg, it was pointed out that the negative perception of clothes lines was encouraged by energy companies in the postwar years to increase the use of drying appliances;[63] drying clothes outdoors is energy-efficient, and refuses the social exclusion which is enhanced when such action is regarded as disorderly. As Lerner notes, Pattonsburg is not a utopian project.[64] Nor is it an intentional community; it demonstrates instead that sustainability can be translated into mainstream society if, again, at a local scale.

A barefoot campus

Finally, I turn to the Social Work Research Centre, Tilonia, Rajasthan. The Barefoot College, as it is known, has a staff of around 50 and provides residential training for up to 200 villagers. On Ghandian lines, it works with the poorest of the poor to seed skills and raise awareness in programmes from water harvesting to community health, craft, puppet-making and education. Founded

in 1972 in a redundant British fever hospital, and initially dealing with water harvesting, it expanded to its current self-built campus in 1986.⁶⁵

Adopting a barefoot philosophy, 'The college aims to demonstrate that village knowledge, skills and practical wisdom can be used to improve people's lives'.⁶⁶ It trains and employs villagers to teach other villagers, for instance, to make and maintain solar lanterns, and as teachers who return to their villages to set up night schools. A solar cooker provides all cooked food except chapattis, sited on the dining-room roof (Figure 8.9). The staff receive a basic salary, with small additions for section heads and a director, and meet to make consensus decisions on everything. Whatever can be recycled is recycled, including the newspapers used in carrier bags for the craft shop (Figure 8.10).

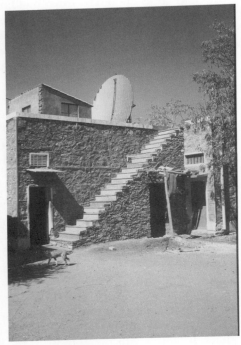

FIGURE 8.9 *Solar cooker on the dining room roof, Social Work Research Centre, Tilonia, Rajasthan, India*

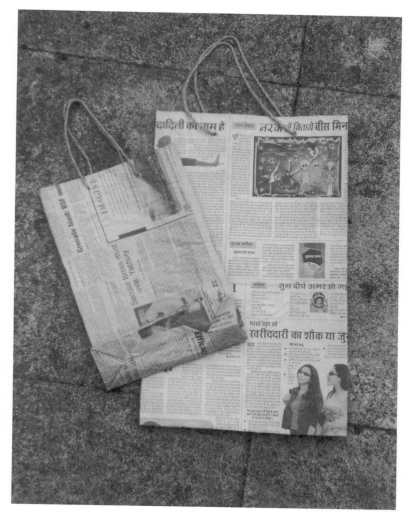

FIGURE 8.10 *Recycled newspapers used for carrier bags, Social Work Research Centre, Tilonia, Rajasthan, India*

I visited Tilonia in 2005, and was taken to two night schools (in a network of more than a hundred). The government runs day schools but many children work in the fields all day; the night

schools are combined with water harvesting, and the teachers are villagers themselves. They offer literacy, numeracy and, I was told, society. Some of the older children work in the marble quarries. They were paid less than the clerk wrote down, which they could read, and brought the matter to the children's parliament consisting of a representative from each school supported secretarially by the college. Letters were sent to the authorities, as a result of which the children began to receive the legal minimum wage. The difference was the price of a bag of fruit in the market, but it appeared that what they had learned was society, or solidarity.

The Barefoot College demonstrates voluntary simplicity in an Indian context. The question is how this can be translated into equivalent tactics in an affluent society so that the aims of energy-efficiency and recycling, which are sometimes read as technical or pragmatic, appear as a basis for a green society – that is, a society of mutual aid, well-being, social and environmental justice and an ethical joy.

NOTES

Introduction

1. Cf Phillips, P., 'Out of Order: the Public Art Machine', *Artforum*, December 1988, pp. 93–96
2. Benjamin, W., 'The Work of Art in the Age of Mechanical Reproduction', in *Illuminations*, ed. Arendt, H., London, Fontana, 1973, pp. 219–254; see Leslie, E., *Walter Benjamin: Overpowering Conformism*, London, Pluto, 2000, pp. 130–167
3. Taylor, A. and Gessen, K. and editors from n+1, *Occupy! Scenes from Occupied America*, New York, n+1, 2011; van Gelder, S., ed., *This Changes Everything: Occupy Wall Street and the 99% movement*, New York, Berrett-Koehler, 2011
4. www.climateaction.org.uk
5. Holloway, J., *Crack Capitalism*, London, Pluto, 2010, p. 255
6. Williams, R., *The Long Revolution*, Harmondsworth, Penguin, 1965

Chapter 1

1. Carrington, D., 'Carbon bubble creates global economic risk', *The Guardian*, 19 April 2013, p. 1
2. Stern, N., 'Stern Review on the Economics of Climate Change', executive summary, www.hm-treasury.gov.uk/Stern/Executive_Summary.pdf [accessed 14 May 2013]
3. Carrington, 'Carbon bubble', p. 1
4. For example, see Christianson, G. E., *Greenhouse: The 200-year Story of Global Warming*, London, Constable, 1999; Flannery, T., *The Weather Makers: The History and Future Impact of Climate Change*, London, Allen Lane, 2005; Gilding, P., *The Great Disruption: How the Climate Crisis will Transform the Global Economy*, London, Bloomsbury, 2011; Kolbert, E., *Field Notes from a Catastrophe: A Frontline Report on Climate Change*, London, Bloomsbury, 2006; Lynas, M., *High Tide: News from a Warming World*, London, Flamingo, 2004; Monbiot, G., *Heat: How to Stop the Planet Burning*, London, Allen Lane, 2006

5 Vince, G., 'Surviving in a warmer world', *New Scientist*, 28 February 2009, pp. 29–33
6 Monbiot, G., *Heat: How to Stop the Planet Burning*, London, Allen Lane, 2006, pp. xi–xii
7 Monbiot, *Heat*, pp. 20–42
8 All quotes from *The Guardian*
9 Collectif Argos, *Climate Refugees*, Cambridge (MA), MIT, 2010, pp. 124–162
10 Verdin, J., Funk, C., Senay, G. and Choularon, R., 'Climate Science and Famine Early Warning', *Philosophical Transactions of the Royal Society*, 360, 29 November 2005, pp. 2155–2168, cited in Monbiot, *Heat*, p. 21
11 Macalister, T., 'Shell's brief testing of oil drilling cap in Arctic is reckless, say campaigners', *The Guardian*, 10 September, 2012, p. 20
12 Amunwa, B. with Minio, M., *Counting the Cost: Corporations and human rights abuses in the Niger Delta*, London, Platform, 2011; Marriott, J. and Minio-Paluello, M., *The Oil Road: Journeys from the Caspian Sea to the City of London*, London, Verso, 2012
13 Marcuse, H., *The Aesthetic Dimension*, Boston, Beacon Press, 1978, p. 1
14 Marcuse, *The Aesthetic Dimension*, pp. 64–65
15 Miles, M., *Herbert Marcuse: an aesthetics of liberation*, London, Pluto, 2011, pp. 65–85
16 Kester, G., *Conversation Pieces: Community and Communication in Modern Art*, Berkeley (CAL), University of California Press, 2004
17 Krauss, R., 'Sculpture in the Expanded Field', in Foster, H. ed., *The Anti-Aesthetic: essays on postmodern culture*, Seattle (WA), Bay Press, 1983, pp. 31–42
18 Beardsley, J., *Earthworks and Beyond*, New York, Abbesville Press, 1996
19 Bourriaud, N., *Relational Aesthetics*, Dijon, les presses du reel, 2002
20 Guatarri, F., *The three ecologies*, London, Athlone Press, 2001, cited in Bourriaud, *Relational Aesthetics*, pp. 79–104
21 Rancière, J., *The Future of the Image*, London, Verso, 2007, p. 64
22 Ross, T., 'Image, Montage', in Deranty, J-P., ed., *Jacques Rancière: Key Concepts*, Durham, Acumen, 2010, p. 167
23 Roy, A., *Listening to Grass Hoppers: Field Notes on Democracy*, London, Hamish Hamilton, 2009
24 Roy, A., *The Ordinary Person's Guide to Empire*, London, Flamingo, 2004, pp. 43–44

NOTES

25 Wigglesworth, S. and Till, J., 'The Everyday and Architecture', *Architectural Design*, profile 134, July–August, 1998, p. 7
26 Till, J., *Architecture Depends*, Cambridge (MA), MIT, 2009
27 Cutts, S., ed., *The Unpainted Landscape*, London, Corcacle, 1987 [exhibition publication]
28 Davies, P. and Knipe, T., eds., *A Sense of Place: Sculpture in the Landscape*, Sunderland, Ceolfrith Press, 1984; Martin, R., *The Sculpted Forest: Sculptures in the Forest of Dean*, Bristol, Redcliffe Press, 1990
29 Leeds City Art Gallery, *Rain sun snow hail mist calm* [exhibition catalogue], Leeds, City Art Gallery and Henry Moore Foundation, 1985 [reprinted 1986],
30 Cited in Lee, M. F., *Earthfirst! Environmental Apocalypse*, Syracuse (NY), Syracuse University Press, 1995, p. 32
31 McKay, G., *Senseless Acts of Beauty: Cultures of Resistance since the Sixties*, London, Verso, 1996, pp. 53–56
32 Phillips, P., 'Maintenance Activity: Creating a Climate for Change', in Felshin, D., ed., *But Is It Art? The Spirit of Art as Activism*, Seattle (WA), Bay Press, 1995, p. 171
33 see Shields, R., *Levebvre, Love and Struggle*, London, Routledge, 1999, pp. 58–64
34 Reason, D., 'A Hard Singing of Country', in Cutts, ed., *The Unpainted Landscape*, p. 24
35 Reason, 'A Hard Singing of Country' p. 25
36 Sandercock, L., *Towards Cosmopolis*, Chichester, Wiley, 1998
37 Reason, 'A Hard Singing of Country', p. 25
38 Strelow, *Natural Reality*, Stuttgart, Daco Verlag, 1999, p. 21
39 Strelow, *Natural Reality*, p. 181
40 de vries, h., 'to be', Meier, A., ed., Ostfildern, Cantz, 1995, p. 119, quoted in de Boer, C., ed., *herman de vries*, Amsterdam, Stichting Fonds voor beelende kunsten, 1998, p. 45
41 Chin, M. interviewed by Cudlin, J., in Moyer, T. and Harper, G., eds., *The New Earthwork*, Hamilton (NJ), ISC Press, 2011, p. 103
42 Harper, G., 'Bob Bingham – building environments', in Moyer and Harper, eds., *The New Earthwork*, pp. 172–174
43 Kester, G., 'Theories and Methods of Collaborative Art Pratice', in *Groundworks*, in Kester, G. ed., Pittsburgh (PA), Carnegie Mellon University, 2005, p. 20

44 www.alaplastica.org.ar
45 Ala Plastica, quoted in *Groundworks*, p. 90
46 Huit Facettes-Interaction, quoted in *Groundworks*, p. 101
47 Huit Facettes-Interaction, quoted in *Groundworks*, p. 101
48 Altaf, quoted in *Groundworks*, p. 113
49 Altaf, quoted in *Groundworks*, p. 113
50 Shiva, V., *Stolen Harvest: The Hijacking of the Global Food Supply*, London, Zed Books, 2000
51 Manacorda, F. and Yedgar, A., eds., *Radical Nature* [exhibition catalogue], London, Barbican Arts Centre and Koenig Books, 2009, p. 88
52 Barreto, R. D., 'Agnes Denes: Sculptural and Environmental Conceptualism', in Moyer and Harper., eds., *The New Earthwork*, pp. 69–73
53 Demos, T. J., 'The Politics of Sustainability: Art and Ecology', in Manacorda and Yedgar, eds., *Radical Nature*, p. 28
54 Swyngedouw, E., 'Circulations and Metabolisms: (Hybrid) Natures and (Cyborg) Cities', *Science as Culture*, 15, 2, 2006, p. 115, cited in Demos, 'Politics of Sustainability', p. 19
55 Demos, 'The Politics of Sustainability', p. 18
56 www.lttds.org/projects/greenwashing [accessed 7th March 2013]
57 Swyngedouw, 'Circulations and Metabolisms,' p. 115
58 George, S., *Another World is Possible If...*, London, Verso, 2004, p. 249
59 George, S., *Another World is Possible If...*
60 Kristeva, J., *The Sense and Non-Sense of Revolt*, New York, Columbia University Press, 2000, p. 146
61 Nochlin, L., 'The Invention of the Avant-Garde: France, 1830–80' in Hess, T. B. and Ashbery, J., eds., *Avant-Garde Art*, New York, Macmillan, 1968, pp. 1–24; Clark, T. J., *Image of the People: Gustave Courbet and the 1848 Revolution*, London, Thames and Hudson, 1973
62 Rosler, M., 'Place, Position, Power, Politics', in Becker, C., ed., *The Subversive Imagination: Artists, Society, and Social Responsibility*, New York, Routledge, 1994, p. 57
63 Clark, T. J., *Farwell to An Idea: Episodes from a history of Modernism*, New Haven (CT), Yale, 1999, p. 9
64 Marcuse, H., 'Ecology and Revolution', in *The New Left and the 1990s*, London, Routledge, 2005, p. 174

65 Marcuse, 'Ecology and Revolution', p. 175
66 Žižek, S., *Living in the End Times*, London, Verso, 2nd ed., 2011, p. 327
67 Žižek, *Living in the End Times*, p. 328
68 Žižek, *Living in the End Times*, p. 328
69 Monbiot, *Heat*, p. 205
70 Monbiot, *Heat*, p. 205
71 Benjamin, 'Theses on the Philosophy of History', in *Illuminations*, London, Fontana, 1973, p. 259
72 Benjamin, 'Theses on the Philosophy of History'
73 Vidal, J., 'Sea ice in Arctic melts to lowest level ever recorded', *The Guardian*, 15 September 2012, p. 1

Chapter 2

1 Carson, R., *Silent Spring*, London, Penguin Classics, 2000, p. 21 [first published New York, Houghton Mifflin, 1962]
2 Bateson, G., *Steps to an Ecology of Mind*, Chicago, University of Chicago Press, 1972; Donaldson, R., ed., *A Sacred Unity: Further Steps to an Ecology of Mind*, New York, Harper-Collins, 1991
3 Warnke, M., *Political Landscape: The Art History of Nature*, London, Reaktion, 1994
4 Carson, *Silent Spring*, p. 25
5 Carson, *Silent Spring*, p. 25
6 Carson, *Silent Spring*, p. 31
7 Carson, *Silent Spring*, p. 42
8 Sloterdijk, P., *Terror From the Air*, Los Angeles (CA), Semiotext(e), 2009, pp. 42–46
9 Carson, *Silent Spring*, p. 23
10 Darwin, C., *The Formation of Vegetable Mould through the Action of Worms, with Observations on Their Habits*, London, John Murray, 1881
11 Carson, *Silent Spring*, p. 63
12 Carson, *Silent Spring*, pp. 63–64
13 Haeckel, E., *The Natural History of Creation*, New York, Appleton, 1914 [first published in German, Berlin, 1868, a revision of *The General Morphology of Organisms*, 1866]

14 Sadler, S., 'The Dome and the Shack: The Dialectics of Hippie Enlightenment', in Boal, I., Stone, J., Watts, M. and Winslow, C., eds., *West of Eden: Communes and Utopia in Northern California*, Oakland (CA), PM Press, 2012, pp. 72–80

15 Gibson, J. J., *The Ecological Approach to Visual Perception*, Boston, Houghton Mifflin, 1979, p. 8, cited in Goodbun, J., 'Gregory Bateson's Ecological Aesthetics – an addendum to urban political ecology', *Field*, 4, 1, p. 37

16 Forty, A., *Words and Buildings: A Vocabulary of Modern Architecture*, London, Thames and Hudson, 2000, p. 220

17 Morton, T., *Ecology Without Nature: Rethinking Environmental Aesthetics*, Cambridge (MA), Harvard, 2007

18 Botkin, D., *Discordant Harmonies: A New ecology for the Twenty-First Century*, Oxford, Oxford University Press, 1990, p. 9, cited in Paden, R., Harmon, L. K. and Milling, C., 'Ecology, Evolution, and Aesthetics: Towards an Evolutionary Aesthetics of Nature', *British Journal of Aesthetics*, 52, 2, 2012, p. 128

19 Paden et al., 'Ecology, Evolution, and Aesthetics', p. 129

20 Odum, H. T., 'Energy, Ecology and Economics', *AMBIO: A Journal of the Human Environment*, 2, 6, 1960, pp. 220–227

21 Pepper, D., *Modern Environmentalism: An Introduction*, London, Routledge, 1996, p. 283, citing Worster, D., *Nature's Economy: a history of ecological ideas*, Cambridge, Cambridge University Press, 1985, pp. 311–313

22 Pepper, *Modern Environmentalism*, p. 283

23 Bramwell, A., *Ecology in the Twentieth Century: a history*, London, Yale, 1989, p. 43, cited in Pepper, *Modern Environmentalism*, p. 185

24 Pepper, *Modern Environmentalism*, p. 188; see also Gasman, D., *The Scientific Origins of National Socialism: social Darwinism and Ernst Haeckel and the German Monist League*, London, MacDonald, 1971; Bramwell, A., *Bloid and Soil: Walther Darre and Hitler's 'Green Party'*, Bourne End, Kensal, 1985

25 Boockchin, M., *Towards an Ecological Society*, Montreal, Black Rose, 1980, p. 16, cited in Kovel, J., 'Negating Bookchin', in Light, A., ed., *Social Ecology after Bookchin*, New York, Guilford Press, 1998, p. 39

26 Bookchin, M. 'Freedom and Necessity in Nature: A Problem in Ecological Ethics', *Alternatives*, 13, 4, 1986, p. 5, cited in Eckersley, R., 'Diving Evolution and Respecting Evolution', in Light, ed., *Social Ecology After Bookchin*, New York, Guilford Press, 1998, p. 62

NOTES

27 Bookchin, *Urbanization without Cities: The Rise and Decline of Citizenship*, Montreal, Black Rose Books, 1992, pp. 175–181
28 Bookchin, M., *The Ecology of Freedom*, Palo Alto (CA), Cheshire Books, 1982, p. 357
29 Light, A., ed., *Social Ecology after Bookchin*, p. 6
30 Bookchin, M., *Remaking Society*, Montreal, Black Rose Books, 1989, p. 102, cited in Kovel, J., 'Negating Bookchin' in Light, ed., *Social Ecology after Bookchin*, p. 29
31 Adorno, T. W. and Horkheimer, M., *Dialectic of Enlightenment*, London, Verso [1944] 1997
32 Albrecht, G. A., 'Ethics and Directionality in Nature' in Light, ed., *Social Ecology after Bookchin*, p. 93
33 Kropotkin, P., *Mutual Aid*, popular edition, London, Heinemann, 1915
34 Kropotkin, *Mutual Aid*, p. 172
35 Bookchin, M., *Defending the Earth: A Dialogue between Murray Bookchin and Dave Foreman*, Montreal, Black Rose Books, 1991, p. 131
36 Light, A., 'Reconsidering Bookchin and Marcuse as Environmental Materialists: Toward an Evolving Social Ecology' in *Social Ecology after Bookchin*, pp. 343–384
37 Bookchin, *Urbanization without Cities*, p. 187
38 Bookchin, M., 'New Social Movements: The Anarchic Dimension', in Goodway, D. ed., *For Anarchism: History, Theory and Practice*, London, Routledge, 1989, p. 273, cited in Light, 'Reconsidering Bookchin' pp. 349–350
39 Bookchin, *Remaking Society*, p. 11
40 Capra, F., 'Deep Ecology: A New Paradigm' in Sessions, G. ed., *Deep Ecology for the 21st Century*, Boston (MNA), Shambala, 1995, p. 20
41 Capra, 'Deep Ecology' p. 24
42 Naess, A., 'The Deep Ecology Movement: Some Philosophical Aspects' in Sessions, ed., *Deep Ecology for the 21st Century: Readings on the philosophy and practice of the new environmentalism*, Boston, Shambhala, 1995, p. 68
43 Meadows, D. H., Meadows, D. L., Randers, J. and Behrens, W. W., *The Limits to Growth*, New York, Universe Books, 1972; Meadows, D. H., Meadows, D. L. and Randers, J., *Beyond the Limits to Growth*, Post Mills (VT), Chelsea Green, 1992; Meadows, D. H., Randers, J. and Meadows, D. L., *Limits to Growth: the 30-year Update*, London, Earthscan, 2005

44. Malthus, T. [1798] *An Essay on the Principle of Population*, available online: www.esp.org/book/malthus/population/malthus.pdf
45. Ehrlich. P., *The Population Bomb*, New York, Sierra Club/Ballantine, 1968, p. 166
46. Naess, 'The Deep Ecology Movement', p. 73
47. Meadows, Randers and Meadows, *Limits to Growth: the 30-year Update*, p. 239
48. Rangan, H., 'From Chipko to Uttaranchal: Development, Environment and Social Protest in the Garwhal Hamalays, India' in Peet, R. and Watts, M. eds., *Liberation Ecologies: Environment, Development, Social Movements*, London, Routledge, 1996, pp. 205–226
49. Simmons, I. G., *Interpreting Nature: Cultural Constructions of the Environment*, London, Routledge, 1993, p. 134
50. Simmons, *Interpreting Nature: Cultural Constructions of the Environment*
51. Naess, A. 'Politics and the Ecological Crisis: An Introductory Note' in Sessions, ed., *Deep Ecology*, p. 445
52. Naess, 'Politics and the Ecological Crisis', p. 446
53. Naess, 'Politics and the Ecological Crisis', p. 447
54. Naess, 'Politics and the Ecological Crisis', p. 450
55. Naess, 'Politics and the Ecological Crisis', p. 453
56. Giroux, H. A., *Twilight of the Social: Resurgent Publics in the Age of Disposability*, London, Pluto, 2012, p. 45, citing www.endpoliticsasusual.com/2010/11/arizona-death-panels-state-revokes-funding-for-heart-transplants-opts-to-save-squirrels/
57. Turner, J. F. C., *Housing by People*, London, Marion Boyars, 1976
58. Sandercock, L., *Towards Cosmopolis*, Chichester, Wiley, 1998
59. Conroy, C. and Litvinoff, M., *The Greening of Aid: Sustainable Livelihoods in Practice*, London, Earthscan, 1998; Guha, R. and Martinez-Alier, J., *Varieties of Environmentalism: Essays North and South*, London, Earthscan, 1997
60. Jarosz, L., 'Defining Deforestation in Madagascar', in Peet and Watts, eds., *Liberation Ecologies*, pp. 151–152
61. Shiva, V., *Stolen Harvest: the hijacking of the global food supply*, London, Zed Books, 2000; Yapa, L., 'Improved Seeds and Constructed Scarcity' in Peet and Watts, eds., *Liberation Ecologies*, pp. 69–85; see also, Mies, M. and Shiva, V., *Eco-feminism*, London, Zed Books, 1993

62 Jarosz, 'Defining Deforestation in Madagascar', p. 161
63 Camacho, D. E., *Environmental Injustices, Political Struggles: Race, Class, and the Environment*, Durham (NC), Duke University Press, 1998; Carmen, R., *Autonomous Development: Humanizing the Landscape*, London, Zed Books, 1996; Kabeer, N., *Reversed Realities: Gender, Hierarchies and Development Thought*, London, Verso, 1994
64 Callicott, J. B., *Earth's Insights: A Multicultural Survey of Ecological Ethics from the Mediterranean Basin to the Australian Outback*, Berkeley (CA), University of California Press, 1994
65 de Rivero, O., *The Myth of Development: the non-viable economies of the 21st century*, London, Zed Books, 2001, p. 51
66 Roy, A., *Power Politics*, Cambridge (MA), South End Press, 2nd edition, 2001
67 Roy, A., *Listening to Grasshoppers: field notes on democracy*, London, Penguin, 2009, p. 39
68 Escobar, A., 'Constructing Nature: Elements for a post-structural political ecology', in Peet and Watts, eds., *Liberation Ecologies*, p. 49
69 Peet, R. and Watts, M., 'Liberation Ecology: Development, sustainability, and environment in an age of market triumphalism', in Peet and Watts, eds., *Liberation Ecologies*, p. 6
70 Rangan, 'From Chipko to Uttaranchal', p. 207
71 Fairhead, J., Leach, M. and Scoones, I., 'Green Grabbing: a new appropriation of nature?' *Journal of Peasant Studies*, 39, 2, p. 239
72 Vidal, J. 'The great green land grab' *The Guardian*, 13 February, 2008 [accessed online]
73 Fairhead, J., Leach, M. and Scoones, I., 'Green Grabbing', *Journal of Peasant* Studies, 39, 2, p. 250
74 Panayotakis, C., *Remaking Scarcity: From Capitalist Inefficiency to Economic Democracy*, London, Pluto, 2011, p. 93
75 Panayotakis, *Remaking Scarcity*, p. 95
76 Panayotakis, *Remaking Scarcity*, p. 97, citing World Commission on Environment and Development, *Our Common Future*, Oxford, Oxford University Press, 1987
77 Panayotakis, *Remaking Scarcity*, pp. 115–119, citing Schweickart, D. 'Socialism, Democracy, Market, Planning: Putting the Pieces Together', *Review of Radical Political Economics*, 24, 3/4, 1992, pp. 29–45; *Against Capitalism*, Cambridge, Cambridge University Press, 1993

78 Panayotakis, *Remaking Scarcity*, pp. 119–124, citing Albert, M. and Hahnel, R., *The Political Economy of Participatory Economics*, Princeton (NJ), Princeton University Press, 1991; Albert, M., *Parecon: Life After Capitalism*, London, Verso, 2003
79 Klein, N., *The Shock Doctrine: The Rise of Disaster Capitalism*, London, Penguin, 2008
80 Marcuse, H., 'Ecology and Revolution' in *The New Left and the 1960s*, London, Routledge, 2005, p. 174 [first published in French, Paris, *Le nouvelle observateur*, 379, 1972],
81 Bahro, R., *Socialism and Survival*, London, Heretic Books, 1982, p. 149
82 Donald, J., *Imagining the Modern City*, London, Athlone, 1999, p. 86
83 Grosz, E., *The Nick of Time: Politics, Evolution, and the Untimely*, Durham (NC), Duke University Press, 204, p. 21
84 Grosz, *The Nick of Time*, p. 33
85 Grosz, *The Nick of Time*, p. 33
86 Grosz, *The Nick of Time*, p. 39

Chapter 3

1 von Goethe, J. W., 'Announcement of a Thesis on Colour' [1791], in Matthaei, R. ed., *Goethe's Colour Theory*, London, Studio Vista, 1971, p. 13
2 Descartes, R., *Discourse on Method*, trans. Wollaston, A., Harmondsworth, Penguin, 1960
3 Wagner, P., *Theorizing Modernity*, London, Sage, 2001, p. 17
4 Wagner, P., *Theorizing Modernity*
5 Dewey, T., *The Quest for Certainty* in *The Later Works 1925–1953*, vol. 4, Carbondale (IL), Southern Illinois University Press, 1984, p. 231, cited in Wagner, *Theorizing Modernity*, p. 16
6 Bowie, A., *Aesthetics and Subjectivity: from Kant to Neitzsche*, Manchester, Manchester University Press, 2nd ed., 2003, p. 2
7 Fredriksson, A., 'Environmental Aesthetics Beyond the Dialectics of Interest and Disinterest', *Nordic Journal of Aesthetics*, 40/41, 2010–2011, p. 90
8 Fredriksson, 'Environmental Aesthetics beyond the Dialectics of Interest and Disinterest'

NOTES

9 Adorno, T. W., *Aesthetic Theory* [1969] trans. Hullot-Kentor, R., London, Athlone, 1997, p. 77
10 Bowie, *Aesthetics and Subjectivity*, p. 104
11 Bowie, *Aesthetics and Subjectivity*, p. 115
12 Bowie, *Aesthetics and Subjectivity*, p. 118
13 Baumgarten, A. *Theoretische Aesthetik*, Hamburg, Meiner, 1988
14 Hammermeister, K. *The German Aesthetic Tradition*, Cambridge, Cambridge University Press, 2002, p. 4
15 Williams, R., *Keywords: a vocabulary of culture and society*, London, Fontana, 1976, p. 27
16 Williams, *Keywords*, p. 28
17 Kieran, M., *Revealing Art*, London, Routledge, 2006, p. 53
18 Körner, W. S., *Kant*, Harmondsworth, Penguin, 1995, pp. 181–182
19 Körner, *Kant*
20 Descartes, *Discourse on Method*, p. 44
21 Lacour, C. B., *Lines of Thought: Discourse, Architectonics, and the Origin of Modern Philosophy*, Durham (NC), Duke University Press, 1996, p. 36
22 Belsey, C. *The Subject of Tragedy: Identity and Difference in Renaissance Drama*, London, Routledge, 1985, p. 120
23 Körner, *Kant*, p. 190
24 Körner, *Kant*, p. 191
25 Wordsworth, W. 'Gordale' [1918] *The Poems* II, Harmondsworth, Penguin, 1979, p. 378
26 Kirwan, J., *Sublimity*, London, Routledge, 2005, p. 54
27 Buchner, G., *Complete Plays, Lenz and Other writings*, London, Penguin, 1993, p. 163
28 Kirwan, *Sublimity*, p. 53
29 Spender, 'Introduction' in Spender, S. ed., *Shelley's Verse*, London, Faber and Faber, 1972, p. 12
30 Dovey, K., *Framing Places: Mediating power in built form*, London, Routledge, 1999, p. 61
31 Bloch, E., 'On the Original History of the Third Reich' [1939] *Heritage of Our Times*, Cambridge, Polity, 1991, pp. 117–137
32 Michalski, S., *Public Monuments: Art in Political Bondage 1870–1997*, London, Reaktion, 1998, p. 62

33 Marcuse, H. 'The Affirmative Character of Culture' [1937] in Kellner, D. ed., *Art and Liberation*, London, Routledge, 2007, p. 103
34 von Goethe, J. W., *Der Sammler und die Seinigen*, toward the end of the 6th letter, no date given, quoted in Marcuse, 'The Affirmative Character of Art' p. 104
35 Gadamer, H-G., *Truth and Method*, London, Continuum, [1975] 2004, pp. 37–38
36 Marcuse, H. 'Society as a Work of Art' [1968], in Kellner, D. ed., *Art and Liberation*, London, Routledge, 2007, p. 123
37 Marcuse, 'Society as a Work of Art', p. 126
38 Marcuse, 'Society as a Work of Art', p. 129
39 Bloch, E., *The Principle of Hope*, Cambridge (MA), MIT, 1986 [3 volumes]
40 Wolff, J., *The Aesthetics of Uncertainty*, New York, Columbia University Press, 2008, p. 73, citing Mulvey, L., 'Visual Pleasure and Narrative Cinema' in Wallis, B., ed., *Art After Modernism: Rethinking Representation*, New York, New Museum of Contemporary Art, 1984, p. 363
41 Gadamer, *Truth and Method*, p. 53
42 Benjamin, W., 'Paris – the Capital of the Nineteenth Century' [1935] in *Charles Baudelaire*, London, Verso, 1997, p. 173–174
43 Harvey, D., *The Urban Experience*, Baltimore (MD), Johns Hopkins University Press, 1989, p. 202
44 Harvey, *The Urban Experience*, p. 219
45 Wilson, E., *Axel's Castle*, London, Fontana, [1931] 1976, p. 22
46 Marcuse, H., 'Ecology and Revolution', in Kellner, D. ed., *The New Left and the 1960s.*, London, Routledge, 2005, pp. 173–176
47 Marcuse, H., 'Some Remarks on Aragon: Art and Politics in the Totalitarian Era'[1945] in Kellner, D. ed., *Technology, War and Fascism*, London, Routledge, 1998, p. 203
48 Marcuse, 'Some Remarks on Aragon', p. 204
49 Marcuse, 'Some Remarks on Aragon', p. 204; see Miles, M. *Herbert Marcuse: An Aesthetic of Liberation*, London, Pluto, 2011, pp. 65–85
50 Gadamer, *Truth and Method*, p. 55
51 Huysmans, J. K., *Against Nature*, Harmondsworth, Penguin, [1884] 1976, p. 22
52 Adorno, T. W., *Minima Moralia*, Frankfurt, Suhrkamp, 1951, p. 11
53 Bowie, *Aesthetics and Subjectivity*, p. 323

54 Kristeva, J., *Revolution in Poetic Language*, New York, Columbia University Press, 1984, p. 118
55 Bourriaud, N., *Relational Aesthetics*, Dijon, les presse du reel, 2002, pp. 25–26
56 Bourriaud, *Relational Aesthetics*, p. 30
57 Rancière, J., *Aesthetics and its Discontents*, Cambridge, Polity, 2009, pp. 12–13
58 Rancière, *Aesthetics and its Discontents*, pp. 25–26

Chapter 4

1 Jeffries, R., *After London*, [1885] in Carey, J., ed., *The Faber Book of Utopias*, London, Faber, 1999, p. 276
2 Jeffries, *After London*, pp. 276–277
3 Jeffries, *After London*, pp. 277–278
4 Jeffries, *After London*, p. 278
5 Woodward, C., *In Ruins*, London, Vintage, 2002, p. 74
6 Woodward, *In Ruins* citing Jeffries' diary [reference not stated]
7 Gandy, M., 'Urban nature and the ecological imaginary', in Heynen, N., Kaika, M. and Swyngedouw, E., eds., *In the Nature of Cities: Urban Political Ecology and the Politics of Urban Metabolism*, London, Routledge, 2006, p. 64
8 Engels, F., *The Condition of the Working Class in England in 1844*, London, Allen and Unwin, 1892; see Donald, J., *Imagining the Modern City*, London, Athlone, 1999, pp. 33–37
9 Illich, I., *H_2O and the Waters of Forgetfulness*, London, Marion Boyars, 1986, p. 50
10 Illich, *H_2O and the Waters of Forgetfulness*
11 Aries, P., *The Hour of Our Death*, New York, Random House, 1982, cited in Illich, *H_2O and the Waters of Forgetfulness*, p. 51
12 Illich, *H_2O and the Waters of Forgetfulness*, p. 51
13 Illich, *H_2O and the Waters of Forgetfulness*, p. 56
14 Laporte, D., *History of Shit* [1993] Cambridge (MA), MIT, 2000, p. 98
15 Corbin, *The Foul and the Fragrant: Odour and the Social Imagination*, London, Macmillan, 1996, p. 20
16 Degen, M. M., *Sensing Cities: Regenerating public life in Barcelona and Manchester*, London, Routledge, 2008, p. 66

17 Shelley, P. B., 'Ozymandias' [1818] *Shelley's Verse*, London, Faber and Faber, 1971, p. 26
18 Merewether, C., 'Traces of Loss', in Roth, M. S., Lyons, C. and Merewether, C., eds., *Irresistible Decay*, Los Angeles (CA), Getty Research Institute for the History of Art and the Humanities, 1997, p. 25
19 Schönle, 'Modernity as a "Destroyed Anthill"', in Hell, J. and Schönle, A., eds., *Ruins of Modernity*, Durham (NC), Duke University Press, 2010, p. 95
20 Schönle, A., 'Modernity as a "Destroyed Anthill"', p. 96
21 Huysen, A., 'Authentic Ruins', in Hell and Schönle, eds., *Ruins of Modernity*, p. 19
22 Lynas, P., *Six Degrees: Our Future on a Hotter Planet*, London, Harper Collins, 2008
23 Lynas, *Six Degrees*, p. 135
24 Lynas, *Six Degrees*, p. 231
25 Žižek, S. 'Censorshop Today: Violence, or Ecology as a New Opium for the Masses', www.lacan.com/zizecology1.htm [accessed 18 March 2013]
26 Žižek, S. 'Censorshop Today: Violence, or Ecology as a New Opium for the Masses'
27 Žižek, S. 'Censorshop Today: Violence, or Ecology as a New Opium for the Masses'
28 Adorno, T. W., 'The schema of mass culture', in *The Culture Industry: Selected essays on mass culture*, London, Routledge, 1991, p. 71
29 Swyngedouw, E., 'Apocalypse Forever? Post-political Populism and the Spectre of Climate Change', *Theory, Culture & Society*, 27, 2/3, 2010, p. 219
30 Katz, C., 'Under the Falling Sky: Apocalyptic Environmentalism and the Production of Nature', in Callari, A., Cullenberg, S. and Biewener, C., eds., *Marxism in the Post-Modern Age: Confronting the New World Order*, New York, Guilford Press, 1995, p. 278
31 Katz, 'Under the Falling Sky: Apocalyptic Environmentalism and the Production of Nature'
32 Ballard, J. G., *The Drowned World*, [1963] London, Dent, 1983, p. 21
33 Ballard, *The Drowned World*, p. 53
34 Ballard, *The Drowned World*, pp. 169–170
35 Ballard, *The Drowned World*, p. 175
36 Ballard, *The Drowned World*, p. 175 [italics original]

NOTES

37 Ballard, J. G., *The Drought*, [1965] Harmondsworth, Penguin, 1974, p. 30
38 Ballard, *The Drought*, pp. 55–56
39 Ballard, *The Drought*, p. 79
40 Ballard, *The Drought*, p. 103
41 Wyndham, J., *The Day of the Triffids*, Harmondsworth, Penguin, 1954, p. 190
42 Wyndham, *The Day of the Triffids*, p. 272
43 Macfarlane, R., 'Introduction', in Christopher, J., eds., *The Death of Grass*, [1956] London, Penguin, 2009, p. xi
44 Christopher, *The Death of Grass*, p. 31
45 Atwood, M., *Oryx and Crake*, London, Bloomsbury, 2003, pp. 119–120
46 Atwood, *Oryx and Crake*, p. 95
47 Atwood, *Oryx and Crake*, p. 225
48 Atwood, *The Year of the Flood*, London, Bloomsbury, p. 327
49 Atwood, *The Year of the Flood*
50 Atwood, *The Year of the Flood*, pp. 411–412
51 Byatt, A. S., 'Sea Story', *The Guardian* review, p. 20, 16 March 2013
52 Wells, H.G., *In the Days of the Comet*, London, Fontana, 1978 [1906], p. 151
53 Wells, *In the Days of the Comet*, p. 152
54 Wells, *In the Days of the Comet*, p. 157
55 Wells, *In the Days of the Comet*, p. 185
56 'Armchair-geddon', *Metro*, 7 June 2006, p. 31
57 Jackson, B., 'Four warned', *The Sun*, 26 February 2009, pp. 38–39
58 Vince, G., 'Surviving in a Warmer World', *New Scientist*, 28 February 2009, pp. 30–31
59 Swyngedouw, 'Apocalypse Forever?', p. 215
60 Swyngedouw, 'Apocalypse Forever?', p. 217
61 Smith, N., 'Afterword on the Third Edition', *Uneven Development*, London, University of Georgia Press, 2008, p. 245, quoted in Swyngedouw, 'Apocalypse Forever?', p. 222
62 Swyngedouw, 'Apocalypse Forever?', p. 228
63 Adorno, 'The schema of mass culture', p. 73
64 Streiber, W., *The Day After Tomorrow*, London, Gollancz, 2004, p. 249

Chapter 5

1. Gablik, S., 'The Nature of Beauty in Contemporary Art' *New Renaissance*, www.ru.org/81/gablik.html [accessed 15 August 2012]
2. Gablik, S., *Has Modernism Failed?* London, Thames and Hudson, 1984, p. 17
3. Gablik, *Has Modernism Failed?* p. 114–115
4. Gablik, *Has Modernism Failed?* p. 116
5. Gablik, *Has Modernism Failed?* p. 94
6. Gablik, S., *The Reenchantment of Art*, London, Thames and Hudson, 1991, p. 19
7. Gablik, *The Reenchantment of Art*, p. 27
8. Bishop, C., ed., *Participation*, Cambridge (MA), MIT, 2006; 'The Social Turn: Collaboration and its Discontents', *Artforum*, 44, 6, 2006, pp. 179–185; Kester, G., *The One and the Many: Contemporary Collaborative Art in a Global Context*, Durham (NC), Duke University Press, 2011
9. Greenberg, C., 'Avant-garde and kitsch', in *Collected Essays and Criticism*, vol. 1, O'Brien, J., ed., Chicago, University of Chicago Press, 1988, pp. 5–22
10. Deloria, P., 'Counterculture Indians and the New Age', in Braunstein, P. and Doyle, M. W., eds., *Imagine Nation: The American Counterculture of the 1960s and '70s*, New York, Routledge, 2002, pp. 159–188
11. Arendt, H., *The Human Condition*, Chicago, University of Chicago Press, 1958
12. Gablik, *The Reenchantment of Art*, p. 57
13. Bennett, J., *The Enchantment of Modern Life: Attachments, Crossings, and Ethics*, Princeton (NJ), Princeton University Press, 2001, p. 58
14. Bennett, *The Enchantment of Modern Life*, p. 60
15. Bennett, *The Enchantment of Modern Life*, p. 60, citing Scaff, L., *Fleeing the Iron Cage: Culture, Political and Modernity in the Thought of Max Weber*, Berkeley (CA), University of California Press, 1989, pp. 224–225; Weber, M., 'Science as a Vocation', in Gerth, H. H. and Mills, C. W., ed. and trans., *From Max Weber: Essays in Sociology*, Oxford, Oxford University Press, 1981, pp. 138–139
16. Adorno, T. W. and Horkheimer, M., *Dialectic of Enlightenment* [1944], London, Verso, 1997, p. 4

17 Preece, R., 'Trans-Species Art: A Conversation with Lynne Hull', in Moyer, T. and Harper, G., eds., *The New Earthwork*, Hamilton (NJ), ISC Press, 2011, p. 160
18 Preece, 'Trans-Species Art', p. 158
19 Mazeaud, D., cited in Lacy, S., ed., *Mapping the Terrain*, Seattle (WA), Bay Press, 1995, p. 263
20 Gablik, S., *Conversations before the end of time: Dialogues on Art, Life and Spiritual Renewal*, London, Thames and Hudson, 1997, pp. 192–197
21 Gablik, *Conversations before the end of time*, p. 75
22 Gablik, *Conversations before the end of time*, pp. 77–78
23 Gablik, *Conversations before the end of time*, p. 83
24 Ingold, T., 'Notes on the foraging mode of production', in Ingold, T., Riches, D. and Woodburn, J., eds., *Hunters and Gatherers: History, Evolution and Social Change*, Oxford, Berg, 1988, p. 272
25 Ingold, 'Notes on the foraging mode of production', p. 279, citing Steward, J., *Theory of culture change*, Urbana (IL), University of Illinois Press, 1955
26 Kropotkin, P., *Mutual Aid*, London, Heinemann [popular edition] 1915
27 Lippard, L. *The Lure of the Local: senses of place in a multicentered society*, New York, The New Press, 1997, p. 23
28 Lippard, *The Lure of the Local*, p. 27
29 Lippard, *The Lure of the Local*, pp. 28–29
30 Lippard, *The Lure of the Local*, p. 113 [photograph, p. 112]
31 Lippard, *The Lure of the Local*, p. 171
32 Lippard, *The Lure of the Local*, p. 129
33 Lippard, *The Lure of the Local*, p. 173
34 Lippard, *The Lure of the Local*, p. 174
35 Ukeles, M. L., 'Touch Sanitation' [1980] in Robinson, H., ed., *Feminism-Art-Theory*, Oxford, Blackwell, 2001, p. 106
36 Phillips, P., 'Maintenance activity: creating a climate for change' in Felshin, P., ed., *But Is It Art?*, Seattle (WA), Bay Press, 1995, pp. 163–194
37 Phillips, 'Maintenance activity' p. 178
38 Deutsche, R., 'Uneven Development: Public Art in New York City', in *Evictions: Art and Spatial Politics*, Cambridge (MA), MIT, 1996, pp. 49–107

39 Ukeles, M. L., unpublished lecture, Statten Island College, 5 February 2002 [attended by the author]; see also Miles, M., *Urban Avant-Gardes: Art, architecture and change*, London, Routledge, 2004, pp. 161–162

40 Miller, M. H., 'Trash Talk: The Department of Sanitation's Artist in Residence is a Real Survivor', *Gallerist NY*, 15 January 2013 [accessed online: http://galleristny.com/2013/01/trash-talk-the-department-of-santitations-artist-in-residence-is-a-real-survivor 31 May 2013]

41 Borden, I., *Skateboarding, Space and the City*, Oxford, Berg, 2001; see also 'What is Radical Architecture?' in Miles, M. and Hall, T., eds., *Urban Futures: critical essays on shaping the city*, London, Routledge, 2003, pp. 111–121

42 Cutts, S., ed., *The Unpainted Landscape*, London, Coracle Press, 1987

43 Conversations with Prigann, Germany, May 2001, Barcelona September 2001 [from memory]

44 Prigann, H., 'Fireline, 1991', in Strelow, H. with David, V., eds., *Ecological Aesthetics: Art in Environmental Design: Theory and Practice*, Basel, Birkhauser, 2004, p. 42

45 Prigann, H., 'Ring der Erinnerung', in Strelow and David, eds., *Ecological Aesthetics*, p. 82

46 Llull, P., 'Herman Prigann and the Unfinished Ecology of Sculpture' in Moyer, T. and Harper, G., eds., *The New Earthwork*, Hamilton (NJ), ISC Press, 2011, pp. 78–79

47 Barndt, K., 'Memory Traces of an Abandoned Set of Futures' in Hell, J. and Schönle, eds., *Ruins of Modernity*, Durham (NC), Duke University Press, 2010, p. 276

48 Barndt, 'Memory Traces', p. 277

49 API, press release, 19 October 2009

50 API, press release, 19 October 2009

51 E-mail to the author from Nicola Triscott, 3 April 2013

52 E-mail to the author from Nicola Triscott, 3 April 2013

53 E-mail to the author from Nicola Triscott, 3 April 2013

54 E-mail to the author from Nicola Triscott, 3 April 2013

55 Muller, A., ed., *Architecture* [Arctic Perspectives Cahier 1], Ostfildern (De), Hantje Kantz, 2010, pp. 22–26

NOTES

56 Triscott, N., 'Critical Art Intervention in the Technologies of the Arctic', in Bravo, M. and Triscott, N., eds., *Arctic Geopolitics and Autonomy*, Ostfildern (De), Hatje Kantz, 2010, p. 20

57 Heinene, L., 'Post-Cold War Arctic Geopolitics: Where are the Peoples and the Environment?', in Bravo and Triscott, eds., *Arctic Geopolitics and Autonomy*, p. 94

58 Heininen, 'Post-Cold War Arctic Geopolitics', p. 101

59 Harris, A., and Moreno, L., *Creative City Limits: Urban Cultural Economy in a New Era of Austerity*, London, Urban Laboratory (UCL), 2012

60 Hamdi, N., *Small Change: About the Art of Practice and the limits of Planning in Cities*, London, Earthscan, 2004; *Housing Without Houses*, London, Intermediate Technology Publications, 1995

61 Awan, N, Schneider, T. and Till, J., *Spatial Agency: Other ways of doing architecture*, London, Routledge, 2011, p. 29

62 Awan, Schneider, and Till, *Spatial Agency*, p. 44, quoting Williams, R., 'Towards an Aesthetics of Poverty: Architecture and the Neo-Avant Garde in 1960s Brazil' in Hopkins, D., ed., *Neo-Avant Garde*, Amsterdam, Rodopi, 2006, p. 211

63 Awan, Schneider, and Till, *Spatial Agency*, p. 144

64 Cf Benjamin, W., 'The Author as Producer' in *Understanding Brecht*, London, Verso, 1998, pp. 85–103

65 Sandercock, L., *Towards Cosmopolis*, Chichester, Wiley, 1998

66 Bodemann-Ritter, C., 'Every Man is an Artist: Talks at Documenta V by Joseph Beuys' in Mesch and Michely, eds., *Joseph Beuys: The Reader*, Cambridge (MA), MIT, 2007, pp. 189–197

67 Bodeman-Ritter, 'Every Man is an Artist', p. 197

68 Tisdall, C., *Joseph Beuys* [exhibition notes] London, Anthony d'Offay Gallery, 1980, [n.p.]

69 In Tisdall, *Joseph Beuys*, n.p. [no source given]

70 Gandy, M., 'Contradictory Modernities: Conceptions of Nature in the Art of Joseph Beuys and Gerhard Richter', *Annals of the Association of American Geographers*, 87, 4, 1997, p. 641

71 Gandy, 'Contradictory Modernities', p. 647

72 Nancy, J-L, 'The Inoperative Community' [1986] in Bishop, C., ed., *Participation*, London, Whitechapel and MIT, 2006, p. 54

73 Nancy, 'The Inoperative Community', p. 65

Chapter 6

1. Walker, G., *Antarctica: An Intimate Portrait of the World's Most Mysterious Continent*, London, Bloomsbury, 2012, p. 259
2. Walker, *Antarctica*, p. 262
3. Walker, *Antarctica*, p. 264, citing Rubin, J., *Lonely Planet Guide: Antarctica*, pp. 29–30
4. Walker, *Antarctica*, p. 265
5. Walker, *Antarctica*, p. 279
6. Walker, *Antarctica*, p. 288
7. Walker, *Antarctica*, p. 288
8. Walker, *Antarctica*, p. 293
9. Walker, *Antarctica*, p. 305
10. Christianson, G. E., *Greenhouse: The 200-year story of global warming*, London, Constable, 1999, p. 194
11. Christianson, *Greenhouse*, pp. 211–214
12. Clifford, S., 'New Milestones: sculpture, community and the land', in O'Hallaran, D., Green, C., Harley, M., and Knill, J., eds., *Geological and Landscape Conservation*, London, The Geological Society, 1994, p. 487
13. *New Milestones* [leaflet] London, Common Ground, 1988
14. Randall-Page, P., quoted in Clifford, 'New Milestones', p. 488
15. In conversation with Clare Lilley, *Peter Randall-Page at Yorkshire Sculpture Park* [exhibition catalogue], West Bretton, Yorkshire Sculpture Park, 2009, p. 10
16. Massey, D., *Space, Place and Gender*, Cambridge, Polity, 1994, p. 232
17. Interviewed by Jackson, T., in *Peter Randall-Page at Yorkshire Sculpture Park*, p. 9
18. In conversation with Lilley, *Peter Randall-Page at Yorkshire Sculpture Park* [exhibition catalogue], p. 12
19. Lowenstein, O., 'Some Distance from the Plant World', in Dalziel + Scullion, eds., *Some Distance from the Sun*, [exhibition catalogue] Aberdeen, Peacock Visual Arts, 2007, p. 10
20. Hartley, K., 'Dalziel + Scullion' in Dalziel + Scullion, *Home* [exhibition catalogue], Edinburgh, Fruitmarket Gallery, 2001, p. 7
21. Lowenstein, O., 'The Re-enchantment of the word', in Dalziel + Scullion, eds., *More Than Us*, Dundee, Dalziel + Scullion, 2009, p. 21

22 Fuller, P., *Art and Psychoanalysis*, London, Writers and Readers Cooperative, 1980, Ch. 3 and 4
23 Hartley, 'Dalziel + Scullion', p. 14
24 www.capefarewell.com/expeditions [accessed 15 August 2012]
25 www.capefarewell.com/expeditions/2010-expedition [accessed 15 August 2012]
26 McEwen, I., *Solar*, London, Jonathan Cape, 2010, pp. 45–46
27 McEwen, *Solar*, p. 61
28 McEwen, *Solar*, p. 66
29 McEwen, *Solar*, p. 75
30 Rushby, K., 'All white on the night', *The Guardian*, Travel, p. 2. 6 November, 2010
31 Walker, *Antarctica*, p. 46
32 Christianson, *Greenhouse*, p. 217
33 Wheeler, S., *The Magnetic North: Travels in the Arctic*, London, Vintage, 2010, p. 191
34 Wheeler, *The Magnetic North*, p. 197
35 Rushby, 'All white on the night', p. 2
36 Rushby, 'All White on the Night', p. 2
37 Rowell, A. and Marriott, J., 'Mercenaries on the Front Lines in the New Scramble for Africa', in Hiatt, S., ed., *A Game as Old as Empire: The Secret World of Economic Hit Men and the Web of Global Corruption*, San Francisco (CA), Berret-Koehler, 2007, p. 111
38 Rowell and Marriott, 'Mercenaries', p. 126 [source not given]
39 Marriott, J. and Minio-Paluello, M., *The Oil Road: Journeys from the Caspian Sea to the City of London*, London, Verso, 2012, p. 6
40 Marriott and Minio-Paluello, *The Oil Road*, pp. 92–93
41 Marriott and Minio-Paluello, *The Oil Road*, p. 124
42 Corner House, *Forest Cleansing: Racial Oppression in Scientific Nature Conservation*, briefing 13, Sturminster Newton, Corner House, 1999
43 Marriott and Minio-Paluello, *The Oil Road*, p. 201
44 Newell, P., *Globalization and the Environment: Capitalism, Ecology and Power*, Cambridge, Polity, 2012, p. 90
45 Marriott and Minio-Paluello, *The Oil Road*, p. 112
46 Marriott and Minio-Paluello, *The Oil Road*, p. 117
47 Marriott and Minio-Paluello, *The Oil Road*, p. 121

48 Amunwa, B. with Minio, M., *Counting the Cost: corporations and human rights abuses in the Niger Delta*, London, Platform, 2011, p. 26
49 Marriott and Minio-Paluello, *The Oil Road*, p. 219
50 Marriott and Minio-Paluello, *The Oil Road*, p. 258
51 Marriott, J., e-mail to the author, 30 April 2013
52 Conversation, 11 March 2013
53 Chomette, G.-P., 'Alaska: the Kigiqtaamiut in jeopardy', in Collectif Argos, ed., *Climate Refugees*, Cambridge (MA), MIT, 2010, p. 19
54 Chomette, 'Alaska', p. 20
55 A request to reproduce images from *Climate Refugees* received no response.
56 Chomette, G.-P. and Collanges, G., 'Indian Ocean: Maldives, an archipelago in peril', in Collectif Argos, ed., *Climate Refugees*, p. 126
57 Chomette and Collanges, 'Indian Ocean', p. 128
58 Chomette and Collanges, 'Indian Ocean', p. 137
59 McKee, Y., 'On Climate Refugees: Biopolitics, Aesthetics, and Critical Climate Change', *Qui Parle*, 19, 2, 2011, p. 311
60 McKee, 'On Climate Refugees', p. 315
61 Palin, M., *The Truth*, London, Weidenfeld and Nicholson, 2012
62 Newell, *Globalization and the Environment*, p. 100
63 Hartley, 'Dalziel _+ Scullion', p. 14
64 Newell, *Globalization and the Environment*, p. 103
65 Newell, *Globalization and the Environment*, p. 112
66 Namdi, B. S., Gomba, O. and Ugiomoh, F., 'Environmental Challenges and Eco-Aesthetics in Nigeria's Niger Delta', *Third Text*, 27, 1, 2013, p. 74
67 Osundu, E. C., ed., *For Ken, For Nigeria: Poems in Memory of Ken Saro-Wiwa*, Cambridge (MA), South End Press, 2001; see also African Writers Abroad, ed., *No Condition is Permanent: 19 Poets on Climate Justice and Change*, London, Platform, 2010

Chapter 7

1 Strelow, H., ed., *Natural Reality* [exhibition publication, German-English text], Stuttgart, Daco, 1999, p. 119
2 Strelow, *Natural Reality*, p. 104

3 Strelow, *Natural Reality*, p. 105
4 Williams, R., *Keywords: A Vocabulary of Culture and Society*, London, Fontana, 1976, p. 77
5 Katz, C., 'Under the Falling Sky: Apocalyptic Environmentalism and the Production of Nature', in Callari, A., Cullenberg, S. and Biewener, C., eds., *Marxism in the Post-Modern Age: Confronting the New World Order*, New York, Guilford Press, 1995, p. 278
6 Murdin, A., 'The Impossible Gaze of the Ecological Subject', unpublished conference paper, 21 June 2012, [n.p.] provided by the artist
7 Žižek, S., *Living in the end times*, London, Verso, 2011, p. 84
8 Murdin, 'The Impossible Gaze' [n.p.]
9 Murdin, 'The Impossible Gaze' [n.p.]
10 Spieker, S., *The Big Archive: art from bureaucracy*, Cambridge (MA), MIT, 2008
11 Fraser, A., quoted in Spieker, *The Big Archive*, p. 181
12 Spieker, *The Big Archive*, p. 182
13 Cornford, M. and Cross, D., *Cornford & Cross*, London, Black Dog, 2009, p. 112
14 Jordan, T., *Activism: Direct Action, Hacktivism and the Future of Society*, London, Reaktion, 2002
15 Cornford & Cross, *Cornford & Cross*, p. 46
16 Cornford & Cross, *Cornford & Cross*, p 108
17 Cornford & Cross, *Cornford & Cross*, p 108
18 Orwell, G., *Coming up for Air*, London, Gollancz, 1939
19 Cornford, M. and Cross, D., e-mail to the author, 29 April 2013
20 Explanatory text provided by the artists, 2012
21 Orwell, G., 'The Lion and the Unicorn: Socialism and the English Genius', in *A Patriot After All, 1940–1944*, Davison, P., ed., London, Secker & Warburg, 2002, pp. 391–437
22 Orwell, 'The Lion and the Unicorn', p. 409
23 Cornford & Cross, e-mail to the author, 29 April 2013
24 Cornford & Cross, e-mail to the author, 29 April 2013
25 www.hehe.org.free.fr [accessed 21 March 2013]
26 Cronin, R., *Colour and Experience in Nineteenth-century Poetry*, Basingstoke, Macmillan, 1988, p. 41
27 Cronin, *Colour and Experience*, p. 42

28 www.zazzle.com [accessed 29 January 2013]
29 Mairie de Saint-Ouen, leaked letter, www.hehe.org2.free.fr [accessed 15 August 2012]
30 www.invisibledust.com
31 Lack, J., 'Can Art Help Us Understand Environmental Disaster?', *The Guardian*, 21 March 2011 [accessed online 20 May 2013]
32 Evans, M., e-mail to the author, 23 April, 2013
33 Quoted, http://liberatetate.wordpress.com [accessed 7 March 2013]
34 Quoted, http://liberatetate.wordpress.com [accessed 7 March 2013]
35 Reproduced in Clarke, J., Evans, M., Newman, H., Smith, K. and Tarman, G., eds., *Not if but when: Culture Beyond Oil*, London, Art Not Oil, Liberate Tate and Platform, 2011, p. 55
36 Mascalistair, T., 'Invest in Iraq and you repeat past mistakes, investors tell BP board', *The Guardian*, 18 April 2008, p. 29
37 Reproduced Clarke et al., *Culture Beyond Oil*, p. 36
38 Marriott, J., 'A Social Licence to Operate', in Clarke et al., *Culture Beyond Oil*, p. 10
39 Marriott, 'A Social Licence to Operate'
40 Stallabrass, J., 'Art Pollutes Oil' in Clarke et al., *Culture Beyond Oil*, p. 70
41 Liberate Tate in conversation with Steven Lam, Gabi Ngcobo, Jack Persekian, Nato Thompson and Anne Sophie Witzke, 'Art, Ecology and Institutions', *Third Text*, 27, 1, 2013, p. 145
42 Bahro, R., *Avoiding Social and ecological Disaster: The Politics of World Transformation*, Bath, Gateway Books, p. 64 [italics original]
43 Bahro, *Avoiding Social and Ecological Disaster*, p. 64
44 Cited in Wall, *The No-Nonsense Guide to Green Politics*, London, New Internationalist, 2010, p. 110
45 Cited in Wall, *Green Politics*, p. 111
46 Bennett, J., *Practical Aesthetics: Events, Affects and Art after 9/11*, London, I. B. Tauris, 2012, p. 187

Chapter 8

1 Duffin, D., artist's statement supplied to the author, e-mail January, 2013
2 Illustrated, Duffin, D., 'Exhibiting Strategies' in Deepwell, K., ed., *New Feminist Art Criticism*, Manchester, Manchester University Press, 1995, pp. 64–65 [plate 14 A and B]

3 Duffin, D., artist's statement
4 Duffin, artist's statement
5 Duffin, artist's statement
6 Duffin, artist's statement
7 Celant, G., *Arte Povera: Histories and Protagonists*, Milan, Eclecta, 1985
8 Swyngedouw, E., *Flows of Power – The Political Ecology of Water and Urbanisation in Ecuador*, Oxford, Oxford University Press, 2004
9 Loftus, A., 'The metabolic processes of capital accumulation in Durban's waterscape', in Heynen, N., Kaika, M. and Swyngedouw, E., eds., *In the Nature of Cities: Urban Political Ecology and the Politics of Urban Metabolism*, London, Rouledge, 2006, pp. 173–190; see also Smith, L. and Ruiters, G., 'The public/private conundrum of urban water: as view from South Africa' in Heynen, Kaika and Swyngedouw, eds., *In the Nature of Cities*, pp. 191–207
10 Gregson, N. and Crewe, L, *Second-Hand Cultures*, Oxford, Berg, 2003, p. 22
11 Gregson and Crewe, *Second-Hand Cultures*, p. 197
12 Gregson and Crewe, *Second-Hand Cultures*, p. 198
13 Gregson and Crewe, *Second-Hand Cultures*, p. 198
14 Durrschmidt, J., 'The local versus the global? Individualised milieu in a complex risk society: the case of organic food box schemes in the South West', in Hearn, J. and Roseneil, S., eds., *Consuming Cultures: Power and Resistance*, Basingstoke, Macmillan, 1999, pp. 131–154
15 Williams, R., *Keywords*, London, Fontana, 1976, p. 77
16 www.littoral.org [accessed 21 May 2013]
17 Hunter I., e-mail to the author, 2 April 2013
18 Littoral, poster for Cumbria Scything Festival, 2011
19 Berger, J., 'Lesson from the past' in *Permanent Red*, London, Methuen, 1960, p. 190
20 Albion Free State Manifesto [1974] cited in McKay, G., *Senseless Acts of Beauty: Cultures of Resistance since the Sixties*, London, Verso, 1996, p. 11
21 McKay, *Senseless Acts of Beauty*
22 McKay, *Senseless Acts of Beauty*, p. 35
23 McKay, *Senseless Acts of Beauty*, p. 35
24 McKay, *Senseless Acts of Beauty*, p. 35
25 McKay, *Senseless Acts of Beauty*, p. 36

26 Brocken, M., *The British Folk Revival 1944–2002*, Aldershot, Ashgate, 2003, p. 25
27 Lloyd, A. L., *The Singing Englishman*, London, Workers' Music Association, 1944, p. 4, quoted in Brocken, *The British Folk Revival*, p. 25
28 Boyes, G., *The Imagined Village: Culture, ideology and the English Folk Revival*, Leeds, No Masters Co-Operative, 2010, p. 7
29 Cottell, F., 'The cult of the individual', in Deepwell, ed., *New Feminist Art Criticism*, p. 94
30 Clifford, S., e-mail to the author, 2 October 2012
31 Bloch, E., 'On the original history of the Third Reich', *Heritage of Our Times*, Cambridge, Polity, 1991, pp. 117–137
32 Boyes, *The Imagined Village*, p. 157
33 Common Ground, 'Community Orchards', Shaftesbury, Common Ground, 2008 [n.p.]
34 Common Ground, 'Community Orchards', Shaftesbury, Common Ground, 2008 [n.p.]
35 Wilson, P. L. and Weinberg, B., eds., *Avant-Gardening: Ecological Struggles in the City and the World*, New York, Autonomedia, 1999
36 Common Ground, 'Knowing Your Place' [exhibition leaflet], London, Common Ground, 1987, [n.p.]
37 Crouch, D. and Matless, D., 'Refiguring geography: Parish Maps of Common Ground', *Transactions of the Institute of British Geographers*, 21, 1996, p. 245
38 Crouch and Matless, 'Refiguring Geography'
39 Crouch and Matless, 'Refiguring geography', p. 251
40 Crouch and Matless, 'Refiguring geography', p. 253
41 Schwitters, K., letter to Richard Huelsenbeck, quoted in Humphreys, R., ed., 'Introduction', *Kurt Schwitters* [exhibition catalogue] London, Tate Gallery, 1985, p. 11
42 Humphreys, 'Introduction' to *Kurt Schwitters*, p. 13
43 Griffin, J., 'Folkestone Triennial', *Frieze*, 117, quoted at www.morison.info/talesofspaceandt.html [accessed 7 March 2013]
44 Boal, I., Stone, J., Watts, M. and Winslow, C., eds., *West of Eden: Communes and Utopia in Northern California*, Oakland (CA), PM Press, 2012
45 Sadler, S., 'The Dome and the Shack: The Dialectics of Hippie Enlightenment', in Boal et al. eds, *West of Eden*, p. 78

NOTES

46 Bang, M. J., *Eco-Villages: A Practical Guide to Sustainable Communities*, Edinburgh, Floris Books, 2005; www.diggersanddreamers.org.uk

47 Fairlie, S., *Low Impact Development: Planning and People in a Sustainable Countryside*, Charbury, Jon Carpenter, [2nd edition] 2009, p. 150 (illustration); see also *Meat: a benign extravagance*, East Meon, Permanent Publications, 2010

48 Segal, W., 'View from a lifetime' *Transactions of the RIBA*, 1, 1, 1982, pp. 7–14; *Home and Environment*, London, Leonard Hill, 1955; Blundell Jones, P., 'Sixty-eight and after' in Blundell Jones, P., Petescu, D. and Till, J. eds., *Architecture and Participation*, Abingdon, Taylor and Francis, 2009, pp. 127–139

49 Ward, C., 'Anarchy and Architecture: a personal record' in Hughes, J. and Sadler, S. eds., *Non-Plan: essays on freedom, participation and change in modern architecture and planning*, Oxford, Architectural Press, 2000, p. 47

50 Fernandes, E. and Varley, A., eds., *Illegal Cities: Law and Urban Change in Developing Countries*, London, Zed Books, 1998

51 City of Cape Town, 'Five-Year Integrated Housing Plan 2011/12-2015/16' Cape Town, City of Cape Town, 2011

52 Hardy, D., and Ward, C., *Arcadia for All: The Legacy of a Makeshift Landscape*, Nottingham, Five Leaves, [2nd edition] 2004, p. 27

53 AVAG, self-build portal website, www.self-buildportal.org.uk/ashleyvale [accessed 15 8 2012]

54 Fairlie, *Low Impact Development*, p. 95

55 Till, J., 'The negotiation of hope', in Blundell Jones, P., Petrescu, D. and Till, J., eds., *Architecture and Participation*, p. 23

56 Till, 'The negotiation of hope' p. 25, citing Pateman, C., *Participation and Democratic Theory*, Cambridge, Cambridge University Press, 1970

57 Till, 'The negotiation of hope', p. 34

58 Till, *Architecture Depends*, Cambridge (MA), MIT, 2009, p. 193

59 Hockerton Housing Project, *The Sustainable Community: A Practical Guide*, Hockerton, Hockerton Housing Project, 2001, back cover

60 www.hockertonhousingproject.org.uk [accessed 30 June 2013]

61 www.hockertonhousingproject.org.uk [accessed 30 June 2013]

62 Lerner, S., *Eco-Pioneers: Practical Visionaries Solving Today's Environmental Problems*, Cambridge (MA), MIT, 1998, p. 217

63 Lerner, *Eco-Pioneerrs*, p. 225
64 Lerner, *Eco-Pioneerrs*, p. 225
65 www.barefootcollege.org
66 Aga Khan Award for Architecture, *Modernity and Community: Architecture in the Islamic World*, London, Thames and Hudson, 2001, p. 78

SELECTED BIBLIOGRAPHY

Amunwa, B. with Minio, M. (2011) *Counting the Cost: Corporations and human rights abuses in the Niger Delta*, London, Platform.
Araeen, R. (2009) 'Ecoaesthetics: A Manifesto for the Twenty-First Century', *Third Text*, 23:5, pp. 679–684.
Argos, C. (2010) *Climate Refugees*, Cambridge (MA), MIT.
Atwood, M. (2003) *Oryx and Crake*, London, Bloomsbury.
———, (2009) *The Year of the Flood*, London, Bloomsbury.
Awan, N., Schneider, T., and Till, J. (2011) *Spatial Agency: Other ways of doing architecture*, London, Routledge.
Bahro, R. (1982) *Socialism and Survival*, London, Heretic Books.
Ballard, J.G. (1963) *The Drowned World*, London, Gollancz.
———, (1965) *The Drought*, London, Cape.
Bang, M.J. (2005) *Eco-Villages: A Practical Guide to Sustainable Communities*, Edinburgh, Floris Books.
Baumgarten, A. (1988) *Theoretische Aesthetik*, Hamburg, Meiner.
Beardsley, J. (1996) *Earthworks and Beyond*, New York, Abbesville Press.
Bell, B. and Wakeford, K. eds. (2008) *Expanding Architecture: Design as Activism*, New York, Metropolis Books.
Bennett, J. (2012) *Practical Aesthetics: Events, Affects and Art after 9/11*, London, I. B. Tauris.
Bishop, C. ed. (2006) *Participation*, Cambridge (MA), MIT.
Blundell Jones, P., Petrescu, D. and Till, J. eds. (2005) *Architecture and Participation*, Abingdon, Taylor & Francis.
Boal, I., Stone, J.,Watts, M. and Winslow, C. eds. (2012) *West of Eden: Communes and Utopia in Northern California*, Oakland (CA), PM Press.
Bookchin, M. (1980) *Towards an Ecological Society*, Black Rose, Montreal, 1980.
———, (1982) *The Ecology of Freedom*, Palo Alto (CA), Cheshire Books.
———, (1991) *Defending the Earth: A Dialogue between Murray Bookchin and Dave Foreman*, Montreal, Black Rose Books.
———, (1992) *Urbanization without Cities: The Rise and Decline of Citizenship*, Montreal, Black Rose Books.

Botkin, D. (1990) *Discordant Harmonies: A New ecology for the Twenty-First Century*, Oxford, Oxford University Press.
Bourriaud, N. (2002) *Relational Aesthetics*, Dijon, les presses du réel.
Bowie, A. (2003) *Aesthetics and Subjectivity: from Kant to Nietzsche*, Manchester, Manchester University Press [2nd ed].
Bramwell, A. (1989) *Ecology in the Twentieth Century: a history*, London, Yale.
Brocken, M. (2003) *The British Folk Revival 1944–2002*, Aldershot, Ashgate.
Buell, L. (2011) 'Ecocriticism: Some Emerging Trends', *Qui Parle: Critical Humanities and Social Sciences*, 19:2, pp. 87–115.
Callicott, J.B. (1994) *Earth's Insights: A Multicultural Survey of Ecological Ethics from the Mediterranean Basin to the Australian Outback*, Berkeley (CA), University of California Press.
Camacho, D.E. (1998) *Environmental Injustices, Political Struggles: Race, Class, and the Environment*, Durham (NC), Duke University Press.
Capra, F. (1995) 'Deep Ecology: A New Paradigm' in Sessions, G. ed., *1995 Deep Ecology for the 21st Century*, Boston (MNA), Shambala.
Carmen, R. (1996) *Autonomous Development: Humanizing the Landscape*, London, Zed Books.
Carson, R. (1962) *Silent Spring*, New York, Houghton Mifflin.
Christianson, G.E. (1999) *Greenhouse: The 200-year Story of Global Warming*, London, Constable, 1999.
Christopher, J. (1956) *The Death of Grass*, London, Michael Joseph.
Clarke, J., Evans, M., Newman, H., Smith, K. and Tarman, G. eds. (2011) *Not if but when: Culture Beyond Oil*, London, Art Not Oil, Liberate Tate and Platform.
Clifford, S. (1994) 'New Milestones: sculpture, community and the land', in O'Halloran, D., Green, C., Harley, M., Stanley, M. and Knill, J. eds., *Geological and Landscape Conservation*, London, The Geological Society, 487–491.
Conroy, C. and Litvinoff, M. (1998) *The Greening of Aid: Sustainable Livelihoods in Practice*, London, Earthscan.
Cornford, M. and Cross, D. (2009) *Cornford & Cross*, London, Black Dog.
Cromwell, D. and Levene, M. eds., (2007) *Surviving Climate Change: The Struggle to Avert Global Catastrophe*, London, Pluto.
Crouch, D. and Matless, D. (1996) 'Refiguring geography: Parish Maps of Common Ground', *Transactions of The Institute of British Geographers*, 21, pp. 236–255.
Cutts, S. ed. (1987) *The Unpainted Landscape*, London, Corcacle.
Dalzeil + Scullion (2007) *Some Distance from the Sun* [exhibition catalogue], Aberdeen, Peacock Visual Arts.

Darwin, C. (1881) *The Formation of Vegetable Mould through the Action of Worms, with Observations on Their Habits*, London, John Murray.
Davies, P. and Knipe, T. eds. (1984) *A Sense of Place: Sculpture in the Landscape*, Sunderland, Ceolfrith Press.
de Boer, C. ed. (1998) *herman de vries*, Amsterdam, Stichting Fonds voor beelende kunsten.
Demos, T.J. (2009) 'The Politics of Sustainability: Art and Ecology', in Manacorda, F. and Yedgar, A., eds. *Radical Nature: Art and Architecture for a Changing Planet 1969–2009* London, Barbican Arts Centre [exhibition catalogue], pp. 17–30.
———, (2013) 'The Art and Politics of Ecology in India', *Third Text*, 27:1, pp. 151–161.
de Rivero, O. (2001) *The Myth of Development: the non-viable economies of the 21st century*, London, Zed Books.
de vries, h. (1995) 'to be', Meier, A., ed., Ostfildern, Hatje Cantz.
Donaldson, R. ed., (1991) *A Sacred Unity: Further Steps to an Ecology of Mind*, New York, Harper-Collins.
Dunaway, F. (2009) 'Seeing Global Warming: Contemporary Art and the Fate of the Planet', *Environmental History*, 14, 9–31.
Dunster, B. (2003) *From A to ZED: Realising Zero (fossil) Energy Developments*, London, Bill Dunster Architects.
Durrschmidt, J. (1999) 'The local versus the global? Individualised milieu in a complex risk society: the case of organic food box schemes in the South West', in Hearn, J. and Roseneil, S. eds, *Consuming Cultures: Power and Resistance*, Basingstoke, Macmillan, pp. 131–154.
Fairhead, J., Leach, M., and Scoones, I. (2012) 'Green Grabbing: a new appropriation of nature?', *Journal of Peasant Studies*, 39:2, pp. 237–261.
Fairlie, S. (2009) *Low Impact Development: Planning and People in a Sustainable Countryside*, Charlbury, Jon Carpenter, [2nd edition].
Fernandes, E. and Varley, A. eds., (1998) *Illegal Cities: Law and Urban Change in Developing Countries*, London, Zed Books.
Flannery, T. (2005) *The Weather Makers: The History and Future Impact of Climate Change*, London, Allen Lane.
Fredriksson, A. (2011) 'Environmental Aesthetics Beyond the Dialectics of Interest and Disinterest', *Nordic Journal of Aesthetics*, 40/41, pp. 89–105.
Gablik, S. (1984) *Has Modernism Failed?*, London, Thames and Hudson.
———, (1991) *The Reenchantment of Art*, Thames and Hudson, London, 1991.
Gandy, M. (1997) 'Contradictory Modernities: Conceptions of Nature in the Art of Joseph Beuys and Gerhardt Richter', *Annals of the Association of American Geographers*, 87:4, pp. 636–659.

Gandy, M. (2006) 'Urban nature and the ecological imaginary', in Heynen, N., Kaika, M. and Swyngedouw, E. eds., *In the Nature of Cities: Urban Political Ecology and the Politics of Urban Metabolism*, London, Routledge, pp. 63–74.

George, S. (2004) *Another World is Possible If…*, London, Verso.

Gilding, P. (2011) *The Great Disruption: How the Climate Crisis will Transform the Global Economy*, London, Bloomsbury.

Giroux, H.A. (2012) *Twilight of the Social: Resurgent Publics in the Age of Disposability*, London, Pluto.

Gregson, N. and Crewe, L. (2003) *Second-Hand Cultures*, Oxford, Berg.

Grosz, E. (2004) *The Nick of Time: Politics, Evolution, and the Untimely*, Durham (NC), Duke University Press.

Guha, R. and Martinez-Alier, J. (1997) *Varieties of Environmentalism: Essays North and South*, London, Earthscan.

Haeckel, E. (1914) *The Natural History of Creation*, New York, Appleton.

Hamdi, N. (1995) *Housing Without Houses*, London, Intermediate Technology Publications.

———, (2004) *Small Change: About the Art of Practice and the limits of Planning in Cities*, London, Earthscan.

Hammermeister, K. (2002) *The German Aesthetic Tradition*, Cambridge, Cambridge University Press.

Hardy, D. and Ward, C. (2004) *Arcadia for All: The Legacy of a Makeshift Landscape*, Nottingham, Five Leaves, [2nd edition].

Harries, K. (2011) 'What Need is There for an Environmental Aesthetics?', *Nordic Journal of Aesthetics*, 40–41, pp. 7–22.

Hell, J. and Schönle, A. eds. (2010) *Ruins of Modernity*, Durham (NC), Duke University Press.

Heynen, N., Kaika, M. and Swyngedouw, E. eds. (2006) *In the Nature of Cities: Urban Political Ecology and the Politics of Urban Metabolism*, London, Routledge.

Hockerton Housing Project. (2001) *The Sustainable Community: A Practical Guide*, Hockerton, Hockerton Housing Project.

Illich, I. (1986) *H_2O and the Waters of Forgetfulness*, London, Marion Boyars.

Jordan, T. (2002) *Activism: Direct Action, Hacktivism and the Future of Society*, London, Reaktion.

Kastner, J. and Wallis, B. eds. (1998) *Land and environmental art*, London, Phaidon.

Katz, C. (1995) 'Under the Falling Sky: Apocalyptic Environmentalism and the Production of Nature', in Callari, A., Cullenberg, S. and Biewener, C. eds., *Marxism in the Post-Modern Age: Confronting the New World Order*, New York, Guilford Press, pp. 276–282.

Kester, G. (2005) 'Theories and Methods of Collaborative Art Pratice', in Kester, G., ed., *Groundworks* [exhibition catalogue], Pittsburgh (PA), Carnegie Mellon University.
———, (2011) *The One and the Many: Contemporary Collaborative Art in a Global Context*, Durham (NC), Duke University Press.
Kirwan, J. (2005) *Sublimity*, London, Routledge.
Klein, N. (2008) *The Shock Doctrine: The Rise of Disaster Capitalism*, London, Penguin.
Kolbert, E. (2006) *Field Notes from a Catastrophe: A Frontline Report on Climate Change*, London, Bloomsbury.
Körner, W.S. (1995) *Kant*, Harmondsworth, Penguin.
Lam, S., Ngcobo, G., Persekian, J., Thompson, N., Witzke, A.S. and Tate, L. (2013) 'Art, Ecology and Institutions', *Third Text*, 27:1, pp. 141–150.
Lee, M.F. (1995) *Earthfirst! Environmental Apocalypse*, Syracuse (NY), Syracuse University Press.
Leeds City Art Gallery. (1985) *Rain sun snow hail mist calm* [exhibition catalogue], Leeds, Leeds City Art Gallery and Henry Moore Foundation.
Light, A. ed., (1998) *Social Ecology after Bookchin*, New York, Guilford Press.
Lippard, L. (1997) *The Lure of the Local: senses of place in a multicentered society*, New York, The New Press
Lynas, M. (2004) *High Tide: News from a Warming World*, Flamingo, London, 2004.
Manacorda, F. and Yedgar, A. eds., (2009) *Radical Nature: Art and Architecture for a Changing Planet*, London, Barbican Arts Centre and Koenig Books, [exhibition catalogue].
Marcuse, H. (1978) *The Aesthetic Dimension*, Boston, Beacon Press.
———, (2005) 'Ecology and Revolution', in Kellner, D., ed., *The New Left and the 1960s*, London, Routledge, pp. 173–176.
Marriott, J. and Minio-Paluello, M. (2012) *The Oil Road: Journeys from the Caspian Sea to the City of London*, London, Verso.
Martin, R. (1990) *The Sculpted Forest: Sculptures in the Forest of Dean*, Bristol, Redcliffe Press.
Matilski, B. (1992) *Fragile Ecologies: Contemporary artists' interpretations and solutions*, New York, Rizzoli.
Matless, D. and Revill, G. (1995) 'A Solo Ecology: The erratic art of Andy Goldsworthy', *Ecumene*, 2:4, pp. 423–448.
Matthaei, R. ed. (1971) *Goethe's Colour Theory*, London, Studio Vista.
McEwen, I. (2010) *Solar*, London, Jonathan Cape.
McKay, G. (1996) *Senseless Acts of Beauty: Cultures of Resistance since the Sixties*, London, Verso.

McKee, Y. (2011) 'On Climate Refugees: Biopolitics, Aesthetics, and Critical Climate Change', *Qui Parle: Critical Humanities and Social Sciences*, 19:2, pp. 309–325.

Meadows, D.H., Meadows, D.L., Randers, J., and Behrens, W.W. (1972) *The Limits to Growth*, New York, Universe Books.

———, Randers, J., and Meadows, D.L. (2005) *Limits to Growth: the 30-year Update*, London, Earthscan.

Mesch, C. and Michely, V. eds., (2007) *Joseph Beuys: The Reader*, Cambridge (MA), MIT.

Miles, M. (2004) *Urban Avant-Gardes: Art, Architecture and Change*, London, Routledge.

———, (2011) *Herbert Marcuse: an aesthetics of liberation*, London, Pluto.

Monbiot, G. (2006) *Heat: How to Stop the Planet Burning*, London, Allen Lane.

Morton, T. (2007) *Ecology Without Nature: Rethinking Environmental Aesthetics*, Cambridge (MA), Harvard.

———, (2011) 'Here Comes Everything: The Promise of Object-Oriented Ontology', *Qui Parle: Critical Humanities and Social Sciences*, 19:2, pp. 163–190.

Moyer, T. and Harper, G. eds., (2011) *The New Earthwork*, Hamilton (NJ), ISC Press.

Muller, A. ed., (2010) *Architecture* [Arctic Perspectives Cahier 1], Ostfildern (De), Hantje Kantz.

Namdi, B.S., Gomba, O., and Ugiomoh, F. (2013) 'Environmental Challenges and Eco-Aesthetics in Nigeria's Niger Delta', *Third Text*, 27:1, pp. 65–75.

O'Hallaran, D., Green, C., Harley, M., and Knill, J. eds., (1994) *Geological and Landscape Conservation*, London, The Geological Society.

Orwell, G. (1939) *Coming up for Air*, Gollancz, London.

Paden, R., Harmon, L.K., and Milling, C.R. (2012) 'Ecology, Evolution, and Aesthetics: Towards an Evolutionary Aesthetics of Nature', *Journal of Aesthetics*, 52:2, pp. 123–139.

Palin, M. (2012) *The Truth*, London, Weidenfeld and Nicholson.

Panayotakis, C. (2011) *Remaking Scarcity: From Capitalist Inefficiency to Economic Democracy*, London, Pluto.

Pearson, D. (1994) *Earth to Spirit: In Search of Natural Architecture*, London, Gaia Books.

Peet, R. and Watts, M. eds. (1996) *Liberation Ecologies*, London, Routledge.

Pepper, D. (1996) *Modern Environmentalism: An Introduction*, London, Routledge.

Phillips, P. (1995) 'Maintenance activity: creating a climate for change' in Felshin, P. ed., *1995 But Is It Art?*, Seattle (WA), Bay Press, pp. 163–194.

Roy, A. (2001) *Power Politics*, 2nd ed, Cambridge (MA), South End Press.
———, (2009) *Listening to Grass Hoppers: Field Notes on Democracy*, London, Hamish Hamilton.
Segal, W. (1982) 'View from a lifetime', *Transactions of the RIBA*, 1:1, pp. 7–14.
Shiva, V. (2000) *Stolen Harvest: The Hijacking of the Global Food Supply*, London, Zed Books.
Simms, A. (2005) *Ecological Debt: Global Warming and the Wealth of Nations*, London, Pluto.
Sloterdijk, P. (2009) *Terror From the Air*, Los Angeles (CA), Semiotext(e).
Sonfist, A. (1983) *Art in the Land: A critical anthology*, New York, Dutton.
Strelow, H. ed., (1999) *Natural Reality* [exhibition catalogue], Stuttgart, Daco Verlag.
———, with David, V., eds., (2004) *Ecological Aesthetics: Art in Environmental Design: Theory and Practice*, Basel, Birkhauser.
Swyngedouw, E. (2004) *Flows of Power – The Political Ecology of Water and Urbanisation in Ecuador*, Oxford, Oxford University Press.
———, (2006) 'Circulations and Metabolisms: (Hybrid) Natures and (Cyborg) Cities', *Science as Culture*, 15:2, pp. 105–121.
———, (2010) 'Apocalypse Forever? Post-political Populism and the Spectre of Climate Change', *Theory, Culture & Society*, 27:2/3, pp. 23–232.
Till, J. (2009) *Architecture Depends*, Cambridge (MA), MIT.
Tisdall, C. (1980) *Joseph Beuys*, London, Anthony d'Offay Gallery [exhibition catalogue].
Turner, J.F.C. (1976) *Housing by People*, London, Marion Boyars.
Verdin, J., Funk, C., Senay, G., and Choularon, R. (2005) 'Climate Science and Famine Early Warning', *Philosophical Transactions of the Royal Society*, 360, pp. 2155–2168.
Walker, G. (2012) *Antarctica: An Intimate Portrait of the World's Most Mysterious Continent*, London, Bloomsbury.
Wall, D. (1994) *Green History: A Reader in Environmental Literature*, London, Routledge.
———, (1999) *Earth First! and the Anti-Roads Movement*, London, Routledge.
———, (2010) *The Rise of the Green Left: Inside the Worldwide Ecosocialist Movement*, London, Pluto.
Warnke, M. (1995) *Political Landscape: The Art History of Nature*, London, Reaktion.
Wheeler, S. (2010) *The Magnetic North: Travels in the Arctic*, London, Vintage.
Wigglesworth, S. and Till, J. (1998) 'The Everyday and Architecture', *Architectural Design*, profile 134, July–August.

Wilson, P.L. and Weinberg, B. eds. (1999) *Avant-Gardening: Ecological Struggles In The City and The World*, New York, Autonomedia.
Wines, J. (2000) *Green Architecture*, Koln, Taschen.
Woodhouse, K.M. (2009) 'The Politics of Ecology: Environmentalism and Liberalism in the 1960s', *Journal for the Study of Radicalism*, 2:2, pp. 53–84.
Woodward, C. (2002) *In Ruins*, London, Vintage.
Wyndham, J. (1951) *The Day of the Triffids*, London, Michael Joseph.
Yorkshire Sculpture Park. (2009) *Peter Randall-Page at Yorkshire Sculpture Park* [exhibition catalogue], West Bretton, Yorkshire Sculpture Park.
Žižek, S. (2011) *Living in the End Times*, London, Verso, [2nd edition].

INDEX

A12 26
A.I.R. Gallery 100
Aachen (Germany) 4, 20, 141–142
Abbeystead (Lancashire, UK) 175
Ackling, Roger 103
Ackroyd, Heather 128
Adam Gallery (London, UK) 67
Adivasi 24
Adorno, Theodor W. 37, 39, 53, 67, 69, 77, 88, 90, 96
Africa 172
 sub-Saharan Africa 26
 African biomes 91–92
 South Africa 186
Ala Plastica (Argentina) 23
Alaska 131, 136, 160
Albion 176
Albrecht, Glenn 38
Almarcegui, Lara 26
Alps mountain range 117
Altaf 24
Amazon river 129
Ambleside (Cumbria, UK) 182–183
Amsterdam 182
Antarctic 87, 117, 118, 130
Aragon, Louis 27
Arctic 7, 10, 16, 28, 30, 108–112, 127, 130, 160
Arctic Council 112
Arctic Perspective Initiative (API) 108–112, 138
Arendt, Hannah 95

Argos Collective 136
Aries, Philippe 73
Armenia 178–179
Art Not Oil 164
Ashley Vale (Bristol, UK) 187–188
Ashley Vale Action Group 187
Atelier Populaire 156
Atkinson, Conrad 180
Atwood, Margaret 5, 14, 83–85, 88, 90
Auschwitz-Birkenau (Poland) 33, 64
Australia 10, 87, 109
Avebury (Wiltshire, UK) 178–179
Awan, Nishat 113–114
Azerbaijan 131–133
Azeri-Chriag-Gunlashi oilfield 135

Baffin Island (Nunavut, Canada) 111
Bahro, Rudolph 46–47, 163
Baku-Tbilisi-Ceyhan pipeline 131–135
Balestrero, Andrea 26
Ballard, James Graham 5, 78, 81, 83, 84
Bangladesh 136
Bangor beach (Wales, UK) 161
Barbican Art Gallery (London) 25, 184
Barbican Arts Centre (London) 24–26
Barcelona 62

INDEX

Barreca, Gianandrea 26
Barndt, Kerstin 107
Barsham (Suffolk, UK) 177
Basingstoke (Hampshire, UK) 121
Bastar (India) 24
Bateson, Gregory 32
Battery Park City (Manhattan) 24
Baudelaire, Charles 65, 67
Bauhaus the 27
Baumgarten, Alexander 5, 55–57
Beaumont, Betty 101
Becker, Berndt 107
Becker, Hilda 107
Belsey, Catherine 59
Benjamin, Walter 3, 29, 65
Bennett, Jill 165
Bennett, Jane 96
Bera, Baribor 131
Bergen zoo (Netherlands) 125
Berger, John 176
Berkebile, Robert 190–191
Berlin 61, 63, 182
Bern (Switzerland) 147
Brodsky Lacour, Claudia 59
Bertuzzi, Romano 19
Beuys, Joseph 19, 26, 115–116
Biederman, Matthew 108–112
Bingham, Robert 22
Black, August 111
Black Country (UK) 150, 152
Blake, William 176
Bligh Reef (Alaska) 131
Bloch, Ernst 64
Bookchin, Murray 36–39, 42, 46, 114
Bonascossa, Ilaria 26
Bonn 23
Bonomini, Paul 91–92
Borden, Iain 101
Boston 76
Bourriaud, Nicolas 14, 68–69
Bowie, Andrew 52, 54, 67
Bowland (Lancashire, UK) 175
Boyes, Georgina 177

BP (Beyond Petroleum) 132–135, 159, 160–163
Brazil 99
Brecht, Bertold 64, 69
Breton, André, 27
Brewis, Jolyon 123
Brighton (UK) 82
Brimblecombe, Peter 156
Bristol
 Stokes Croft 165, 173,
 Ashley Vale 187–189
Britain 16, 17, 103, 130, 152, 172, 182
 British coastline 131
British Telecommunications 167–168
British Workers' Sports Federation 146
Brocken, Michael 177
Bruzzose, Antonella 26
Bryant Park (New York, US) 100
Buchner, Georg 60
Buckland, David 127, 129
Burkina Faso 172
Byat, Antonia Susan 85–86, 90
Byron, George 61

Call, Sophie 69
Cambridge 156–157
Camp for Climate Action 6
Canada 5, 87, 108, 110, 159, 160
Canada House (London, UK) 111
Capra, Fritjof 39
Carbonnier, Richard 108–109
Carson, Rachel 4, 31–34, 36–37, 41, 47
Caspian Sea 130, 133
Celant, Germano 171
Celebration (Florida, US) 191
Chadwick, Helen 180
Charlbury (Oxfordshire, UK) 180–181
Charlemagne, Emperor 142–143

INDEX

Charleville (Champagne-Ardenne, France) 59
Chasewater Park reservoir (Staffordshire, UK) 149–150
Chhattisgarh 24
Chia, Sandro 93
Chile 5
Chin, Mel 21–22
China 17, 87
Chomette, Guy-Pierre 136
Chomsky, Noam 14
Christianson, Gale 130
Christopher, John 83
Clare, John 176
Clark, Tim 28
Clifford, Sue 179
Coleridge, Samuel Taylor 155
Coliseum (Rome) 73
Collange, Guillaume 136
Common Ground 119, 179–180
Communist Party, 27 (French) 148
Constable, John 176
Copenhagen 156
Corbin, Alain 74
Cornford & Cross 5, 146–153
Cornford, Matthew 5, 146–153
Cornwall 91–92, 123
Corporate Watch 138
Cottbus (Germany) 104–106
Cottel, Fran 179
Courbet, Gustave 28, 65
Covent Garden (London, UK) 168
Cragg, Tony 170–171, 182
Crewe, Louise 172–173
Cronin, Richard 155
Cross, David 5, 146–153
Crouch, David 180–181
Cuban missile crisis 32
Cumbria (UK) 174–175, 183
Curitiba (Brazil) 99
Cylinders Estate (Cumbria) 174–175

DaDa 182
Dalston (East London, UK) 24
Dalston Mill (London, UK) 25
Dalziel, Matthew 124–127, 138
Dalziel + Scullion 124–127, 138
Dartmoor (Devon, UK) 121
Darwin, Charles 4, 33–34, 47–48
David, Hélène 136
Davies, Siobhan 128
Deakin, Richard 73
Deepwater Horizon 156–158, 160
Degen, Monica 74
Demos, T. J. 26
Denes, Agnes 24–25
Denver (Colorado, US) 98
Derbyshire (UK) 146
Descartes, René 51–52, 57, 59
Dewey, Thomas 51
Dietz, Madeleine 21
Dietzler, Georg 21–22
Diggers 17, 173
Dion, Mark 21, 142
Dobee, Saturday 131
Donald, James 47
Dorset (UK) 119–120, 191
Douglas, Lyndon 184
Dovey, Kim 61
Drake Passage 118
Drury, Chris 16, 103, 175
Dudley, Bob 161
Duffin, Deborah 167–171, 182
Duisburg (Germany) 107
Duisburg North Landscape Park 107
Dutton, Rachel 96, 97

Earthfirst! 16–17
East Germany (G.D.R.) 101, 105–106
East Midlands (UK) 189
Eawo Nordu 131
Ecuador 172

Eden Project (Cornwall, UK) 91–93, 123
Edinburgh 125
Egypt 61, 74–75
Ehrlich, Paul 40
Elemental 113–114
Elterwater (Cumbria) 174–175
Éluard, Paul 27
Emscher Park (Duisburg, Germany) 107
Engels, Friedrich 73
England 1, 7, 16, 67, 72, 82, 176, 179, 186, 188
Epstein, Jacob 91, 93
Escobar, Arturo 44–45
Ethiopia 10
Euphrates river 133
Europe 40, 87, 89, 179
Evans, Helen 153–154
Exxon Valdez 131
EXYZT 24

Fairlie, Simon 188
Farthing, Steven 180
Ferran, Magdalena de 26
Feynman, Richard 142
Finland 24, 109
Firat (river) 133
Folkestone (Kent, UK) 185
Fondazione Sandretto Re Rebaudengo (Turin, Italy) 26
Forest of Dean (Gloucestershire, UK) 16, 103
Forest of Grizedale (Cumbria, UK) 16, 103
Forty, Adrian 34
Foster, Norman 148, 149
Frankfurt 135
Frankfurt School 37
Fraser, Andrea 147
Frederick Barbarossa 61
Fredriksson, Antony 52–53

Fresh Kills landfill (Statten Island, New York, US) 100
Fuller, Richard Buckminster 26, 184
Fulton, Hamish 16

G8 6
Gablik, Suzi 93–96, 103, 115
Gadamer, Hans-Georg 63–65, 67
Galerie Ars Longa (Paris, France) 156
Gallaccio, Anya 26
Gandy, Matthew 115
Gaudi, Antoni 187
Gauguin, Paul 66
Gbokoo, Daniel 131
Geghard Monastery (Armenia) 178
Gelsenkirchen (Ruhr, Germany) 101–103
Genoa (Italy) 171
George III 74
George, Susan 27
German Democratic Republic (G.D.R.) 47
Germano Celant 171
Gessuram 24
Gibson, James 34
Gide, André, 66
Gila Wilderness (New Mexico, US) 17
Gilbert & George 93
Giroux, Henry 42
Goethe, Johann Wolfgang von 5, 49–51, 53, 62, 155
Goldsworthy, Andy 16, 103
Gordale Scar (Yorkshire, UK) 60
Gore, Albert Arnold 137
Gorky, Arshile 178
Gormley, Antony 128
Grand Canyon 117
Grand Central Station (New York, US) 100

INDEX

Grand River (US) 190
Grasmere (Lake District, UK) 144
Green Party 47, 155
Greenberg, Clement 36, 95
Greenland 10, 78
Greenlund, David 98
Greenpeace 16, 155
Greenwood, James 73
Gregson, Nicky 172–173
Griffin, Duane 141
Griffin, Jonathan 185
Grimshaw Architects 123
Grosz, Elizabeth 47, 48
Guattari, Felix 14
Gulaliyev, Mayis 134
Gulf of Mexico 156, 159, 163
Gulf Stream 129

Haacke, Hans 26
Hacalli (Azerbaijan) 133
Haeckel, Ernst 4, 33, 35, 47
Hague (Netherlands) 90
Hamburg (Germany)
 St Pauli district 23
Hamdallaye Samba M'Baye (Senegal) 23
Hamdi, Nabeel 113
Hammermeister, Kai 55
Hampshire (UK) 121
Hannover (Germany) 182
Hanson, Heike 153
Hardy, Dennis 186
Hardy, Thomas 73
Harrison, Helen Mayer 23
Harrison, Newton 23
Hartley, Keith 124, 127, 138
Harvey, David 65
Harz Mountains (Germany) 61
Hatton Gallery (Newcastle, UK) 183
Haussmann, Georges-Eugène 65
Hayward, Tony 161

Heathrow airport (London, UK) 6
HeHe 5, 153–157
Heininen, Lassi 112
Helsinki (Finalnd)
 Ruoholahti district 153–156
Henrion, J. F. K. 155
Hesse, Eva 170
Hillman, James 96
Hiroshima (Japan) 164
Hockerton Housing Project (East Midlands, UK) 189
Holloway, John 7
Horkheimer, Max 37, 39, 96
Houshiary, Shirazeh 170
Huit Facettes-Interaction 23
Hull, Lynne 96
Hunter, Ian 175, 177
Huysen, Andreas 76
Huysmans, Joris-Karl 67

Igloolik (Pond Inlet, Nunavit, Canada) 110
Ikpik (Nunavit, Canada) 110–111
Illich, Ivan 73
India 6, 24, 40, 138, 172, 191–194
Ingold, Tim 97
International Building Exhibition (IBA) 103, 107
Inuit 109
Inupiat 136
Inverness (Scotland, UK) 124
Invisible Dust 156
Iqaluit (Pond Inlet, Nunavit, Canada) 110
Iquique (Chile) 113
Isle of Wight 82
Ivry-sur-Seine (Paris, France) 156

Jarosz, Lucy 43
Jeffries, Richard 71–73, 145
Jerusalem 77

Jesus Green Lido
 (Cambridge, UK) 156
Johannesburg Stock Exchange
 172
Jostedalsbreen glacier (Norway)
 125

Kant, Emanuel 5, 51–53, 56–58,
 60–65
Katz, Cindi 77, 143
Kazakhstan 80
Kelo (river) 24
Kent (South East England, UK)
 148
Kester, Grant 22–23
Keswick 144
Khanna, Balraj 180
Khorkhom (Armenia) 179
Kieran, Matthew 57
Kinder Scout (Derbyshire, UK)
 146
Kiobel Barinem 131
Kirwan James 60–61
Klein, Melanie 160
Körner, Stephan W. 58, 60
Kosseleck, Ruppe 160
Kpunien, John 131
Krauss, Rosalind 13
Kristeva, Julia 28, 68
Kropotkin, Peter 38,
 41, 97
Kunsthalle (Bern, Switzerland)
 147
Kunuk, Josh 111
Kunuk, Zacharius vii, 111

La Plata (Argentina) 23
Lacan, Jacques 145
Lack, Jessica 157
Lake Chad (Africa) 136
Lake District (UK) 60, 83,
 144–146, 174, 182
Lakota 99

Lam, Steven 163
Lancashire (North West
 England, UK) 174
Lang, Fritz 47
Langdale (Cumbria, UK) 175, 182
Laramée, Eve Andrée 22,
 141–142, 164
Larner, Celia 175
Larsen B ice shelf 119
Latin America 113, 186
Lattitudes 26
Lea Valley (London, UK) 26
Lefebvre, Henri 17, 113
Lerner, Steve 190–191
LeSanto-Smith, Martin 159
Levura, Paul 131
Lewisham (London, UK) 186
Lewty, Simon 180
Liberate Tate 5, 158–164
Lilley, Clare 122
Little Norton (Somerset, UK) 185
Littoral 174, 175
Lippard, Lucy 97–100, 114,
 127, 160
Ljubljana (Slovenia) 110
Lloyd, Bert 177
Llull, Paula 106
Loftus, Alex 172
Loire Valley 80
London 4, 23, 24, 71, 73, 76, 78,
 82, 87, 91, 127, 131, 135,
 151, 161, 168, 184, 186
 Heathrow airport 6
 Dalston Mill, Barbican Art
 Gallery 25
 Lea Valley 26
 Surbition suburb, West End 72
 borough of Merton 179
Long, Richard 16
Longyearbyen (Norway) 128, 130
Lowenstein, Oliver 124
Ludwig Forum
 (Aachen, Germany) 20

Lugard, Frederick 134
Lulworth Cove (Dorset, UK) 119
Luther Standing Bear 99
Lyme Regis (Dorset, UK) 90
Lynas, Mark 76

MacColl, Ewan 177
MacDonalds 89
Madagascar 43
Madras (Tamil Nadu, India) 80
Madrid 27
Maine (US) 97
Mains d'Œuvres (Paris, France) 156
Majorca (Spain) 128
Makrolab 109
Malagasy 43
Maldives 10, 136–137
Malé (Maldives) 136
Malevich, Kazimir 161
Mallarmé, Stéphane 65–66
Malthus, Thomas 40
Manchester (UK) 73
Manhattan (New York, US) 24, 142
Marchia, Massimiliano 26
Marcuse, Herbert 12–13, 18, 28, 39, 46, 61–64, 66
Marriott, James 131–135, 161
Marx, Karl Heinrich 39
Matisse, Henri 67
Matless, David 180–181
Mazeaud, Dominique 96, 170
McEwen, Ian 128–129, 138
McKay, George 176
Meadows, Dennis 40
Meadows, Donella 40
Mecca, Giuseppe 108–109
Medicaid 42
Mediterranean
 countries 74
 biomes 91–92

Mendietta, Ana 19
Merewether, Charles 75
Merkel, Angela 156
Merton (London, UK) 179
Mexico 17, 89,
 Gulf of Mexico 156, 159, 163, 191
Millet, Jean-François 176
Minio-Paluello, Mika 131–135
Minneapolis-St Paul (Minnesota, US) 21
Minnesota (US) 191
Miss, Mary 13
Missouri (US) 190
Mittimatalik (Pond Inlet, Canada) 110
Monbiot, George 10, 29
Mondrian, Piet 50
Montreal 184
 protocol 119
Moore, Henry 149, 171
Morocco 103
Morrison, Heather 26, 184–185
Morrison, Ivan 26, 184–185
Moscow 75, 80
Muller Ice Shelf 118
Mulvey, Laura 64
Mumbai 24, 76
Munich (Germany) 63
Munster (Germany) 145
Murdin, Alex 143–146
Museum of Modern Art (New York, US) 178
Muttitt, Greg 160

Naess, Arene 39–42, 46
Nancy (Lorraine, France) 59
Nancy, Jean-Luc 116
Nansen, Fridtjof 130
Napoleon III 65
Narmada Valley 44
Nash, David 180

National Maritime Museum (London, UK) 127
National Oceanographic and Atmospheric Administration 101
National Park Service (US) 98
Natural History Museum (London, UK) 127–128
Nepal 136
Netherlands 90
New Age Travellers 17
New Mexico 17
New Orleans (Louisiana, US) 76
New York 27, 28, 76, 89, 100, 135, 173
 Department of Sanitation 17, 99–100
 Harbour 101
 Museum of Modern Art 178
New Zealand 87
Newcastle (North East England, UK) 183
Newell, Peter 133, 138
Newton, Isaac 49
Niger Delta 131, 138
Nigeria 130
 Nigerian Senate 131
 Royal Niger Company 134
Nnamdi, Basil 138
Nobel Peace Prize Forum 98
Nome (Alaska, US) 136
Norfolk (East of England, UK) 149
North America 16, 21, 31, 36,
 West Coast 95, 184, 185
Norway 40, 125, 128, 182
Nunavit (Canada) 110
Nwate, Felix 131

Occupy 2, 6, 16, 27, 165, 174
Odi (Nigeria) 131
Odum, Eugene 35
Odum, Howard 35

Office for Direct Democracy 115
Ogoni 131
Oil Watch 138
Okadigbo Chuba 131
Olds, Rob 96, 97
Open Society Institute 134
Organisation for Economic Cooperation and Development 134
Orwell, George 151–152
Oxfordshire (South East, UK) 180

Pacific ocean 117, 136
Palin, Michael 138
Palmer, Laurie 23
Panayotakis, Costas 45–46
Pancevo (Serbia) 147
Paris 51, 62, 65, 73, 74, 153,
 Saint-Ouen district 156
Park Fiction 23
Parsons, Scott 98
Patagonia 87
Patmos (Greece) 77
Pattonsburg (Missouri, US) 190–191
Peet, Richard 44
Peljhan, Marko 108–110, 112
Pepper, David 35
Phillips, Patricia 17, 100
Picasso, Pablo 27
Pierce, Harry 182
Pittsburgh 4, 22, 23
Plane Stupid 164
Platform 23, 131–132, 135, 158–161, 164
Pond Inlet (Nunavut, Canada) 110
Poundbury (Dorset, UK) 191
Priestley, Joseph 155
Prigann, Herman 21–22, 101–107, 171
Prince William Sound (Alaska) 131

INDEX

Projekt Atol 108
Prudhoe Bay (Alaska) 160

Quinta Monroy (Iquique, Chile) 113–114

Rajasthan (India) 183, 191–194
Rajkumar 24
Ramesses II 75
Ramesseum (Thebes, Egypt) 75
Rancière, Jacques 14, 68–70
Randall-Page, Peter 119–123
Rangan, Haripriya 45
Rannou, Catherine 108–109
Reason, David 17
Redon, Odilon 66
Rio de la Plata basin 23
Rio Grande 96, 170
Rivero, Oswaldo de 44
Rome 73
Rome, rue de (Paris, France) 66
Rougham (Suffolk, UK) 177
Rosler, Martha 28
Ross, Toni 14
Rothko, Mark 125
Rowell, Andrew 131
Roy, Arundhati Suzanna 14, 24, 44
Ruhr (Germany) 101, 107
Ruoholahti (Helsinki, Finland) 153
Rushby, Kevin 130
Russia 82, 87, 160

Sacred Heart basilica (Paris, France) 65
Sadler, Simon 185
Sahara (Africa) 103
Sainsbury Centre for Visual Arts (East Anglia, UK) 148–149
Saint-Ouen district (Paris, France) 156
Salmisaari power plant (Helsinki, Finland) 153
San Francisco (California, US) 173
Santa Barbara (California, US) 110
Saskatchewan (Canada) 80
Saro-Wiwa, Ken 131, 138
Scaff, Lawrence 96
Scaife, Amy 162
Scandinavia 89
Schelling, Friedrich 53–54
Schmitz, Bruno 61
Schneider, Tatjana 113–114
Schönle, Andreas 75
Schultz-Dornburg, Ursula 21
Schwitters, Kurt 181–182
Scotland (UK) 109
Scullion, Louise 124–127, 138
Seattle (Washington, US) 27
Segal, Walter 186–187
Senegal
 village Hamdallaye Samba M'baye 23
Serbia and Montenegro 147
Serota, Nicholas 160
Shakleton, Ernest Henry 130
Shanghai 76, 87
Shantibal 24
Shell 131, 160
Shelley, Percy Bysshe 61, 74–75
Shishmaref (Alaska, US) 136
Shiva, Vandana 24
Shoshone 99
Shuerholz, Dana 99
Siberia 76
Silbury Hill (Wiltshire) 178
Simmons, Ian Gordon 41
Sioux Falls (South Dakota, US) 98
Siurarjuk Peninsula 111
Sloterdijk, Peter 33
Smith, Neil 88

Smithson, Robert 16, 19, 142
Social Work Research Centre – Barefoot College (Tilonia, Rajasthan) 183, 191–194
Soho (London, UK) 168
Soldier's Grove (Wisconsin, US) 190–191
Solnit, Rebecca 160
Somerset (UK) 7, 185
Sonfist, Alan 21
South Dakota 98
South Pole 130
Speer, Albert 61
Spender, Stephen 61
Spieker, Sven 147
Spitsbergen (Svalbard, Norway) 128, 130
Staeck, Klaus 156
St Austell (Cornwall, UK) 92, 123
St Pauli district (Hamburg) 23
St Petersburg (Russia) 21
St Werburghs (Bristol) 188–189
Staffordshire (UK) 149, 184
Standlake (Oxfordshire, UK) 180–181
Stallabrass, Julian 161
Statten Island 100
Stern, Nicholas 9
Stokes Croft (Bristol, UK) 165, 173
Strelow, Heike 18–19, 22, 142
Suffolk (East Anglia, UK) 177
Sussex (South East Englang, UK) 82
Svalbard archipelago (Norway) 128, 130
Swyngedouw, Erik 26–27, 77, 87–88, 172

Tate Gallery (London) 91, 158–163
Tatton Park (Staffordshire, UK) 184
Tennyson, Alfred 73
The Corner House 134
The Arts Catalyst 109–110
Thebes (Egypt) 75
Till, Jeremy 15, 113–114, 188
Tilonia (Rajasthan, India) 183, 191–194
Tin Creek (Alaska) 136
Tinker's Bubble (Somerset, UK) 185–186
Tipi Valley (Wales, UK) 17
Tiravanija, Rirkrit 68
Tisdall, Caroline 115
Tolpuddle Martyrs 175, 177
Tolstoy, Leo 75, 80
Torrey Canyon oil tanker 130
Trost, Nejc 111
Trotsky, Leon 37
Turin (Italy) 26
Turner, John 186
Turner, Joseph Mallord William 60, 155
Tuvalu islands (Pacific ocean) 136

Udo, Nils 21, 22, 142
Ugiomoh, Frank 138
U.K. 111, 134, 135, 189
Ukeles, Mierle Laderman 17, 18, 99–101
United Nations 137, 186
University of East Anglia 148, 156
Urban Laboratory, The, University College London 112
d'Urbano, Alba 19, 20, 22
Ushuaia (Argentina) 117

Valery, Paul 66
Vavilov Institute (St Petersburg, Russia) 21
Venezuela 130
Vienna (Austria) 23, 63

INDEX

Vietnam 28
vries, herman de 19, 145

Wagner, Peter 51
Walker, Gabrielle 117–119
Wall, Derek 164
Wall Street 51, 100
Ward, Colin 186
Ward, James 60
Washington 64
Watts, Michael 44
Watts, Terry 179
Weber, Max 95–96
Weimar 50
Weld Estate (Dorset, UK) 119
Wells, Herbert George 86–87
Wessex 73
West Midlands 152
Wheeler, Sarah 130
Whiteread, Rachel 128
Wigglesworth, Sarah 15
Wilde, Oscar 66
Williams, Raymond 7, 56
Willats, Stephen 180
Wilson, Edmund 66
Wiltshire 72, 178
Wisconsin (US) 190
WochenKlausur 23
Wolff, Janet 64
Wolverhampton 152
 Art Gallery 151
Woodward, Christopher 72
Wordsworth, William 60, 155
World Commission on Environment and Development 46
World Trade Centre, New York 24, 100
World Trade Organisation 27
Wyman, Eliot 25
Wyndham, John 5, 81, 83
Wyoming (US) 96

Yeats, William Butler 66
Ylojarvi (Finland) 24
Yorkshire (Northern England, UK) 60
Young Pioneers 36
Young Communist League 36
Yugoslavia 148

Žižek, Slavoj 28–29, 76–77, 87, 144–145